Fifty Years of Modern Art
1916-1966

EDWARD B. HENNING

PUBLISHED BY THE CLEVELAND MUSEUM OF ART

Copyright 1966 by The Cleveland Museum of Art
University Circle, Cleveland, Ohio 44106
Library of Congress Catalog Card Number 66-21228
Printed in United States of America

Distributed by the Press of Western Reserve University, Cleveland, Ohio 44106

PREFACE

This is a selection of paintings, sculptures, and one print which were created during the fifty-year period between 1916 and 1966 and which we consider to be of outstanding artistic merit. It is not necessarily made up of the greatest works of art of this period; but it is an exhibition that makes an effort to deal mainly with the question of quality in modern art rather than with such themes as style, motif, or form.

Too often we are most aware of the chaff with which we are surrounded. It may be that there really is more chaff today than in previous times, but we must remember that history and connoisseurship have screened out the grain of earlier periods for our delectation. Further, it is precisely by means of collections, articles, books, and exhibitions—in short by comparisons—that choices are made and the judgments of history formulated.

Choices inevitably reflect the taste of the chooser. Even in an increasingly computerized world there still are no objective criteria which can be "put in" the machines to select those objects representing the qualitatively superior modern works of art. Quantity connotes a different measure from quality. Fortunately in areas such as morality and art, where value is central, the attitudes, opinions, feelings—and even prejudices—of men still play an important role. Inevitably then, one misses certain favorites here. Hopefully, however, a large proportion of these works of art would be included on many lists of great works of modern art.

The text and reproductions which follow are organized chronologically. Brief discussions aim to relate the works to important artistic developments of the period and also to indicate their individual significance. There are two major divisions, each with a brief introduction—the first sketching in the background of the period from 1916 to World War II and the second, from that point to the present. The final section of the book lists the artists alphabetically, with a brief biography of each, and catalogue information on each work.

The position taken is that certain information about the physical form of a work of art, the process by which it was created, or background conditions can be related to it verbally and contributes to the development of a state of mind sympathetic to its appreciation. However, the fullest experience of a work of art is ultimately a private affair between that work and each perceiver. It is here that everything truly significant and valuable occurs, and it is precisely here that words are beside the point. The text concentrates on those things that can be put into words. Seeing and knowing are of incomparably greater value and importance, but they are personal and ineffable.

An exhibition that has no single didactic purpose but is dedicated to the idea of quality, finds itself with several variable determinants which overlap and

even conflict with one another. The most difficult problem where different styles and arts are included is that quality must be recognized in many different manifestations. Artists can be fully committed to an idea, a movement, or a style. Quality, however, is not an adjunct of any of these. It occurs, as always, in various guises. In such an exhibition, therefore, one must not choose works simply because they illustrate an important style; and such factors as inventiveness and historical significance cannot be regarded here as of central importance.

The introductory essay tries to define a theoretical position regarding artistic value. It does not provide specific criteria for the evaluation and selection of works of art, for ultimately, choices are made on other than strictly rational bases. It aims, therefore, only to clarify the attitude from which the selections were made.

Success in such an undertaking depends finally on sympathetic understanding and cooperation on the part of many people. Lenders to the exhibition have been listed elsewhere but special mention should be made of The Museum of Modern Art, Albright-Knox Art Gallery, Musée National d'Art Moderne, and the Philadelphia Museum of Art for particular help and consideration.

The difficulties of loaning such works of art as these to any exhibition are very well appreciated. These are precisely the works most sought out by visitors to a collection and held most dear by their possessors. It is particularly generous when collectors, who live with and love the works that they have so painstakingly acquired, send them out for public exhibition. Their gesture is deeply appreciated.

Without the hard work and cooperation of many people, however, an exhibition of this kind would never come into being, despite the ideas and selections of the curatorial staff and the generosity of lenders. Edward B. Henning is responsible for the exhibition and for this concrete memory of its only-too-short existence. His devotion and labor have known no limits of time, effort, and competence. More thanks than can be acknowledged are due to members of the staff as listed in Mr. Henning's acknowledgments.

Sherman E. Lee

ACKNOWLEDGMENTS

In retrospect one wonders at one's own audacity in undertaking an exhibition intending to base itself largely on quality. In an age devoted to scientific exactness, measurement, and mechanical logic, such a selection must seem an anachronism. I do not believe that it is. Whether it is well or badly chosen, let it at least testify that the idea of value still exists in the world and is a powerful and protean force. The variety of forms must remind us that man is not merely a machine within the greater machine of historical process. For here is a gathering of products of quality produced by men who moved as often—perhaps more often—against economic, social, and all other historical pressures as they did with them. These are the products of gratuitous actions—an idea our age is not very well equipped to understand.

Let it also remind the rabid partisans of the avant-garde that value is not inevitably a quality of the new. In the scramble to stay abreast of the latest developments in art, these seers are perhaps involved with the market and with their own image rather more often than with art.

Value is a fickle creature; she does not bed down only with the new, nor yet with the accepted old. She can be found with the most disreputable types, and with the most sedate and respectable. She insists only on one characteristic among her lovers, and that is absolute fidelity. She is at once inconstant and demanding, capricious and jealous. But it is to her that we must finally pay our highest homage and not to her various rivals for our attention: style, historical significance, influence, tradition, invention, etc. It is indeed true that she often reserves her finest favors for the daring and heroic figures who push into hitherto-unknown areas of expression and ultimately enlarge the range of human experience. But it is foolish for any of us to believe that we can accompany the creator on his wild adventure. Frequently he invents his language as he discovers experience and reveals its form. Let us at least do him the courtesy of acknowledging his aloneness.

In bringing together works of such great value, one must count heavily on the generosity and understanding of many collectors and institutions. On behalf of the Trustees and the Director of The Cleveland Museum of Art, therefore, I extend my gratitude to the collectors, museums, artists, and dealers listed on page 209. Special thanks are due to the museums mentioned by Sherman E. Lee in the Preface and to Mr. and Mrs. Burton Tremaine, Sidney Janis, and Frank Lloyd for particularly large and important loans and for their spirit of generous cooperation.

I owe a special debt of gratitude to the many people in the United States and in Europe who gave advice, assistance, and suggestions that aided in the final selections. Especial mention must be made of: M. Louis Carré, M. Bernard

Dorival, Richard Feigen, M. Hubert Landais, Mr. and Mrs. Arthur Lejwa, Miss Dorothy Miller, William Rubin, John Russell, and Eugene Thaw.

I wish also to thank my colleagues at the Museum for assistance, advice, and, in some instances, for hard labor. Particularly to be mentioned are: Sherman E. Lee, Thomas Munro, James R. Johnson, George Reid, and Richard Burton for reading various parts of the text and giving excellent criticism and advice; William Ward for solving serious problems of installations; Richard Burton for handling publicity; Lillian Kern and her staff for planning for transportation and recording the large number of works coming from points all over this country and Europe; Merald Wrolstad and his assistant, Rosalie Ault, for preparing this catalogue; Richard West for valuable help in preparing the text for certain sections of the catalogue (Mr. West's initials will be found below the sections for which he is largely responsible); and, above all, Alice Wright for endless typing, filing, keeping records straight, and constantly reminding me of things needing attention.

Last, I would like to thank the Trustees of The Cleveland Museum of Art and its Director for the opportunity to present this exhibition and catalogue in celebration of the Fiftieth Anniversary of The Cleveland Museum of Art.

Edward B. Henning
March 4, 1966

CONTENTS

Preface *page v*

Acknowledgements *page vii*

The Problem of Evaluation *page 1*

Part I: 1916 to World War II *page 5*

Part II: World War II to the Present *page 96*

Catalog—alphabetically by artist *page 196*

Lenders to the Exhibition *page 209*

The presumption of a critic or curator who seems to be deciding what is good and bad in art is matched only by the moralist who tries to decide how people should act. Yet a world without values—without the ideas of good and bad, right and wrong—would be not only asocial, it would be a world fit only for brutes. Indeed, it is mainly "the knowledge of good and evil" (and of aesthetic value) that separates the world of man from that of other creatures.

In art, the issues are not always as dramatic or pressing as the moral questions, but they are equally present. Thus, when the main determining factor in any selection of art is quality, something should be said about the aesthetic position from which the choices were made. Two hundred and fifty years ago such a task would have presented few problems. Despite certain controversies, such as that between the Poussinists and Rubenists, the factors contributing to quality in art were not in serious dispute. Roger de Piles confidently defined them and even graded a list of artists in such categories as drawing, color, composition, and expression. Two hundred years later—around the time that marks the starting point for this survey—many critics would have refused to attempt a clear-cut, inclusive, and consistent statement of criteria for evaluating art. The certainty that there is only one correct kind of art was already moribund. Artists such as Courbet, Manet, Monet, Cézanne, Van Gogh, and Rodin were recognized as belonging among the leading creative figures of the preceding century. Yet it was precisely they who had violated the canons of academic taste. Some, such as Gauguin and Matisse, even looked outside the Western tradition to the art of the Orient and primitive cultures for inspiration.

The immediate "aftermath of the absolute" was, predictably, anarchy. Without a "correct" form of art, it seemed that all works of art and all opinions about them must be entitled to equal respect. In place of a universal dogma, a plethora of individual opinions flourished. Anatole France put the attitude of critical relativism succinctly when he stated that it was the critic's duty to recount the "adventures of his soul among masterpieces." Criteria were held to be personal, flexible, and indescribable. There could, therefore, be no point in trying to establish them objectively, or even in discussing the problem.

Since then, many critics have substituted history or descriptive analyses for evaluative judgments. Others, elaborating on M. France's advice, have produced lyrical prose intended to reveal the emotional experience of the critic before a work of art and thus to parallel its spirit. Such methods have produced quantities of literature, but have proved less than enlightening for a public still instinctively asking, " Why are certain works of art selected for prizes or for inclusion in exhibitions and public collections?" And to anyone conditioned to the logic of law, to the pragmatic truths of medicine, to the

statistical truths of marketing, or to the more objective truths of science, such writing must appear irrelevant, vague, or both.

In the words of Aristotle—spiritual father of Western science—there are areas where "we must be content . . . to indicate the truth roughly and in outline," for here we are "speaking about things which are only for the most part true and with premises of the same kind to reach conclusions that are no better." And "it is the work of an educated man to look for precision in each class of things just so far as the nature of the subject admits." Applied to problems attendant upon the evaluation of art, this seems to suggest that we should give up the search for exact qualitative measurements, yet also continue to "look for precision . . . so far as the nature of the subject admits."

The critic is inevitably located in the area between the creative artist and the concerned public. Hopefully he is in contact with both. It is proposed here that his purpose should be to comprehend and somehow evaluate the first while helping to open the door to the fullest knowledge and experience for the second. Thus, his job is not to put the essential meaning and quality of works of art into ordinary words—for they are inappropriate to that task, and attempts to do this can only mislead the audience and degrade the works of art. His problem is to somehow open the eyes, minds, and sensibilities of human beings to visual qualities, stimulating them to perceive, comprehend, and evaluate works of art in relation to relevant contexts—contexts that they have actually helped fashion. When Cézanne's paintings, for example, are judged in relation to Western art of the late nineteenth and early twentieth centuries, they are being evaluated by standards that they have helped create. In this sense, any reasonable method for evaluating works of art must consider them in their own terms and not in the terms of another kind of art, nor in the terms of verbal logic.

It is axiomatic, however, that one can only begin from where one is. For most people this means approaching works of art by means of the language with which they are already familiar—the language of words used to describe what the senses preceive and what the mind reasons.

It is, therefore, not irrelevant for the critic to indicate how Cézanne used the same blue in the foliage, mountain, and sky of a landscape or how he paralleled the curving ridge of a mountain in the distance with the limb of a tree in the foreground to help integrate the two-dimensional composition of a painting with its order in suggested depth. It may even be useful to point out how he tilted a plane or broke the continuity of a table edge to create a visual tension. Granted, such information neither illuminates the content nor reveals the quality of the works of art; but the sense of familiarity with the "vocabulary" which contributes to their full comprehension is normally preceded by just such mundane knowledge. It is necessary—in Aristotle's words—"to look for precision . . . so far as the nature of the subject permits" or, as a favorite quotation of Braque's has it: "if you wish to get hold of the invisible you must

2

penetrate as deeply as possible into the visible." The compositional order of a work; the appropriateness of its material or medium to its style; its position in the evolution of the artist's style; the relative significance of his work within the context of a period, a style, or a movement; the relationship of the style or movement to others with which it is contemporary, or to a tradition which provides its context; the singular quality of a line, of a shape, or of a painted surface—such are the kinds of things that can be discussed with a fair degree of clarity and precision and be depended on to yield relevant information. Usually the people whose particular business it is to evaluate art do not consciously consider and weigh all such factors; they are so completely familiar with them that it becomes an unconscious activity. They simply select the works that excite and "move" them. Yet such apparently spontaneous reactions are based on knowledge that has been carefully—and often painfully—acquired, no matter how much "taste" the critic naturally possesses.

Obviously then, factual information and (hopefully) reasoned judgments played a large part in the "instinctive" selections of the works of art gathered together here. And because such information and judgments can be put into words, they comprise the bulk of the short discussions about each work of art. It must be emphasized, however, that they do not pretend to explain the quality of the works of art. At most, they report some of the information that contributed to a feeling of familiarity and rapport with the works of art and made possible the judgments about them.

Selections were made by comparing and evaluating works of art within a common and meaningful context. The tradition of Western painting, for example, includes such key elements as comprehensible space suggested on a flat plane; a unified and ordered composition; the representation of figures and objects from the natural world; the development of surface decoration; and the expression of ideas and emotions both iconographically and formally. It is clear that Cubism contributed in a significant way to this tradition even while inventing new formal concepts. Individual Cubist works, however, can be evaluated only within the context of Cubism and according to the values defined by the body of Cubist paintings and sculptures.

Thus the theoretical basis from which the following selections were made includes neither the notion of absolute, unchanging, and universal values, nor that of values relative only to the immediate, personal experience of the individual. The first of these rejects the idea that the opinions and creations of man had anything to do with the formation of values. It is a position tending to restrict the serious consideration of art to a tradition conforming to what can only be regarded as a transcendental ideal. Art lying outside that tradition is not considered seriously by the absolutist, while art within it is judged according to how perfectly it realizes the ideals of the tradition. Thus, dogmatic Classicists could once confidently relegate Rembrandt and Dürer to positions much lower on their scale than Raphael, the Carracci, and Charles Le Brun.

3

The second, represented above by Anatole France's statement, clearly implies that attempts to evaluate the behavior and products of man are mistaken. There can, therefore, be no such thing as a selection of art on the basis of *its* quality. Any such selection can only be made on the basis of individual taste. Aesthetic (and moral) anarchy must thus be held by extreme relativists to be a natural and desirable state.

The position taken here holds that ideals and standards are the creations of men who also try to live up to them. New ideals and standards, partially based on old, are constantly invented, and parts of the old which no longer are relevant are discarded. Cézanne's paintings, for example, contain elements of both Classicism and Impressionism; Cubism carried these tendencies in his art to a point beyond anything done by Cézanne; Mondrian finally eliminated all traces of Impressionism and developed a severe, purely formal, abstract style based on the classical elements from Cubism. Each development brought with it new forms that were also partly encompassed by the old, and discarded parts of the old that it could not use. Evaluations of art depend, therefore, on standards established by the works themselves as well as those from which they have derived. It would be an obvious error to attempt to evaluate a painting by Chagall using standards derived from Mondrian's art. On the other hand, there may well be valid points of comparison between canvases by Chagall and Redon—or Delacroix. And works by Mondrian have some formal characteristics in common with those by Seurat, J. L. David, Vermeer and Piero della Francesca.

Each work of art can thus be seen as both a carrier of generic traits which it shares with other—and therefore comparable—works, and at the same time as a unique object, an expression of singular values setting it apart from every other work of art that exists. The central problems are to recognize its singularity and at the same time to discern its relative value.

We have now come full circle back to the position that the evaluation of art is necessarily subjective. Hopefully, however, it has been indicated that it need not be whimsical. Judgments by means of careful comparison may have a significant degree of validity within a broad cultural context. Such an attitude carries with it a conviction that neither absolute authority on the one hand, nor anarchy on the other is a tenable position regarding the evaluation of art. Artistic (as well as ethical) values are constantly invented and rejected by men in a dynamic process occurring through their decisions and actions; only after this fact are they normally put into theoretical terms.

World War I opened upon a world that had been exploring, defining, and explaining itself in increasingly materialistic and mechanistic terms since the seventeenth century. The war was a political event that dramatized the end of a three-hundred-year dream of a perfect society that was to have been achieved through science and reason. The sciences themselves, however, had for some time been reappraising many of their most honored concepts and methods. Experiments and theories by Max Planck, Albert Einstein, and Heisenberg, among others, suggested that physical phenomena are not as simple, regular, and linear as they had once appeared. The inevitability of mechanical cause and effect began to break down in certain areas, raising serious problems of prediction and control. Words like "uncertainty," "chance," "free-will," and "vitalism" began to appear in respectable scientific writings and the claim to complete objectivity in laboratory experiments had to be surrendered. So-called objective facts, it began to appear, are only one way of looking at things—a way that is inevitably conditioned by the nature and limitations of our senses and by the tools and "language" of science. Moreover, it began to seem that the scientist often cannot avoid interfering with and influencing the phenomenon he is studying, as well as being influenced by it.

Thus by 1916 many people had concluded that a society devoted to materialistic and mechanistic ideas and methods was not about to bring forth Utopia. On the contrary, it had produced some very serious problems, including the greatest war of history, and it was showing signs of breaking down even in the scientific areas which had in large part fashioned it. To some young artists and writers, a world in such disarray was an absurdity and should be so treated. This was the basic premise of Dadaism, a movement formed in 1915 by young artists and poets who had come together in Zurich from all over Europe. If centuries of convention based on reason, science, and the classical tradition had resulted in a convulsive effort at self-destruction by Western civilization, they held, traditional cultural values might better be given up. And Dadaism set out to laugh them out of existence with mockery, irony, parody, and satire.

The uncompromising negativism and anarchy of Dada, however, led to a split in the group which reached a climax in 1923 when the poet André Breton defined a more positive position in the first Surrealist Manifesto. Breton found much support among artists and poets for a program which incorporated Dada's rejection of reason and of traditional moral and artistic values, but in a more positive spirit, also proposed a return to intuition and impulse as a basis for thought and action. Surrealism accepted the Freudian notion that the irrational relations of dream images often possess a significance and poignancy beyond ordinary or purely logical relations. It developed techniques for inves-

tigating the "landscape" of the unconscious: automatism, free-association, and the precise depiction of dream images—all paralleling methods of psychoanalysis. Surrealism did not seek therapy, however, but a poetry of the marvelous.

Both Dada and Surrealism were thus anti-classical and anti-scientific—in the mechanistic and rationalistic sense. They opposed not only traditional academic art, but also the formalistic, avant-garde art of their own time. Even when they borrowed techniques such as collage from Cubism, their purposes and processes were ultimately different. They used such methods to reveal new kinds of meaning, rather than to create new kinds of forms.

For other artists, however, traditional values were not so easily surrendered. Imagination still afforded the possibility to dream of a better world—a world in which (as in the instance of Chagall) love was the central force, a world in which (as with Social Realism), art served the cause of social reform or revolution, or a world in which (as with Matisse, Mondrian, or Braque) reason might still produce order and art. The forms of art varied enormously but they were still conditioned in different ways and to different degrees by their creator's responses to the material world. In a broad sense, art continued to mirror the world of outer reality, although no longer was there any pretense of a simple one-for-one relationship. Each artist carried his own mirror within himself.

In summary, when the fifty-year period covered here opened, traditional values in almost every field were being called into question. Cubism was the major movement on the side of formal order, and it has exerted a powerful influence ever since. Expressionism continued the more violently emotional side of Romanticism, distorting natural appearances for more forceful expression. It thrived in the shambles of Central Europe following the war and developed special aspects in the United States and Mexico during the 1920's and 1930's. Abstract, or non-representational art, which had first developed around 1910 with Kandinsky and then Mondrian, Lissitzky, Malevitch, Delaunay, Kupka, and others, continued without significant further development until World War II. Dada provided a vigorous, anarchistic counteraction to traditional values; and its magnified avatar, Surrealism, shared its opposition to these, adding a positive program based on exploration of the subconscious.

Following Surrealism there were no truly revolutionary developments in art for twenty years. Artists like Braque, Mondrian, Rouault, and Matisse continued to develop and refine the styles they had earlier created; Bonnard, Maillol, Lachaise, and others worked on in more traditional ways; and Picasso moved erratically, like an inspired genie, feeding on the past, but usually in advance of everyone else.

Those who like to find causal relations between the arts and socio-economic events may find grist for their mill in the relatively static state of the arts during the years of the world-wide depression and the growing threat of Fascism; while during the years of the Second World War and immediately after, there was another burst of creative activity, this time initiated in the United States.

6

Odilon Redon, a contemporary of the Impressionists, was not concerned with their objective view of nature and analytical approach to light. He was loosely associated with the Nabis, who paid him homage in a collective exhibition at Durand-Ruel's in 1899. Along with Gustave Moreau, however, he must really be considered as leader of the French Symbolist movement and, in certain ways, a precursor of Surrealism. He was one of those extraordinary artists appearing from time to time who are fully committed to their own inner visions.

It was probably in the last year of his life that he completed the pastel painting, *Orpheus*. The idealized profile bust of the mythical Thracian, whose song charmed even Hades, reposes, eyes closed in death, upon his lyre. In the background is a fantastic mountain which may be the place where he is supposed to have been brutually killed and dismembered by a band of frenzied Maenads; or perhaps it is the Island of Lesbos where his head floated after his death and thereafter sang or prophesied (according to which legend one prefers); but most likely it is Mount Parnassus, symbol of poetic inspiration.

The softly blended, luminous pastel tones and the delicate line drawing re-enforce the image of lyrical fantasy. Redon frankly espoused ambiguity in his works, about which he said: "They are a kind of metaphor." The figure of Orpheus has frequently served as a symbol of the romantic, inspired artist doomed to be destroyed by those who hate him because of his gift; it is an image particularly appropriate for the lyrical gifts of Redon.

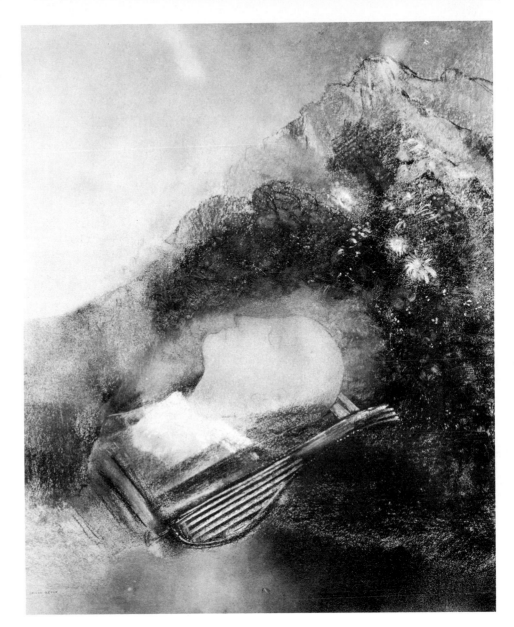

1 Odilon Redon, *Orpheus*

In the same year Juan Gris, a Spaniard who had followed Picasso to Paris in 1906 and became his disciple, represented a more formal point of view in *Still Life with Playing Cards*. Picasso himself admitted that at this time the pupil was beginning to teach the master. It was Gris who succinctly defined an important change that took place within the Cubist movement during 1912 and 1913. "I begin," he remarked to the dealer Kahnweiler in 1920, "by organizing my picture; then I characterize the objects." That is, he began with a general composition of shapes and colors; then, following the suggestions that they made to his mind, he proceeded to define specific images. Thus he followed a deductive process, going from the general to the specific. In 1916, when he painted *Still Life with Playing Cards,* his technique was sure and his style fully developed. The pattern of interacting rectangular shapes implies—without precisely defining—a table, napkin, glass, the ace of spades, and a chess board. Unlike Chardin or the seventeenth-century Dutch still-life painters, however, Gris is not story-telling. The visual "clues" of the existence of these objects only provide an "entry" for literal minds to the austere framework of the canvas' formal structure. The subject of the painting may reasonably be said to be painting itself.

2 Juan Gris, *Still Life with Playing Cards*

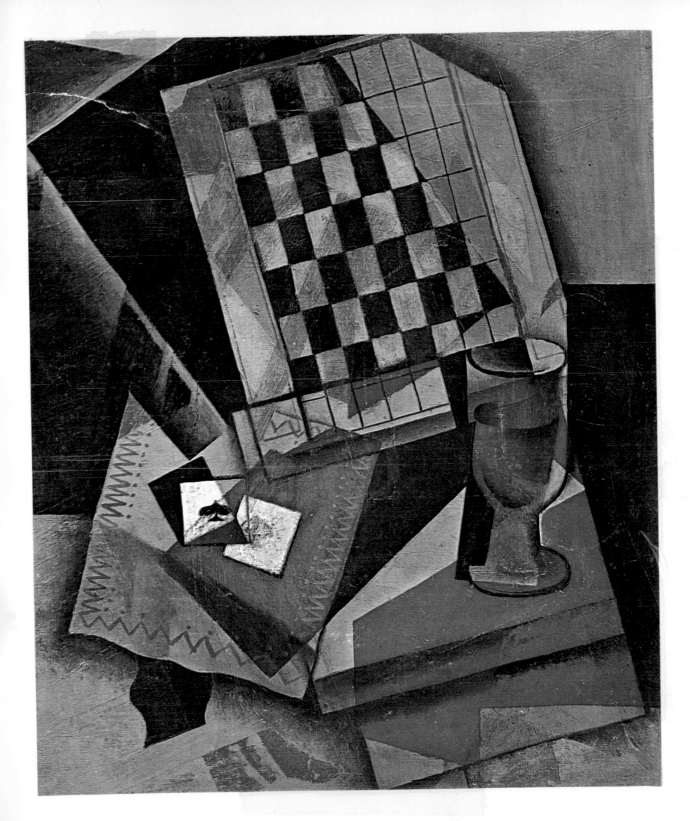

IN THE WAR.

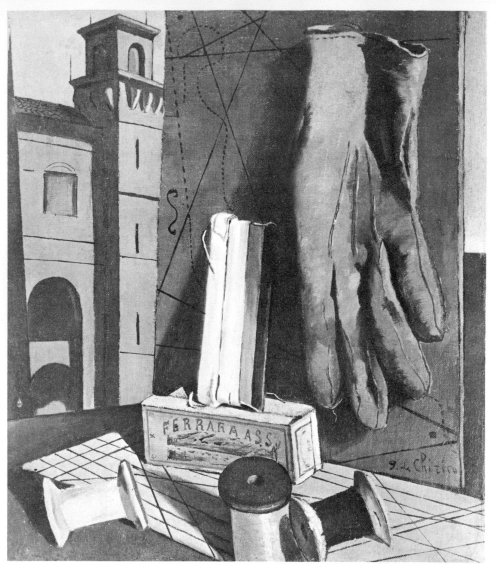

3 Giorgio de Chirico, *The Amusements of a Young Girl*

The last year in the life of the Symbolist painter Redon was a highly productive year in the early career of the "Metaphysical" artist Giorgio de Chirico. Both men are among the immediate forebears of Surrealism. The Italian (born in Greece) met Carlo Carrà (until then a Futurist) in a convalescent hospital for the Italian army in Ferrara in early 1917. There they formed the nucleus of the *Scuola Metafisica,* a movement essentially dedicated to the definition of the art that De Chirico had been creating for the previous five years.

During this time the artist had passed through several stages developing a number of different compositional schema and astonishing combinations of motifs including Renaissance architecture (especially arcades), classical sculpture, diagrams, railway trains, towers, clocks, mannequins, fruits and vegetables, and biscuits. These were usually organized within a deep space with long cast shadows seeming to indicate a deep afternoon sun.

Late in 1916 (or perhaps early in 1917) De Chirico painted, with economy and order, *The Amusements of a Young Girl.* The famous red Castello Estense of Ferrara* appears in the background and a still life in the foreground. Perhaps most remarkable, however, is the solidly modeled glove pinned to a board. Such sensuous handling is without precedent in the artist's earlier work, and it seems to predict a later interest in the work of Courbet.

The clarity with which objects are defined and the incongruity of their relations clearly predict the dream-like imagery of later works by Surrealists such as Dali, Magritte, and Delvaux.

*James T. Soby, *Giorgio de Chirico* (New York: Museum of Modern Art, 1955), p. 114.

Jacques Lipchitz, born in Lithuania, arrived in Paris for the first time in 1909. After a brief remigration to Russia in 1912, he returned to Paris, where he struck up a friendship with the Mexican painter Diego Rivera, who introduced him to Picasso—and to Cubism. Soon, he began to apply Cubist concepts to sculpture. Thus the organization of flat, severe planes to suggest images of a romantic type (rather paradoxically favored by the Cubists) took on a third dimension with sculptures such as *Man with Mandolin*. Like the painters, especially his friend Juan Gris, Lipchitz successfully combined various aspects of the subject which he defined with broad, simple planes. The stone figures of this period are more explicit in their poetic subject matter (harlequins, clowns, musicians) and more solidly sculptural than the slim, vertical, architectonic figures which preceded them. As one moves around the form new aspects of the figure are constantly revealed. Yet the integration of all views in one massive unit is brilliantly resolved.

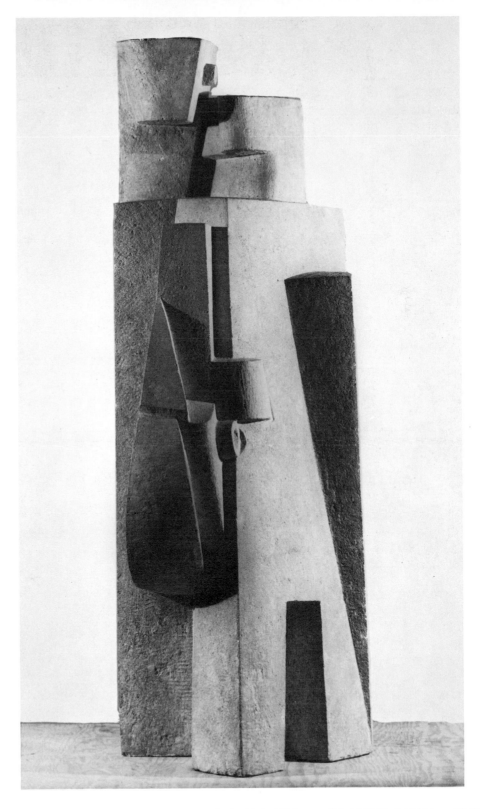

4 Jacques Lipchitz, *Man with Mandolin*

1917 UNITED STATES ENTERS WORLD WAR 1 ON SIDE OF ALLIES. PRINCE LVOV, THEN KERE

Also living in Paris at this time was perhaps the most creative and influential sculptor of the twentieth century. Constantin Brancusi was born in Rumania but from the age of eleven wandered across Europe until settling in Paris when he was twenty-eight. He rejected all current influences, including Cubism, which then excited the atmosphere of that city. He even refused a flattering offer from Rodin to work as an assistant in his studio at Meudon, preferring instead the simpler and more expressive forms of primitive art. His images were at this time reduced to pure primordial and geometric shapes such as the egg, the oval, the block, and the cylinder—which the artist refined until the most subtle nuance of a curve or the relationship of one part to another acquired significance. He worked directly in wood and marble, as well as cast bronze and brass, which he finished by hand. Each work, such as the gleaming, male *Torso*, seems uniquely suited to the character of the material. The artist's ultimate aim was to eliminate all superfluous details, arriving at the simplest, purest possible formal statement which would define the essential meaning of the subject.

5 Constantin Brancusi, *Torso*

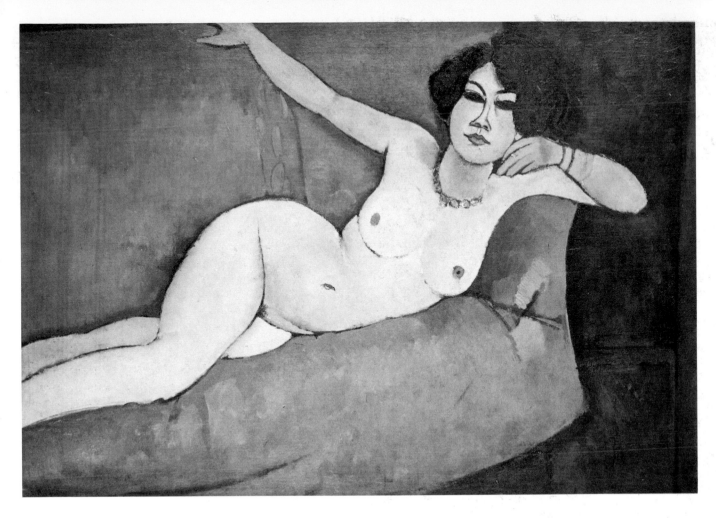

One of Brancusi's close friends was Amedeo Modigliani. The older Rumanian master encouraged the Italian painter's efforts in sculpture, and Modigliani sometimes seemed to regard his own efforts in stone more highly than his paintings. Nevertheless, his major achievement was as a painter. In 1917 he completed what is perhaps the finest canvas in a series devoted to the subject of a reclining female nude. The model in this instance was a beautiful Algerian girl called Almaissa who was painted by the artist at least two other times in head and shoulder portraits. The figure in *L'Algérienne Almaissa,* is elegantly designed in a series of rhythmic curves yet it retains a measure of individuality and truthfulness to life lacking in his more generalized treatments of

the same theme. It clearly demonstrates Modigliani's ability as a linear draftsman of precision and expressiveness. The romantic character of this handsome, gifted, and tragically (but appropriately) tubercular bohemian is reflected in the poetic languor and sensuality of his images. Indebted to the elegant draftsman of the Italian Renaissance, Sandro Botticelli, and to the primitive expressiveness of African Negro sculpture (as well as to Brancusi), he created a style that is expressive, decorative, and uniquely his own.

6 Amedeo Modigliani,
 L'Algérienne Almaissa

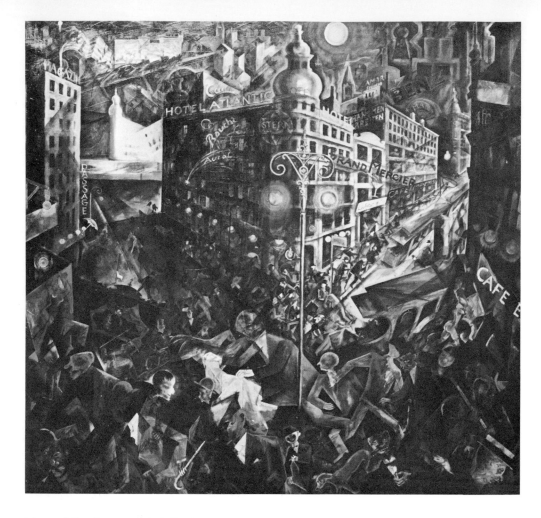

Meanwhile, the anarchistic Dada spirit was sweeping across Europe. Some of its manifestations, particularly in Germany, were bitterly satirical and politically revolutionary. At the end of 1916 and early 1917 George Grosz was on convalescent leave from the German army and spent much of his time working on the canvases, *Funeral of the Poet Oscar Panizza* and *The City*. The attack that both paintings make on society by caricaturing its worst features is an important aspect of the movement called the *Neue Sachlichkeit* (New Objectivity) as it developed in the art of Grosz and Otto Dix in the early 1920's. Drawings and prints by these artists often concentrate on political and social meanings. *The City,* however, like many works by Goya and Daumier, successfully joins such considerations with aesthetic qualities.

The convulsive complexity of the composition brings vigorous opposing movements into conflict with one another forcing their interpenetration in a way that is clearly related to pre-war Italian Futurism, while the distortions, and even caricatures of human types are typically Expressionistic. However, the disrespect for—and attack on—society and culture is in the purest Dada spirit.

7 George Grosz, *The City*

In this year Brancusi produced *Chimera,* a large figure hewn out of oak. The title refers to a fantastic monster uniting various parts of animals and birds. It also has connotations of combined male and female attributes. The image is made up of oval forms of an open block resting on an X-shaped base with a long "neck" above, supporting a circular motif and a short break-like pendant section. The rough forms exploit the character of the material and seem to suggest ponderous, primitive power. Rhythmical repetitions and subtle relationships of forms with variations, however, reveal a mind and taste that is most sophisticated.

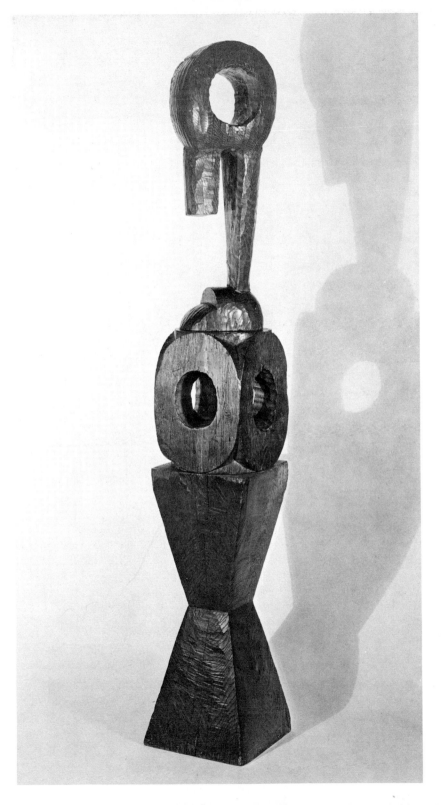

8 Constantin Brancusi, *Chimera*

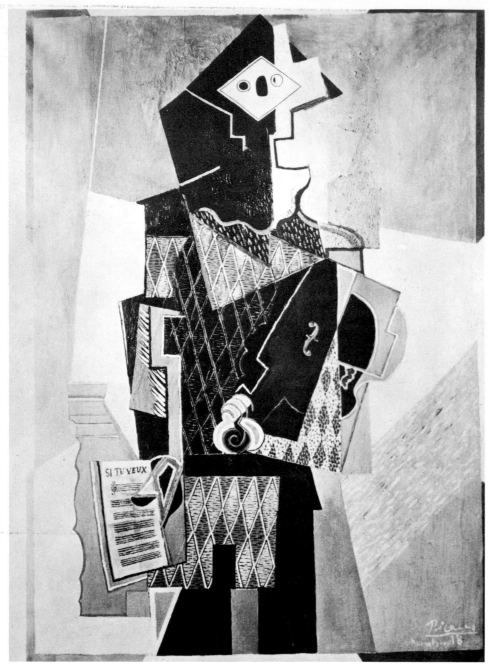

By this time the co-inventors of Cubism, Picasso and Braque, had gone separate ways. Braque spent the war years in the French army, where he was badly wounded, while Picasso, as a Spanish citizen, escaped military service. The second phase of Cubism, called "Synthetic," had reached its full development in the two years preceding the outbreak of hostilities, but many of the artists continued to work in this way through the 1920's and even after. Picasso's inventive drive carried him in several different directions—often at the same time—but Cubist characteristics have always recurred in his work.

Harlequin with Violin (Si Tu Veux) is one of this artist's most important Synthetic Cubist figure paintings. From this point on, for the next few years, his Cubist pictures were almost invariably still lifes, while his figure compositions were in a monumental, classical style (important exceptions are the two versions of *The Three Musicians* done in 1921).

It was during 1918 that he designed the costumes and sets for De Falla's ballet *The Three Cornered Hat*, which was presented by the Russian Ballet in London during Picasso's visit there with his wife Olga. At the same time the troupe risked a second production of *Parade*, a more daring work by Cocteau with music by Satie. It may be that the painting of the *Harlequin* was influenced by Picasso's involvement with this second ballet, for which he had also done the designs, and its story of the circus. In any case, it was a subject that he had long favored.

9 Pablo Picasso, *Harlequin with Violin (Si Tu Veux)*

Pablo Picasso, *Three Musicians*
The Museum of Modern Art, New York
Mrs. Simon Guggenheim Fund

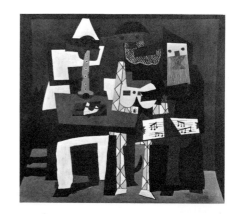

Joseph Stella came to this country from his birthplace in Italy as a young man. From 1909 to 1912 he was back in Europe traveling in France and Italy and associating with the Futurists. After returning to this country he exhibited in the Armory Show in 1913. In the years that followed he painted subjects such as Coney Island and the *Brooklyn Bridge* which were particularly suitable for a Futurist treatment emphasizing the raw power and dynamism of the New World. He wrote about the Brooklyn Bridge that it was "the shrine containing all the efforts of the new civilization of America." And further: "when in 1912 I came back to New York I was thrilled to find America so rich with so many new motives to be translated into a new art. . . .

"Steel and electricity had created a new world. A new drama surged . . . a new polyphony was ringing all around with the scintillating, highly colored lights. The steel leaped to hyperbolic altitudes and expanded to vast latitudes with the skyscrapers and with bridges made for the conjunction of worlds. A new architecture was created, a new perspective."*

About this particular painting Stella wrote: "To realize this towering imperative vision, I lived days of anxiety, torture and delight alike, trembling all over with emotion. . . . Upon the swarming darkness of the night, I rung all the bells of alarm with the blaze of electricity scattered in lightnings down the oblique cables, the dynamic pillars of my composition, and to render more pungent the mystery of my metallic apparition, through the green and red glare of the signals I excavated here and there caves as subterranean passages to infernal recesses."†

*From Joseph Stella, "Autobiographical Notes" (unpublished ms., Whitney Museum of American Art). Quoted by John I. H. Baur, *New Art in America* (Greenwich, Conn.: New York Graphic Society, in cooperation with Frederick A. Praeger, Inc., New York, 1957), p. 64.

†Quoted by Sam Hunter in *Modern American Painting and Sculpture* (New York: Dell Publishing Co., Inc., 1959), p. 58.

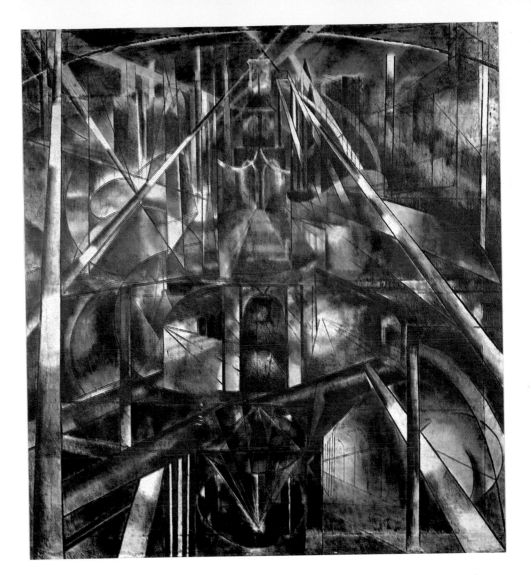

10 Joseph Stella, *Brooklyn Bridge*

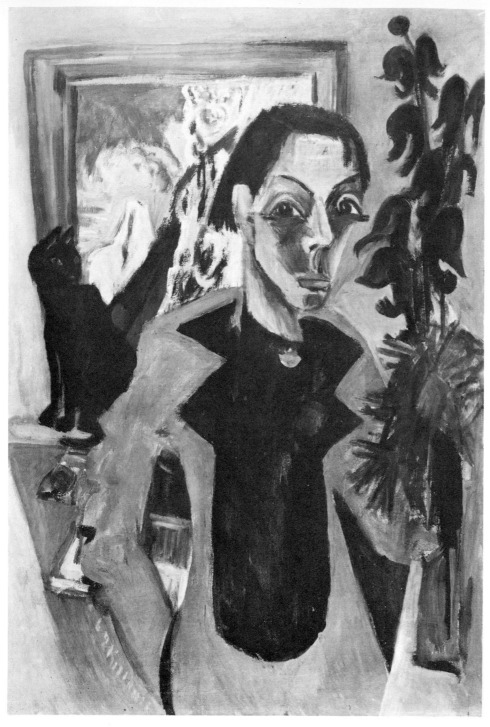

Ernst Ludwig Kirchner is usually considered to have been the dominant figure of the German Expressionist group called *Die Brucke* (The Bridge). Around 1905 the artists of this group, like the Fauves in France, began juxtaposing areas of raw, intense colors. The Germans, however, used these means for the expression of emotions and moods which were often depressed, pessimistic, and morbid, rather than for direct visual and aesthetic shock.

After leaving the German army because of illness in 1917, Kirchner went to Switzerland to recover and stayed for the rest of his life. The restless, intense city dweller seemed to undergo a rejuvenation of his nervous structure in Switzerland, where he lived in a tiny hut facing the gigantic, rugged mountains. Shortly after he arrived there he painted the *Self Portrait with Cat*, which exemplifies a change toward less fearsome subjects and a broader handling of paint.

11 Ernst Ludwig Kirchner, *Self Portrait with Cat*

Marc Chagall was born in Vitebsk, into a Jewish community following the customs and rituals of the mystical Chassidic sect. One of the central legends of this group held that the world was a vessel that had shattered into fragments because it was too full of God's love and each fragment still held a spark of that love. The members of the sect escaped the squalor and misery of their daily lives in the *shtetl* through joyful transports during which they believed they communicated directly with the angels and even God. In typical Chassidic fashion Chagall has never seemed to distinguish in his art between physical reality and his own inner experiences concerned with love, joy, and gentle sadness.

In 1910 he went to Paris, where he became acquainted with Soutine, Modigliani, Léger, and the poets Max Jacob and Guillaume Apollinaire. He took an interest in Cubism which was just developing about this time, but Robert Delaunay and Orphism —which stressed pure, lyrical colors—had the greatest influence on him.

The outbreak of war in 1914 caught the artist on a visit to his home in Russia. After the Revolution there in 1917 he was given a position of authority to establish an academy at Vitebsk. It was during this time that he painted *Green Violinist*. The influence of Cubism is apparent in the firm angular contours, and the arbitrary colors are still Orphist. These are applied, however, to give a clear pictorial reality to his ingenuous dreams rather than to demonstrate any color theories.

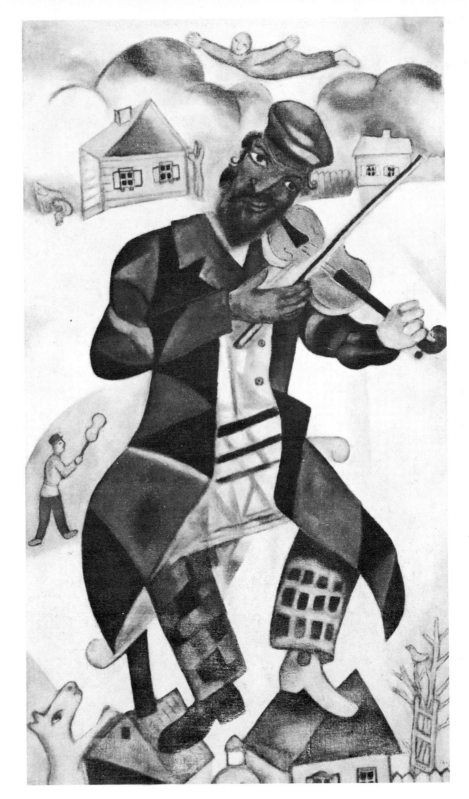

12 Marc Chagall, *Green Violinist*

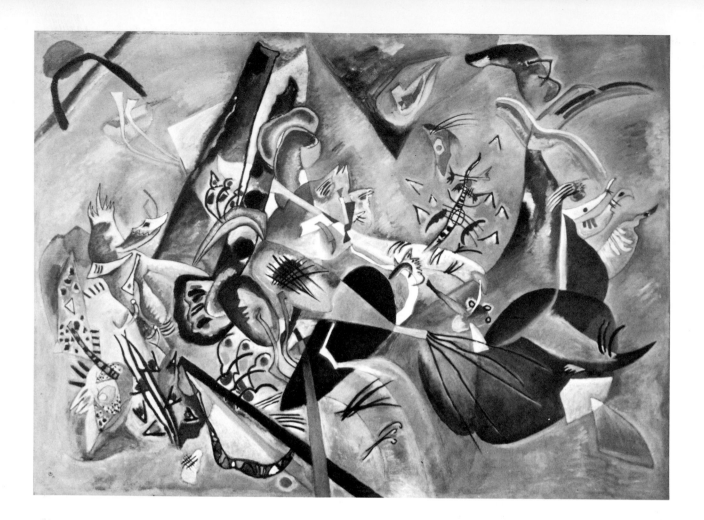

In 1919 Wassily Kandinsky painted *En Gris,* one of the most vigorous and last works of his early "romantic period"—so called because of its loose brushwork, dramatic effects, and suggestions of atmospheric space and movement. In this canvas such qualities just begin to give way to the "hard" contours and clear-cut shapes which distinguish his later works.

Kandinsky is generally regarded as the first artist to do purely non-representational paintings. He led into them, however, from Expressionism rather than from Cubism, which was the basis for the non-representational styles of Mondrian, Delaunay, and others.

In 1896, at the age of thirty, Kandinsky gave up law studies to devote himself to painting. He took up residence in Munich, where he associated with several groups of modern artists. In 1911, with Franz Marc, Gabriele Munter, and Alfred Kubin, he formed the nucleus of a group calling itself The Blue Rider (after the title of one of his pictures).

After the war and revolution Kandinsky returned to his homeland in Russia, where at first he held several important posts at the Commissariat for Popular Culture and at the Academy of Fine Arts. When, however, in the early twenties, the government began to demand socialist realism from Soviet artists, he first returned to Germany and finally went to France to live.

The term "Abstract Expressionism" was first used in 1919 to refer to art that was in-

13 Wassily Kandinsky, *En Gris*

spired by Kandinsky's early abstractions. The American artists who later adopted it for their own art were in some ways also realizing the aims of Kandinsky—to create forms that do not imitate nature "but are related to nature through their rhythm."* This is to say, they aim not to describe the appearance of nature but to create forms that provide insight to the nature and intensity of the artist's subjective experiences of the world.

*Printed in *Der Sturm,* quoted by Dore Ashton in *The Unknown Shore* (Boston and Toronto: Atlantic-Little, Brown and Company, 1962), p. 192.

Henri Matisse matured slowly as an artist; five years older than Toulouse-Lautrec, he was really of the generation of Bonnard and Vuillard. He studied originally with the academic master Bouguereau, switching later to Gustave Moreau's studio, where he met Rouault. Around 1904 he achieved recognition as the dominant figure of the Fauve group—and, indeed, for a time, of the whole French avant-garde.

In 1919, about twelve years after the Fauve period, he completed a portrait of his favorite model, Antoinette. The sweeping rhythms and elegance of her hat provided the painting with its title, *White Plumes*. The shocking color contrasts of the Fauve works have given way here to resonant tones of Indian red, Naples yellow, pearly whites, grays, and black. Not concerned with the tendency toward pure abstraction, Matisse continued to value the subject. In this instance the solemn, seductive beauty of the model indisputably contributes much toward the painting's aesthetic value. Yet the graceful contours of the hat and figure create stately rhythms as sure and obvious as those of any abstraction. The profoundly expressive character of such a painting as well as the sobriety and solid structure of paintings such as *Piano Lesson* from 1916 demonstrate the absurdity of the notion that Matisse was only a decorative painter. He was an artist who valued clarity, order, lucidity, harmony, elegance, and precision in art; in a word, he was French.

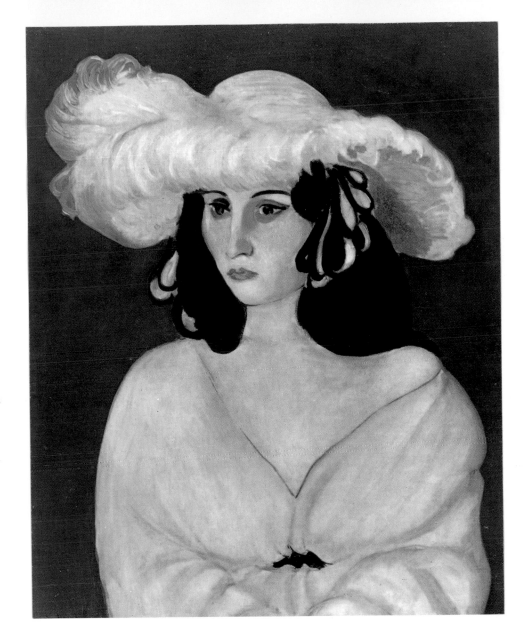

14 Henri Matisse, *White Plumes*

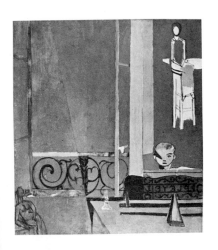

Henri Matisse, *Piano Lesson*
The Museum of Modern Art, New York
Mrs. Simon Guggenheim Fund

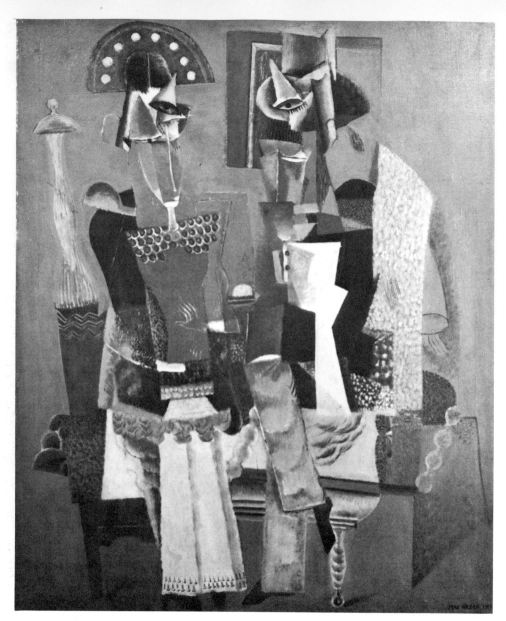

Max Weber came to the United States from his birthplace in Russia when he was ten years old. He studied in this country and later in Paris under Matisse. In the French capital he took part in the Cubist movement along with several other Americans, including Patrick Henry Bruce, Morgan Russell, and Stanton MacDonald-Wright. He returned to this country in 1908 but continued to develop and refine his personal Cubist style with Expressionist overtones for a number of years. *Conversation* is one of his major early canvases demonstrating both of these interests. The broad, flat planes, which Cubism developed for purely formal reasons, are here supplemented by expressively distorted figurative details. The elongated heads and strange eyes, for example, seem to predict the more completely expressionistic paintings of this artist's subsequent career. Even at this time, however, the two seated figures are more explicitly defined than in similar Cubist compositions by Picasso, Braque, and Gris, thus revealing Weber's abiding concern with human relations and problems.

15 Max Weber, *Conversation*

Max Ernst, a highly talented German artist who became a leading Surrealist, was at this time deeply involved with Dadaism. He briefly shared with Hans Arp an interest in making constructions of pieces of wood and other bits of found material mounted on a flat surface. After the war, along with Baargeld, these two formed the nucleus of a virulent Dada group in Cologne which lasted until 1922 when Ernst left for Paris. Assemblages, such as *Fruit of a Long Experience*, also bear an affinity with the *Merz* (rubbish) collages by Kurt Schwitters, who was in Hanover at the time. Ernst coined the term *Fatagaga* for his creations. It is a contraction of the absurd phrase "Fabrications de tableaux garantis gazometriques." Compositions by these artists often have highly suggestive associations. Although the Dadaists opposed traditional art values, being artists, they inevitably created works of art which, while violating old standards, introduced new forms and values into the world.

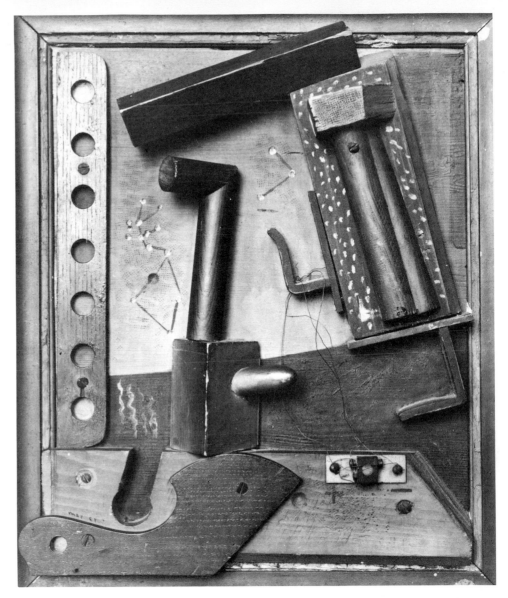

16 Max Ernst, *Fruit of a Long Experience*

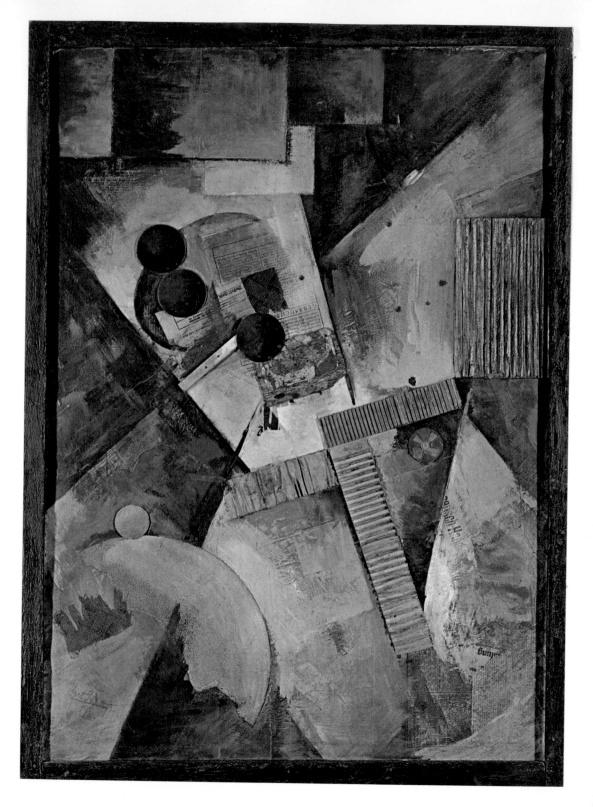

1920 LEAGUE OF NATIONS OFFICIALLY ESTABLISHED. SACCO AND VANZETTI ACCUSED OF

Ja-Was Ist is one of the major *Merz* collages created by the German artist Kurt Schwitters during this period. These were compositions made of odd bits of wood, cork, cardboard, paper, buttons, and other trivia rescued by the artist from the street. The name probably originated with a fragment of a pasteboard advertisement used in a composition and bearing the name of a kom*merz* bank on its face. From these bits of discarded rubbish Schwitters created compositions of order and elegance. He also built several great "Merzbau" (literally "trees" constructed of bits of ready-made objects and found rubbish). Implicit in these assemblages is the idea that art is not a matter of technical facility—the ability to draw natural forms or render textures accurately—rather, it is a matter of creating. "Everything an artist spits is art" is a statement attributed to Schwitters. What at first sounds like arrogance is really only an expression of his beliefs that art can be made of anything if it is done in a certain way and that a "true artist" will make art out of whatever is available to his hand. For Schwitters, the creative act was a continuation of the gratuitous process of creation and formation of nature through man, rather than an imitation of her products.

18TH AMENDMENT PROHIBITION AND 19TH AMENDMENT WOMEN S SUFFRAGE ENACTED IN UNIT

This same year (and for a period of many years), the aged Impressionist leader, Claude Monet, was working on a series of mural-sized canvases of the lily pond in his garden at Giverny, a motif that he continued to paint until his death in 1926. Impressionism was now fifty years old, yet this venerable master continued to plow his own still-fertile field. For some years, his late paintings such as *Water Lilies* were generally considered to be a degenerated form of Impressionism indicating the master's weakened powers. In more recent years, however, works by artists such as Pollock and Guston have brought about an awareness of their abstract qualities. Monet's obsession with visual experience and therefore with light had finally carried him beyond the objectivity of his earlier work. He was led in this series of paintings to a direct involvement with color and brushwork for the sake of their intrinsic qualities rather than as a means for describing natural appearances. The iridescent blue, green, and violet tones spread out over such a large surface force one to be aware of the quality of the paint itself. Rather than viewing a scene "through a window," one seems to be directly involved with what is actually on the surface of the canvas and empathetically to "feel" the swaying and floating movements suggested by the brush of the artist.

ED STATES. CIVIL WAR IN RUSSIA ENDS WITH DEFEAT OF WHITE RUSSIAN ARMIES AND WITHDR

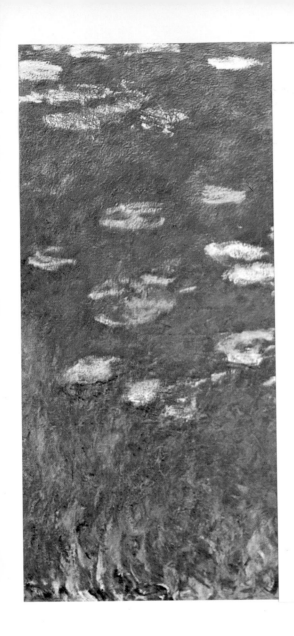

18 Claude Monet, *Water Lilies*

FOREIGN TROOPS. GABO AND PEVSNER PUBLISH REALIST MANIFESTO IN RUSSIA.

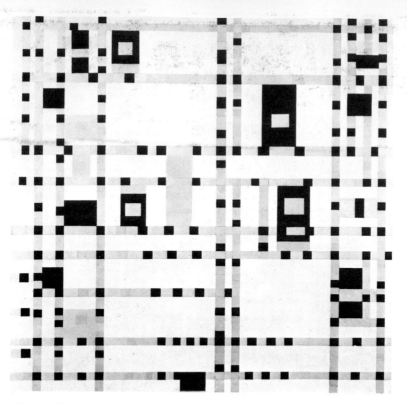

Piet Mondrian, *Broadway Boogie Woogie,*
The Museum of Modern Art, New York

In stark contrast to the flickering brushwork of Monet's late Impressionist canvases and to the textured surfaces and gratuitous elements in Schwitter's *Merz* collages, Mondrian's abstract paintings of this period introduce the qualities of purity, precision, and absolute order as major characteristics. This artist had gone through periods of academic Impressionism and abstraction influenced by Analytical Cubism. The evolution of his style between 1912 and 1920 is complex and produced a number of great works of art of various appearances. By 1920, however, when he painted *Composition in Grey, Red, Yellow, and Blue,* his art had reached maturity. From this point on its evolution was steady and consistent and moved only toward greater purity and austerity (except for the late rhythmical paintings such as *Broadway Boogie Woogie* which were done in New York).

Artistic influences aside, however, Mondrian's personality and his world view in large measure determined the form that his art took. He was a mystic who believed in an ideal order—a Platonic reality. His canvases are images which refer to the idea of universal order and harmony.

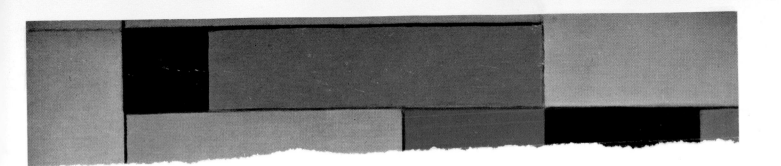

19 Piet Mondrian, *Composition in Grey, Red, Yellow, and Blue*

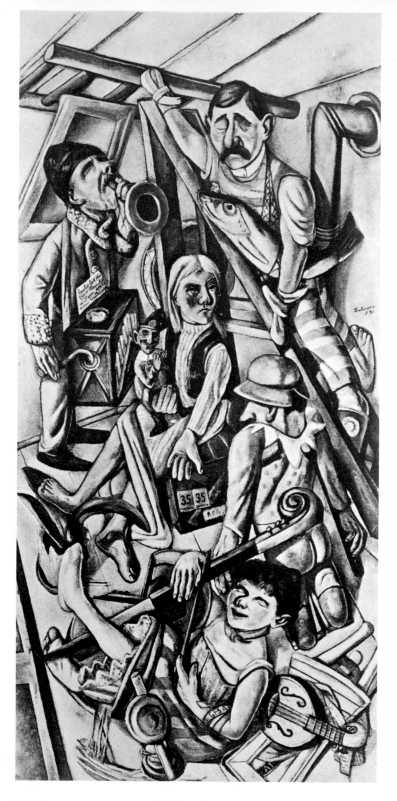

Though Max Beckmann was an important expressionist painter, he did not belong to any of the organized groups in Germany. After difficult battlefield experiences he returned to painting and took the human figure almost exclusively as his subject. *The Dream,* painted in a vigorous manner, suggests the nervous tensions and morbid interests typical of much German art of the period and provides a shocking contrast to Monet's sensuous art and Mondrian's classicism. It includes figures of mutilated men, unattractive but seductive women, and a complex symbolic paraphernalia including musical instruments, ladder, fish, puppet (or monkey with human face?), etc. Unlike the Cubist and abstract artists, Beckmann was obviously concerned with specific meanings. However, he was also concerned, perhaps more than any of the other Expressionists, with formal relations. Cézanne, rather than Van Gogh, was the Post-impressionist master who most influenced him. Further, he studied Renaissance artists such as Piero della Francesca and the nineteenth-century German classical-romantic painter, Hans von Marees. The strange nightmare scenes that he painted during this period reflect the social and political tensions that existed in Germany. They also seem, in retrospect, to predict the living nightmare that was soon to be experienced by that unhappy land. This particular work was apparently the first fully developed allegorical painting in the artist's *oeuvre,* a type of painting that was later elaborated in a series of large triptychs.*

*See Bernard Myers, *The German Expressionists* (New York: Frederick A. Praeger, Inc., 1957), p. 302.

20 Max Beckmann, *The Dream*

A different tendency in German art during this period is to be seen in the works of Georg Kolbe. This artist switched from painting to sculpture in 1898 after discovering Rodin while visiting Paris. His own art, however, is probably closer to the serene classicism of Maillol than to the Impressionism and expressionism of Rodin.

During his early career Kolbe developed several ideal types of male and female forms. During the Nazi period, however, he tried to bring his art into line with the officially approved "heroic" style with disastrous results. Only late in his career did he again recapture some of the quality of his finest earlier works such as *Assunta*.

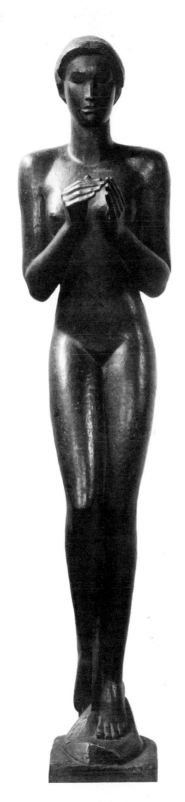

21 Georg Kolbe, *Assunta*

D IN THE U.S.S.R. MANY ARTISTS LEAVE. DADAIST DEMONSTRATIONS TAKE PLACE IN PARIS.

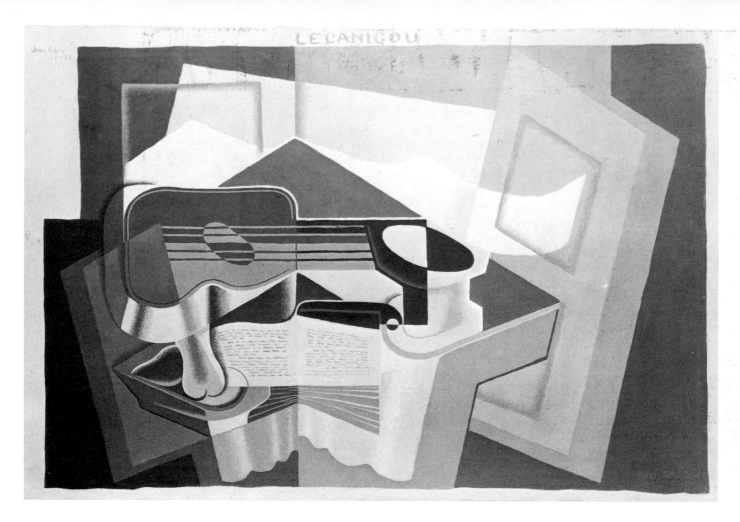

By 1921 Juan Gris' compositions achieved greater clarity and precision than anything he had previously done or, indeed, than anything that Picasso or Braque ever did. Clearly recognizable in *Le Canigou* are a guitar, an open book, and a bowl on a table-top before a door. The images are clearly defined with broad planes and muted, "poetic" tones. The tightly integrated composition and "space" which is also flat and on the surface, still lie well within the Cubist idiom.

22 Juan Gris, *Le Canigou*

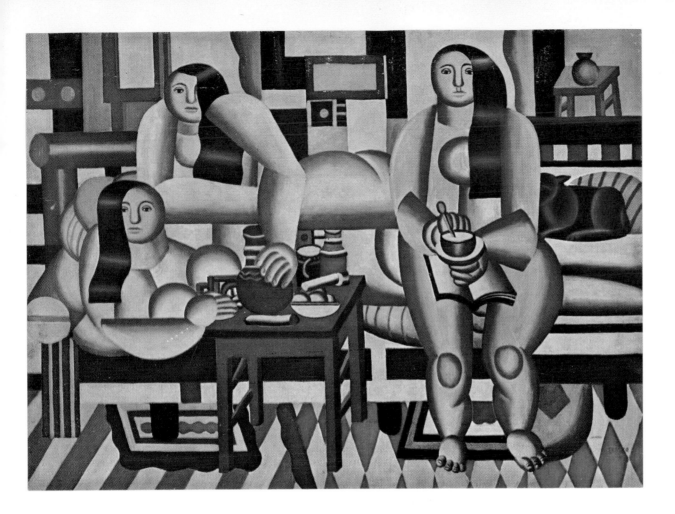

One of the early Cubists (following Picasso and Braque), Fernand Léger went on to develop a monumental style peculiarly his own. Clearly defined and solid forms, tightly organized compositions, pure colors, and unpretentious subjects reflect his simple, honest nature and down-to-earth common sense.

Le Petit Déjeuner is a study for the larger canvas, *Le Grand Déjeuner,* in The Museum of Modern Art in New York. It is essentially the same composition, but the images are more generalized and less detailed. The "classicism" of the artist is clear, however, in both versions. As in *The City,* a monumental canvas of 1919, the broadly modeled figures present a heavy and static appearance reminiscent of Seurat, J. L. David, and Piero della Francesca. Cubism had taught Léger to integrate three-dimensional forms with surrounding space and the surface design to create a single, unified composition. Expressive brushwork has no role to play in such paintings; it is rather the integration and balance of shapes, colors, and suggested forms that matters.

23 Fernand Léger, *Le Petit Déjeuner*

Fernand Léger, *Le Grand Déjeuner*
The Museum of Modern Art, New York
Mrs. Simon Guggenheim Fund

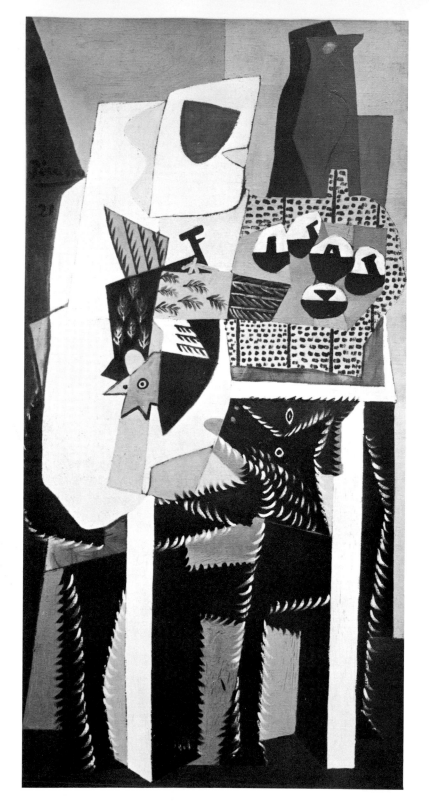

During the early twenties Picasso created a number of still lifes that must be ranked with his most important works. Among them are *The Red Tablecloth, The Ram's Head, The Bottle of Wine,* and *Dog and Cock.* All are composed of flat, interlocking planes parallel to the surface of the canvas; they make up a last brilliant development of this artist's Analytical Cubist style. He worked for some time in this manner applied to still lifes and also in a firmly modeled, "classical" style using figure compositions. In both instances he was working on the problem that had concerned many painters since Cézanne: reconciling a suggested three-dimensional space with the two-dimensional surface of the picture. *Dog and Cock* combines a still life with animal forms in a typically Synthetic Cubist solution. Hard contours define planes which overlap, thus suggesting steps back into space which are then reversed by using color and pattern to force the more distant planes forward. The natural appearance of objects and figures gives way before the demands of the composition, so that while subject matter is still apparent, it is obviously only a motif and has little to do with the real "meaning" of the painting—a meaning which is primarily aesthetic.

23a Pablo Picasso, *Dog and Cock*

Marc Chagall, like Kandinsky, Lissitzky, and other Russian artists, briefly held a position of responsibility and authority in Russia following the Revolution there. After quarreling with the more academically inclined Suprematists led by Malevitch, however, he resigned and a little later left Russia, going first to Berlin and finally returning to Paris.

His fantastic visions, which preceded Surrealism by more than ten years, seemed at first to place him within the scope of that movement. In 1922 he was invited to join the group led by André Breton which was just breaking away from Dadaism and the leadership of Tristan Tzara. Chagall's refusal caused the Surrealists to suspect the truth: the dreamlike world that he was painting was the world of Chassidic fantasy—it was mystical rather than Freudian.

About this time he painted *Lovers under Lilies,* one of a series of charming canvases devoted to the theme of rhapsodic love between men and women—or, more precisely, between himself and his love, Bella.

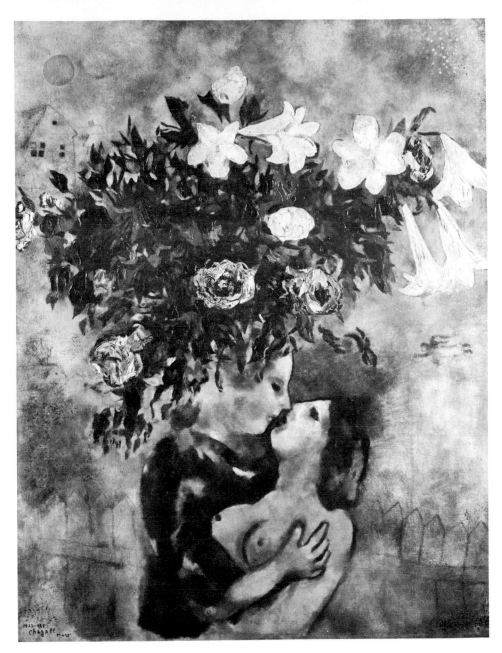

24 Marc Chagall, *Lovers under Lilies*

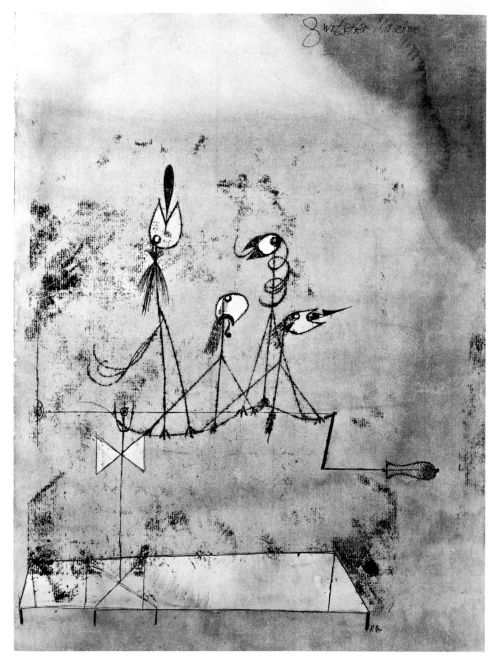

25 Paul Klee, *Twittering Machine*

Tenuously related to Cubism and to Surrealism but clearly independent of both, was the Swiss-born artist, Paul Klee. After visiting Italy and Paris, he made Munich his home, and there he worked in close association with Kandinsky, Franz Marc, and other artists of the Blue Rider group. However, it was only at age 35, after slow development as a draftsman, that Klee finally arrived at a point where he felt free to declare: "Color and I are one; I am a painter."

His works at first appear disarmingly simple. Beyond their childlike appearance, however, are sophisticated complexities and subtleties. They are always free of cliché, and they reveal a world that is often humorous, sometimes frightening, but in spite of appearances, never truly fantastic. It is not a world which tries to furnish an escape from reality; on the contrary, it aims to provide insight to the true nature of reality. Klee was not a Cubist, although he made use of Cubist discoveries, for he was always concerned with content (which Cubism was not). Neither was he a true Surrealist, for he never considered eliminating intellectual control over the creative act. He penetrated the subconscious, not through automatism, but by means of strenuous intellectual effort.

The Twittering Machine is one of a series of important water colors painted in the early twenties. The sharply defined, bird-like figures sit on the handle of a useless machine as if it were the limb of a tree. Their sharp, open beaks, peculiarly shaped tongues, and long angular legs all suggest, by association, high-pitched, thin, rasping, chirping sounds, which might refer to both birds and machines. However, the whimsy of this incongruous association cannot mask the more serious suggestion that the world is in danger of confusing the values of nature with—even subordinating them to—mechanical invention. Hans Christian Anderson evoked a similarly disquieting vision in the fairy tale *The Emperor's Nightingale*.

26 Wassily Kandinsky, *Composition 8*

By 1923 Kandinsky had joined the Bauhaus in Weimar and passed from the fluid, atmospheric, "romantic" style of his earlier non-objective paintings to a more severe style which was, however, still concerned with suggestions of active forces and tensions. *Composition 8* is one of the major canvases of this period. It has been suggested that Kandinsky was influenced in this direction by Malevitch while he was in Russia after World War I. However, Kandinsky's works are still a long way from the severity and purity of such works as *White on White* by the Suprematist master; besides, Kandinsky never seemed to be in the least attracted by Malevitch. Probably his association with Klee, which was especially close at this time, and the original ideas of the Bauhaus had more to do with the changes that took place. Most likely, however, it was simply a logical, evolutionary development intrinsic to Kandinsky's own style and thinking. Despite the greater precision and clarity in the definition of shapes, the variety of themes, rich colors, and suggestions of space and movement assure that the works of this period remain lyrical and even in many respects romantic.

Kasimir Malevich, *White on White*
The Museum of Modern Art, New York

KAMPF DURING HIS IMPRISONMENT. MARCEL DUCHAMP, LIVING IN NEW YORK, GIVES UP PAIN

Lomolarm (L'Homme au Larmes, or *Man of Tears)* is another major water color done by Paul Klee in the early twenties. The title refers of course to Jesus as the Man of Sorrows, a familiar image in early Netherlandish art. The figure here is made up of certain repeated motifs, such as vase-like shapes, lozenge shapes split lengthwise by a line, dangling bead shapes, and fine, hair-like lines. These are woven together with a pattern of mottled color to comprise the image which the title makes specific.

27 Paul Klee, *Lomolarm*

EVOTE HIS TIME TO CHESS. BRAQUE DOES COSTUMES AND DECOR FOR BALLET LES FACHEUX.

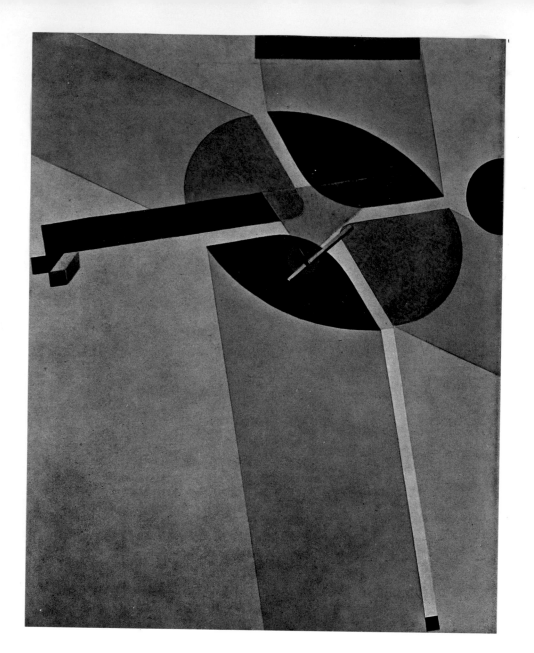

After studying engineering in Germany, El Lissitzky returned to Russia, where he had been born, and began painting under the influence of Constructivist theories. He gave the title *Proun* to his works, such as *Proun G 7*, which attempted to combine two-dimensional shapes with suggested three-dimensional, geometrical forms. In 1921 he left his position as a professor at the Moscow Academy and returned to Germany before increasing pressure from the Soviet government to create socialist realist art. In Germany he became friendly with Moholy-Nagy and through the Hungarian artist exerted a marked influence at the Bauhaus. Later, after living and working in Hanover for several years, he returned to Russia as the Nazi party grew stronger in Germany. Lissitzky probably influenced avant-garde art in Western Europe more than any other Russian artist with the possible exception of Kandinsky.

Proun G 7 demonstrates this artist's unusual ability to organize two-dimensional and three-dimensional figures in compositions of great purity and balance while avoiding symmetrical arrangements. It is significant that he arrived at pure non-representational painting by a leap, bypassing the process of gradual abstraction from natural subjects which was the course followed by Kandinsky, Mondrian, Delaunay, and other early abstract painters.

28 El Lissitzky, *Proun G 7*

Normally all elements in Picasso's classical figure compositions contribute to an over-all impression of solidity and weightiness. *Woman in White,* however, is not a typical example of this aspect of his work—it is less general and monumental than others—but it provides an inspired variation of it. The bulky form of the figure is curiously contrasted by the delicacy of the drawing, the thin veils of color, and the light, close values. The introspective expression, pearly grays and whites, and the proportions of the figure are reminiscent of Corot's figure compositions. The serene classical spirit contrasts with the morbid subjects, cruel distortions, and violent painting techniques of the Expressionist artists of the same period. It also provides a counterpoint to Picasso's own Cubist works and to his later brutally expressive canvases such as the *Guernica.*

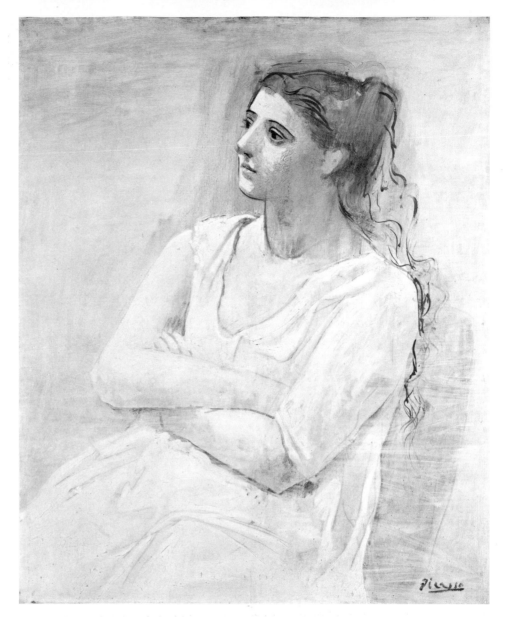

29 Pablo Picasso, *Woman in White*

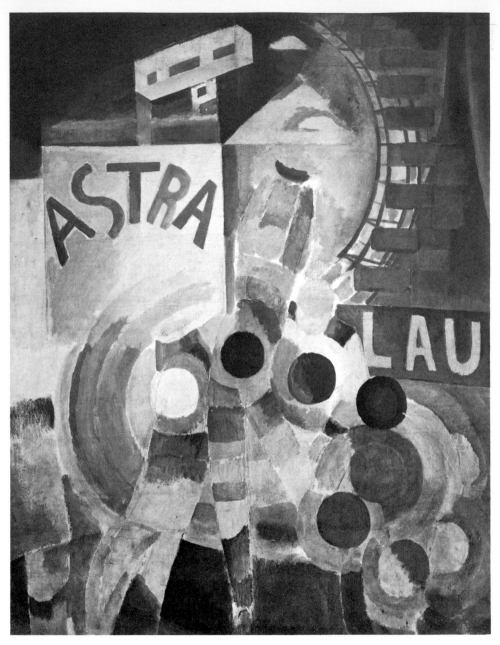

Among the early abstract painters (Kandinsky, Mondrian, Delaunay, Kupka, Lissitzky, Malevitch, and others) Robert Delaunay was probably the most completely intuitive. In contrast to both the expressionistic abstractions of Kandinsky and the severe, rectangular compositions of Mondrian, Delaunay's works are built with light, lyrical colors and circular shapes. Around 1911 the poetic quality of these paintings led Guillaume Apollinaire to christen the style "Orphism." After a brief affair with pure abstraction (derived from Cubism) Delaunay returned to subject matter, and by 1923, when he painted *L'Equipe de Cardiff,* images are once again quite clear. The airplane, the Eiffel Tower, and the Ferris wheel are motifs which he used many times. The athletes—probably a soccer team—are also a familiar theme in his *oeuvre.* His chief concern, however, was obviously the rhythmical movements created by turning forms and by colors echoing one another and combining in specific ways. Like Seurat, he had also read the color theories of Chevreul. "Color alone is form and subject," he said.

In *L'Equipe de Cardiff* the interweaving, curving rhythms are the major theme, but a staccato counterpoint of repeated rectangles formed by the Ferris wheel boxes, the box-like shape of the airplane, the flat rectangles of the signs, and the stripes of the athletes' jerseys is interwoven. The emphasis on rhythmical movements and counter-movements recalls Futurist paintings, while the simultaneous contrasts of light, pure colors are directly related to Neo-impressionism.

30 Robert Delaunay, *L'Equipe de Cardiff*

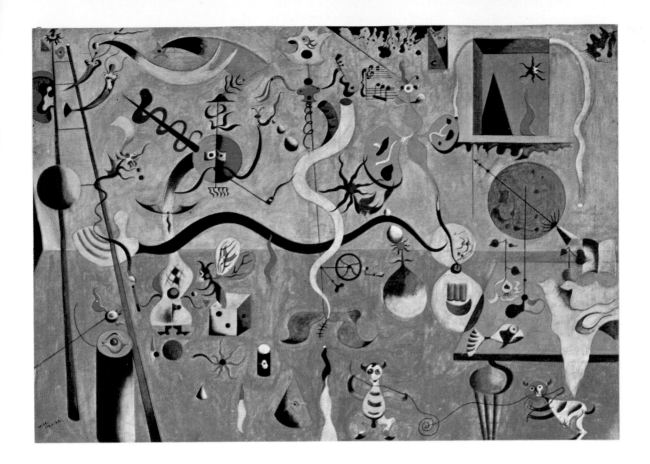

Among the signers of the first Manifesto of Surrealism and a participant in the first Surrealist exhibition in 1925 was still another Spanish painter living in Paris, Joan Miró. At this time, he was working on one of the major paintings of his career, *Carnival of Harlequin*. This bizarre and marvelous composition contains many of the images that have since characterized Miró's work. Droll insect-like, fish-like, and animal-like figures cavort about a room, filling it completely. A window opens out on the silhouetted peak of a steep pyramid, a red tongue of flame, and a globular form with seven undulating, pointed arms. At this time the artist probably tried to follow to some extent the Surrealist method of "automatism." "Spontaneity" is probably a better word to de-

scribe Miró's process, however, for the notion of pure automatic creation as postulated by André Breton was really a theoretical ideal which never seems to have been perfectly realized in the art of painting. Its great value was in freeing artists from adherence to traditional and systematic programs for creating works of art.

Carnival of Harlequin is the summation and apogee of a period in Miró's career. It is a "moment" in which the spirit of free, childlike play and joyful humor reign. The composition is basically simple but is elaborated with details which must be "read" individually. It cannot be taken in all at once but must be explored slowly, section by section.

31 Joan Miró, *Carnival of Harlequin*

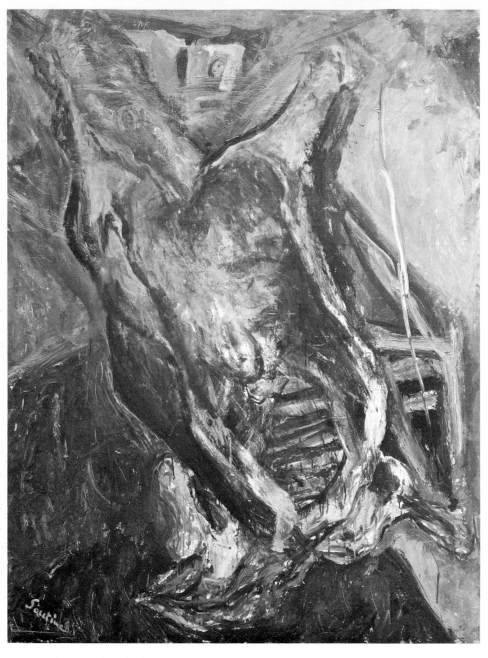

Like Chagall and Kandinsky, Chaim Soutine was born in Russia (Lithuania) but came to France to follow a career as an artist. He spent several years at Ceret in the South, where, like Van Gogh, he produced some of his finest work. Also like the Dutch painter, he worked with an intense fervor which is reflected in the thick streams of pigment that flowed from his violent brush. The distorted forms and hot, rich colors reflect a highly emotional and sensitive temperament. Yet personally Soutine was quiet, tender, and endowed with immense love for the world.

Around 1925 he painted *Side of Beef*, a subject also treated by artists such as Rembrandt and Daumier, both much admired by Soutine. Surely for this gentle painter, the subject held horror as well as beauty. It suggests the idea of the sacrificial innocent (sacrificed for the good or pleasure of others). Yet, the rich, hot colors, turbulent brushstrokes, and swirling shapes indicate the artist's ability to find visual excitement even in the most brutal subject.

32 Chaim Soutine, *Side of Beef*

During the early part of his career, the German painter Lovis Corinth was a gifted artist, working in what is known as the German Impressionist style—a more vigorous and romantic form of the French movement. After 1911, however, when he suffered a stroke, his work suddenly gained enormously in expressive power. As Kirchner remarked, "In the beginning, he was only of average stature; at the end, he was truly great." He must be regarded as a transitional figure of real significance between Impressionism and Expressionism, a role in which he was a German counterpart of Van Gogh.

 Among the finest works of his career, and indeed bearing comparison with the Dutch master's intensely introspective self-portraits, are the paintings that he did of himself toward the end of his life. These are paintings which convey a deep and somber mood of utter truthfulness. The double portrait, *Letztes Selbstporträt* combines two different aspects of the model: one involves the spectator immediately through the direct and candid gaze of the artist's image, the other (a profile view seen in a mirror) seems remote and disengaged. The gray, brown, and mauve tones are far from the intense colors of the Expressionists, yet they contribute in the same way toward the creation of mood.

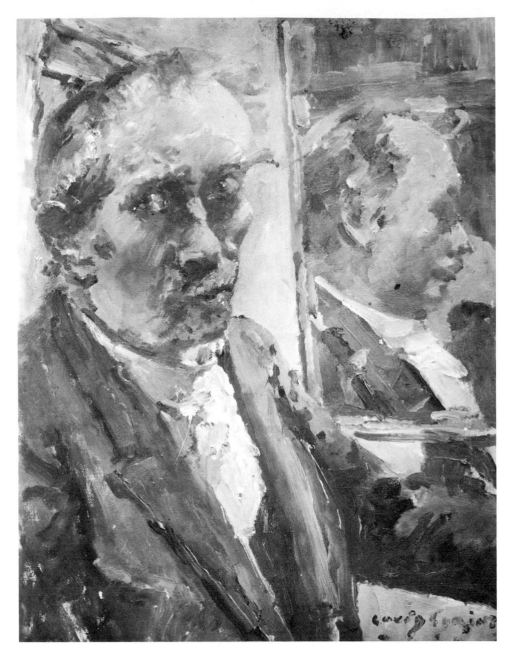

33 Lovis Corinth, *Letztes Selbstporträt*

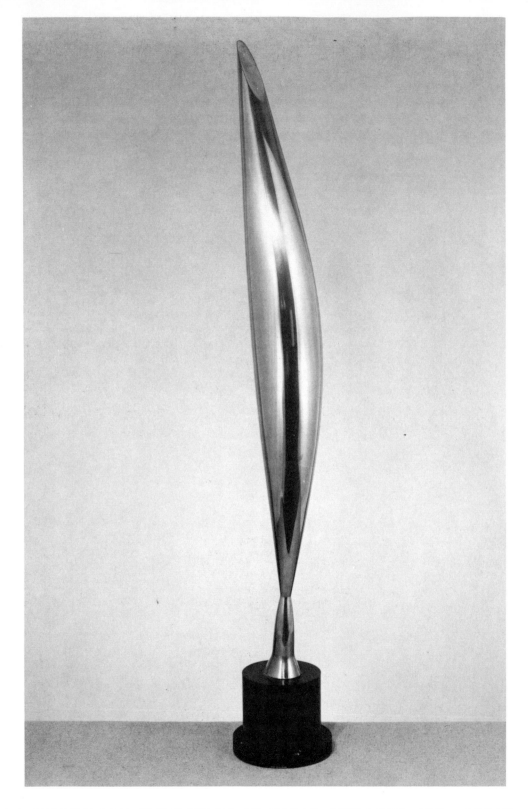

One of Brancusi's master works, *Bird in Space,* is a sculpture that he did in several versions. The smooth, subtly curved, elongated form is far from an actual representation of a bird. Instead, it evokes the *sensation* of a bird in flight. Words such as smooth, clean, glint, sweep, and dart refer with equal justice to a swiftly soaring bird and this gleaming form. It is, therefore, by analogy that the work of art refers to the essence of the natural phenomenon, and it may thus be considered as a visual metaphor. Its truth is not descriptive: it is poetic.

An interesting sidelight is the celebrated legal trial between Edward Steichen and the United States Customs Service over one version of this sculpture. When Steichen imported it in 1926, the Customs Service taxed it as "a manufacture of metal" instead of allowing it to enter tax-free as a work of art. During the course of the ensuing trial, experts were called by both sides, and a dictionary entry which defined sculpture in terms of "imitations of natural objects" was cited by a government counsel. With wisdom, and a recognition of the pragmatic relativity of value in art, the Court arrived at a decision which pronounced that an object is to be regarded as a work of art if the artist intended it to be such, and if other persons (especially experts) regard it as such.*

*See Thomas Munro, *The Arts and Their Interrelations* (New York: The Liberal Arts Press, 1949), pp. 7f, for a fuller exposition of this trial.

34 Constantin Brancusi, *Bird in Space*

Like *Bird in Space,* Brancusi's *Fish* captures the essential spirit rather than the exact appearance of the living organism. The smooth, glistening surface of the stream-lined shape evokes a sensation of a silvery flash and a darting form. The artist did several versions of the theme, including a larger and more stately marble. Often, however, his sculptures seem particularly appropriate in highly polished metal.

Brancusi also designed the base for this work. Its rough, wooden spiral shape contrasts in texture and color with the elegant polished metal form on top. Thus, the total sculpture—wooden base, metal disk, and fish shape—was designed as a formal unit.

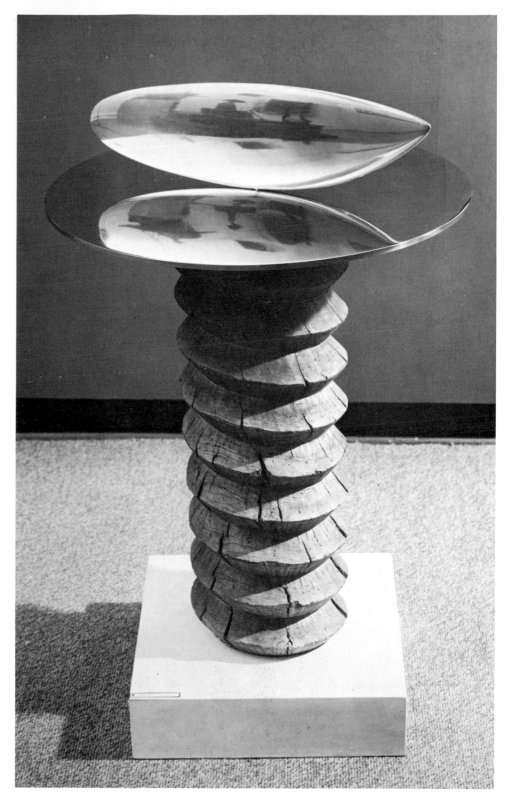

35 Constantin Brancusi, *Fish*

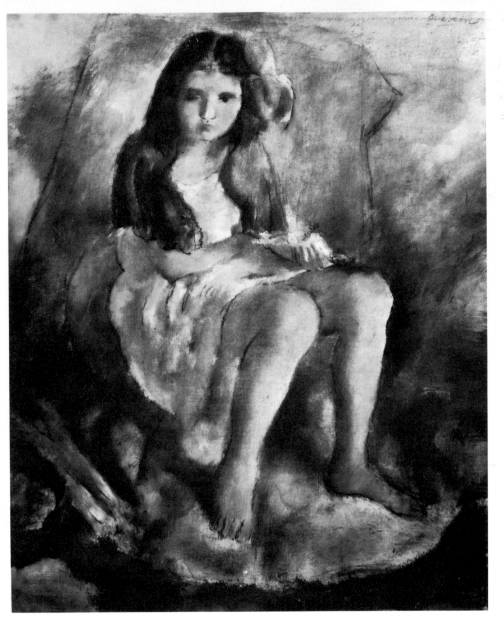

A precocious artist, Jules Pascin arrived, by the age of twenty, at the themes that were to interest him for the remainder of his life. Born in Bulgaria, he began contributing drawings to the famous German magazine *Simplicissimus* when only fifteen. He lived in Munich, Berlin, and Vienna, but Paris soon became his home, although he stayed in America during and after World War I. Acquainted with many of the major artists in France and Germany, he remained aloof from any particular movement.

Pascin developed an evocative but economical linear technique heightened by pale washes of color. When he worked in oils, his style became quite sensuous and lyrical. In a painting such as *Seated Girl,* or *Cinderella (Cendrillon)* the shimmering, translucent tints of color washed over the linear contours of the figure suggest a sensation of actual pulsating flesh. The drapery forms a nebulous setting from which the figure seems to emerge, pensive and melancholy. Painted only a few years before the artist's tragic death, *Cinderella* demonstrates the final development of his method. The sensitive, calligraphic line is less insistent than before; it disappears behind the figure and reappears on the edge as it is integrated with areas of luminous color.

Although Pascin moved in a tawdry milieu and seemed to enjoy it, in his paintings the world is seen at a distance, through a kind of haze. A lyric poet, rather than a dramatist or a reporter, Pascin rarely failed to transform reality by his own personal idiom.

R. W.

36 Jules Pascin, *Seated Girl (Cinderella)*

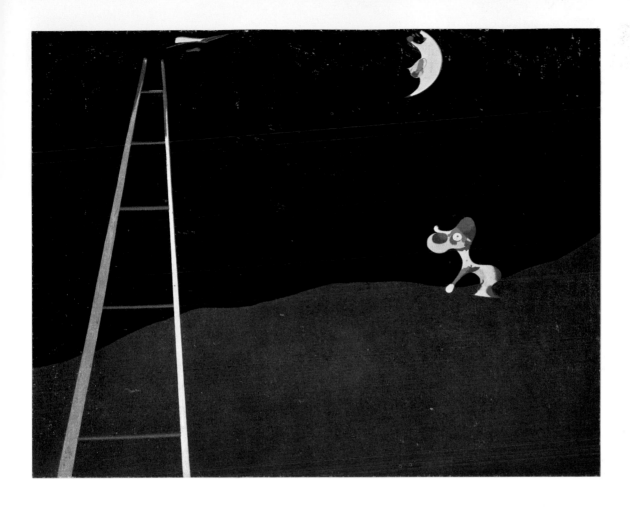

By 1926 many of Miró's compositions were bare and severe in contrast to the complexities of the *Carnival of Harlequin*. Notable is a series of stark landscapes with isolated figures. Among the most haunting of these is the *Dog Barking at the Moon*. The harsh Catalan landscape of the artist's home is recalled in the hard, hilly horizon separating black sky from brown earth. The only images are a dog, a moon, and (one of Miró's favorite symbols) a ladder leading up into the sky.

Perhaps the dog signifies animality; the moon, spiritual aspiration; and the ladder which joins the two realms may indicate the possibility that man can escape his mundane realm and achieve the stars. The images seem to suggest such a meaning. Yet explanations of this kind will never reveal the import and poignancy of such a work. Only the painting can evoke exactly its own singular sense of eerie loneliness, austerity, and yearning.

37 Joan Miró, *Dog Barking at the Moon*

A new figure among the Surrealists at this time was Yves Tanguy, a French artist who had started painting suddenly, without any training, after having seen a painting by Giorgio de Chirico. In this year he painted *Mama, Papa Is Wounded!,* one of the key works in an *oeuvre* that always seems to depict the same vast, extra-terrestrial landscape. It has the long vista and distant horizon that is also typical of canvases by De Chirico and Salvador Dali. The recognizable architectural forms and figures in paintings by the other two artists, however, are replaced in Tanguy's work by clearly defined, but completely unnatural images. Amoeba-*like,* bone-*like,* rock-*like,* bean-*like,* and cloud-*like* shapes fill the landscape. They stand on the flat ground or hover above it casting shadows. A tall, hairy pole with a bulbous tip, leans precariously to one side. The irrational is commonplace in the world invented by Tanguy. Yet relationships are clear, and it is a world that is disquietingly familiar, without being specifically recognizable. Amoebas, bones, rocks, beans, hair, clouds, horizons, shadows, earth, and sky are all normal parts of the natural world. It is their irrational relationships here that evoke the peculiar "atmosphere" of a dream. The title does not make "sense" of the painting, but it adds to it suggestions of bizarre humor and evokes an uneasy suspicion of a cruel, enigmatic drama.

38 Yves Tanguy, *Mama, Papa Is Wound*

1927 LINDBERGH FLIES ATLANTIC NON STOP, ALONE. TROTSKY BANISHED FROM U.S.S.R.

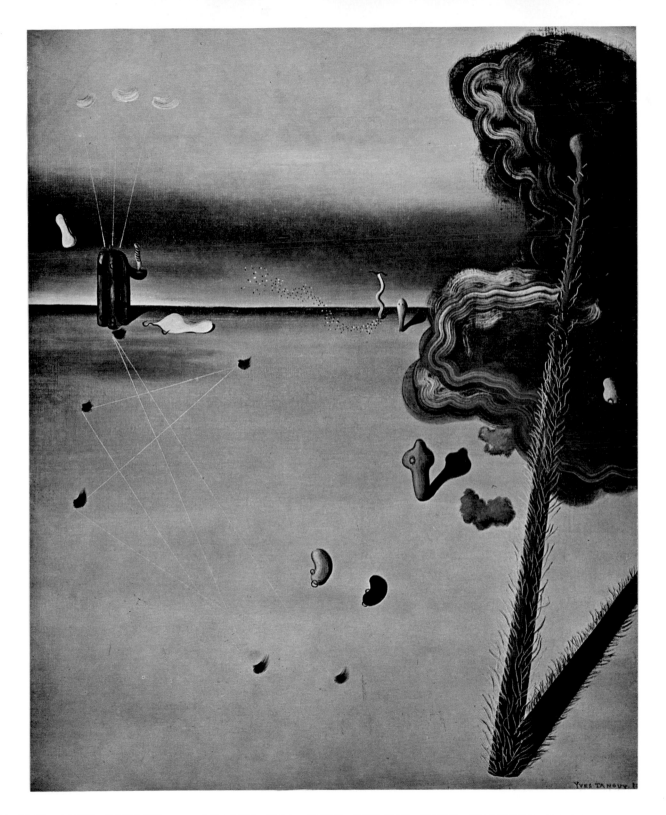

One of the key works of Henri Matisse's long career is the painting, *Decorative Figure on an Ornamental Background*. The drawing of the seated nude figure is based on a framework of verticals and horizontals stabilizing the composition as they parallel the edges of the canvas (and presumably the wall on which it hangs). The sumptuous wallpaper decoration, ornate mirror, potted plant, and elaborate floor covering all contrast with the simply defined figure. An over-all ochre tonality links these elements, however, and the broad modeling and intense warm color of the massive figure cause it to hold its place in the shallow space against its richly decorated surroundings. Thus this canvas demonstrates Matisse's ability to successfully join on one plane opulent, flat decoration and simply modeled monumental forms; an ability which he shared with certain Renaissance artists such as Piero della Francesca, Benozzo Gozzoli, and Botticelli.

39 Henri Matisse, *Decorative Figure on an Ornamental Background*

CIPLE OF INDETERMINACY PROPOUNDED BY GERMAN PHYSICIST, WERNER HEISENBERG.

Although Gaston Lachaise is considered to be an American sculptor, he was born and educated in France. Only at twenty-four years of age did he emigrate to the United States. He rejected the classical tradition, but by no means belonged to the avant-garde. The robust female nude provided a theme on which he invented many variations. In later years, the proportions of these figures were sometimes exaggerated even beyond the most opulent baroque standards. *Standing Woman,* however, begun in 1912, worked on for ten years, and finally cast only in 1927, marks the very peak of Lachaise's accomplishment. The voluptuous curves are not yet completely overblown and the figure is reminiscent of the full-bodied beauties of Titian and Rubens as it stands on tiptoe, seeming almost to sever contact with the earth. The great, full form of her body thus seems buoyantly weightless, and she gestures sinuously with proud and effortless grace.

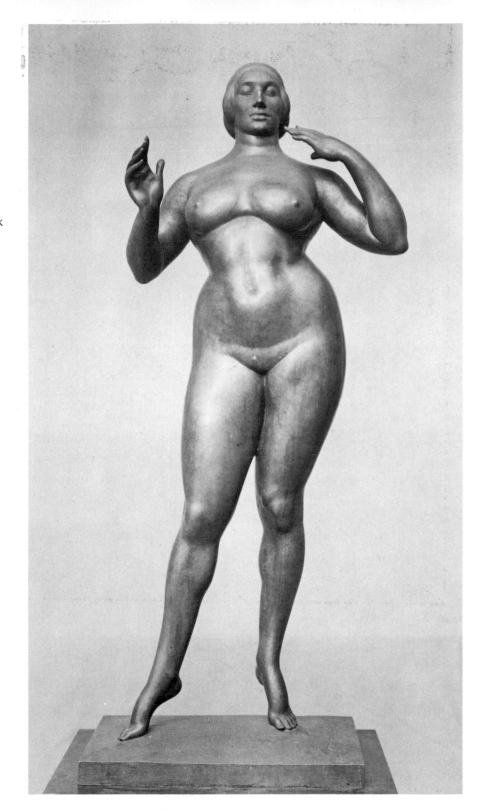

40 Gaston Lachaise, *Standing Woman*

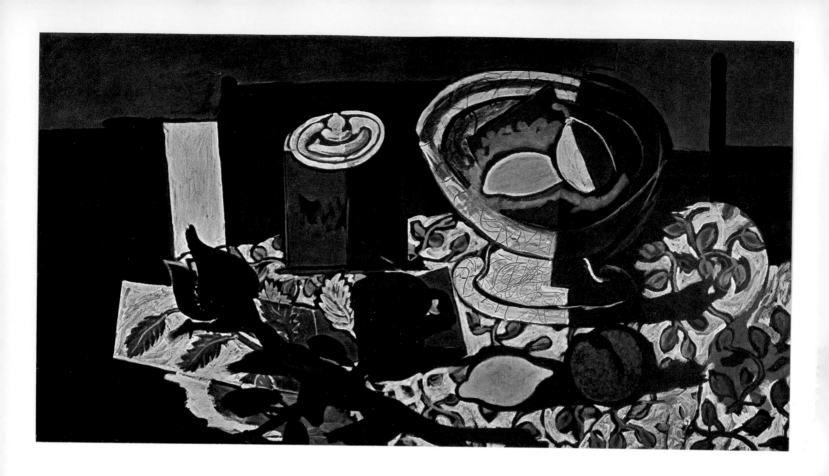

41 Georges Braque, *The Black Rose*

At one point Georges Braque was a member of the Fauves. Later, together with Picasso, he invented Cubism. After World War I, however, he developed a personal style, based on Synthetic Cubism, which was remarkably consistent throughout the rest of his career.

Still life was always a favorite subject with this artist, for it permitted him to concentrate on formal compositional problems, avoiding the anecdotal, while still retaining contact with the visible world. *The Black Rose,* painted in 1927, reveals the artist at the peak of his powers as an organizer of precisely ordered compositions and at the same time as a great decorative painter. His palette at this point was rich and muted, including browns, grays, greens, lemon-yellows, blacks, and whites. The Cubists had learned to create the illusion of shallow space while preserving the integrity of the surface by overlapping and relating in various ways their flat planes. Later, more supple contours and resonant colors were related with equal precision in the over-all adjustment of parts to create an organic union.

With artists such as Matisse and Braque, the term "decorative" loses all connotations of superficiality and regains the eminently respectable meaning it had with the painters of the early Italian Renaissance.

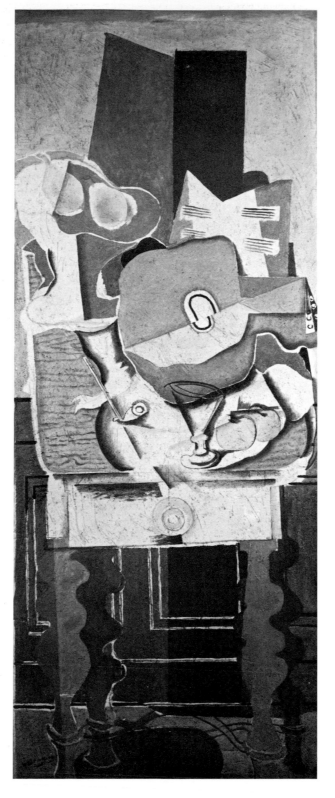

The following year Braque completed one of the major canvases in a continuing series of large vertical still lifes. *The Table* demonstrates a tendency toward a lighter palette and rather thick, sandy textures.

Objects are clearly recognizable. A fruit bowl with pears, a sheet of music, a mandolin, a long-stemmed pipe, a goblet, and two apples rest on top of a table with elaborately turned legs. Yet these objects are only the motifs on which the artist has freely created variations to satisfy the needs of the composition. Ultimately, the subject is painting —the artist's primary purpose was to create a successful painting rather than a still life. And since a painting is physically two-dimensional, three-dimensional figures have been conceived in terms of flat shapes on the canvas surface. Shallow space and forms are suggested by means of overlapping and interpenetrating planes parallel to the picture surface, and by a light and dark pattern. Finally, the over-all image is not only richly decorative, it is also intricately and firmly structured.

42 Georges Braque, *The Table*

As cofounder of the Dada movement in Cologne and one of the original Surrealists, Max Ernst occupies a most important position in the art of this century. His contacts with American artists while in this country during World War II also helped stimulate the flowering of the experimental spirit which occurred here in the immediate postwar years.

In the 1920's he produced a series of drawings called *Natural History (Histoire Naturelle)* in which various textures obtained by the rubbing of objects are arranged in visually new and suggestive sequences. This technique Ernst called *frottage* to distinguish it from *collage* where the actual object, or image of an object is attached to the picture surface. *Frottage* provided the artist with a visual technique of spontaneous creation akin to the Surrealist literary process of automatic writing. The drawings obtained in this manner lose the character of the material (wood grain, cloth weave, leaf pattern, etc.) and through a series of suggestions and transmutations take on a hallucinatory vision; patterns and shapes become powerful stimuli for a succession of superimposed images. The ultimate source (often quoted by the Surrealists) is a well-known passage from Leonardo's *Treatise on Painting*.

Flower and Animal Head was painted soon after the *Natural History* and shows the continuation of Ernst's experimentation with visual processes. Here *frottage* has been adapted to oil painting by scumbling pigments on a prepared ground placed over a patterned surface. Ernst has removed all traces of literary references yet has retained a high degree of poetic allusion. By his technique, as well as his title, he attempts to evoke a vision rather than describe one.

R. W.

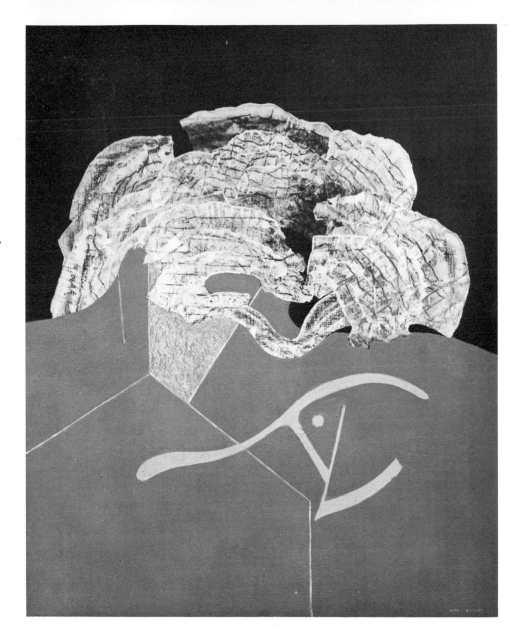

43 Max Ernst, *Flower and Animal Head*

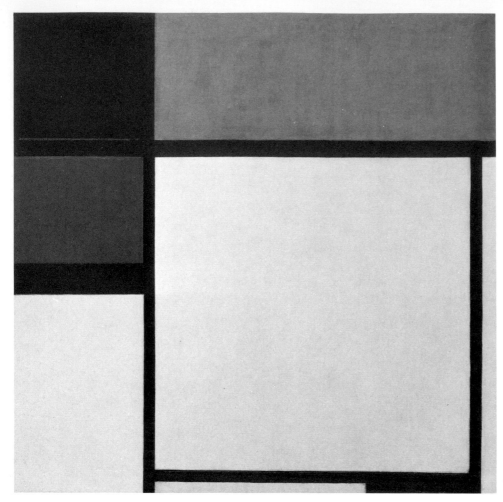

44 Piet Mondrian, *Foxtrot B*

The Dutch artist, Piet Mondrian, carried the formal tendencies inherent in Cubism to their logical conclusion. After an initial period of Impressionist painting, he proceeded to create abstract compositions by arbitrary manipulations of the monochromatic facets of Analytical Cubism and finally arrived at a severely geometrical, completely abstract style termed Neo-Plasticism. For about twenty years he developed this restrained mode in paintings such as *Foxtrot B*. Invariably they are composed of judiciously related vertical and horizontal lines creating rectangular shapes painted in the primary colors—red, yellow, and blue—and the non-colors—white, black, and gray.

Mondrian was an intellectual and articulate artist who developed his ideas in lengthy essays published in *De Stijl,* a magazine founded by the artist and his friend and follower, Theo van Doesberg. His theories were, at this time, probably more influential than his paintings.

He was concerned with the development of an art of purity devoid of illusionism, decoration, and all sensuous qualities. He painted a world not of *things* but of *relations,* a world of precisely adjusted asymmetrical balance. His works might be described as "classical" (in form) and as signifying the idea of an absolute order in a philosophical sense. They stand in opposition to the emotional extreme of Expressionism as well as to the anti-intellectual position of Surrealism. The precision, order, subtle relations, and chaste colors of these works have had a profound influence on architecture and graphic design as well as painting.

Mondrian's theories concerning art had an important influence at the Bauhaus in Germany, where his colleague Van Doesburg visited and lectured. Among the Bauhaus masters at this time was Lyonel Feininger, an American artist with German parents, who were both musicians. When he was sixteen years old, he returned with them to Germany, where he taught and worked until 1937, when he fled from the oppression of the Nazi regime.

During this time he associated with most of the leading artists of Germany and France including the Cubists (particularly Delaunay), The Bridge group, the artists of The Blue Rider (especially Marc), and, of course, the other Bauhaus masters (including Kandinsky, Klee, and Gropius). Despite the sharply defined, overlapping, Cubist-like planes of such complex compositions as *Gables III,* however, Feininger remained essentially romantic. His major concern was always with light and atmosphere with which he created poetic moods—especially moods of nostalgia. As Gropius remarked: "He does not think and construct in terms of architecture. . . . Those straight lines are rays. They are not architectural, they are optical."*

*Quoted by Frederick S. Wight in *The Work of Lyonel Feininger* (exhibition catalogue; Cleveland: The Print Club of Cleveland and The Cleveland Museum of Art, 1951), p. 13.

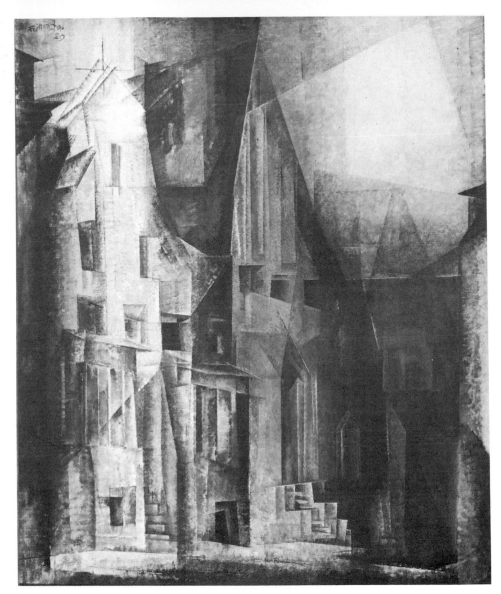

45 Lyonel Feininger, *Gables III*

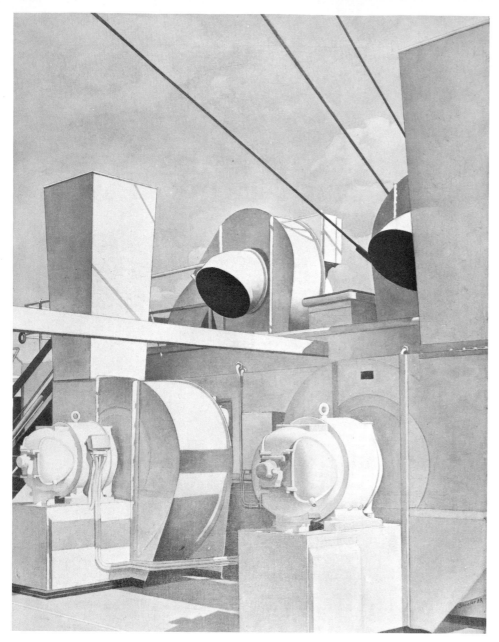

The American artist Charles Sheeler developed a manner of painting that for clarity, purity, order, and precision does not yield to that of Feininger or even Mondrian. Yet as *Upper Deck* demonstrates, it is also photographically realistic. It presents an image of a machine-tooled world in an appropriately clear-cut exact way. Yet paradoxically there is also an air of unreality. The absence of people, or of any casual residue of their existence, and the absolute purity of the forms contribute to the dreamlike atmosphere, as does the clarity of the images.

Sheeler studied with William Chase in New York, made several trips to Europe, and went through an abstract period. Largely because of the influence of photography which he took up with enthusiasm, however, he reintroduced the world of appearances in his painting and eliminated the last traces of slashing, bravura brushwork left over from the years under Chase. Finally, these tendencies led to the idealized, dehumanized style of precise realism sometimes called "Cubism-Realism."

Upper Deck is a key work in Sheeler's career. He had spent six weeks at Ford's River Rouge Plant making photographs, and he said that he ". . . had come to feel that a picture could have incorporated in it the structural design implied in abstraction and be presented in a wholly realistic manner."*

*Quoted in *Art USA NOW* (New York: Viking Press, 1963), p. 26.

46 Charles Sheeler, *Upper Deck*

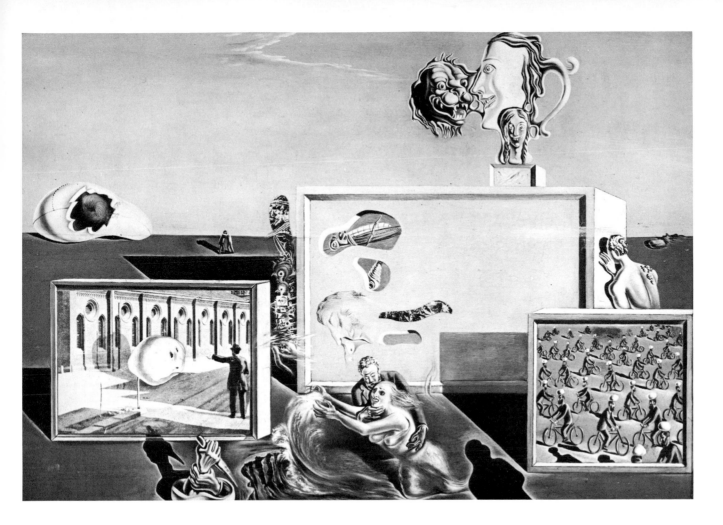

In the late 1920's and early 1930's Salvador Dali was one of the brightest hopes of the Surrealist movement. Like Sheeler, master of a meticulous painting technique, the artist developed a method of creating which he described thus: "I spent the whole day seated before my easel, my eyes staring fixedly, trying to 'see,' like a medium, the images that would spring up in my imagination. Often I saw these images exactly situated in the painting. Then, at the point commanded by them, I would paint, paint with a hot taste in my mouth. . . . At times I would wait whole hours without any such images occurring. Then, not painting, I would remain in suspense, the brush hanging motionless from one hand. . . . Sometimes nothing resulted. . . .''*

Illumined Pleasures combines sadistic and erotic images in irrational relationships. Many of these figures—such as the lion's head, the bicycle riders, the grasshopper, and the voluptuous woman—were used other times by the artist in various combinations. During this period Dali contributed much to Surrealism, not only with his tightly drawn and rendered paintings, but also with two films on which he collaborated with the celebrated director Luis Buñuel: *Le Chien Andalou* and *L'Age d'Or.*

*Quoted by Marcel Jean, *The History of Surrealist Painting*, trans. by George Weidenfeld and Nicolson Ltd. (New York: Grove Press, Inc., 1960), p. 203.

47 Salvador Dali, *Illumined Pleasures*

The deep resonance of Rouault's somber-toned paintings is contrasted in some instances (particularly in his late works) by canvases with more acerb colors. One of the favorite subjects of this devoutly religious artist was a broad, flat landscape, usually with figures and buildings. Rouault was a friend of Leon Bloy and adopted the same gloomy brand of Catholicism. Yet paintings like *End of Autumn #4*, thickly encrusted with acid yellows, greens, and blues, suggest a bittersweet mood—a nostalgic mood—rather than one of gloom or mystery. The usual heavy, blunt line is present, although less insistent than usual. The landscape is bathed in a peculiar, sulphurous light, and small figures converge in groups. Rouault's artistic heritage includes not only the romantic symbolism of his teacher, Gustave Moreau, but also elements from artists such as Daumier, Goya, and Rembrandt. His style was Expressionist, but entirely different from the more virulent German brand.

48 Georges Rouault, *End of Autumn #4*

ARIS. LUIS BUNUEL AND DALI MAKE SURREALIST FILM UN CHIEN ANDALOU.

Since 1922 a group of Mexican artists led by Diego Rivera, David Siqueiros, and José Clemente Orozco had been creating a major school of mural painting, using social themes. Orozco's work especially reveals a starkly expressionistic character based partially on native traditions. As *Wounded Soldier* demonstrates, however, the artist was well aware of plastic qualities and possessed an ability to order his compositions in a way that carries his art well beyond social comment. The revolution had freed the Mexican peon from abject domination by the old landlords, and themes taken from the revolution often served these artists as subject matter. They revived fresco painting (painting with pure pigment on wet plaster), a technique not used extensively since the Italian Renaissance. Commissions to decorate public buildings were forthcoming and did much to stimulate a surge of native art at this time. Orozco, however, did many of his finest works in the United States, at Duke University, Pomona College, and the New School for Social Research.

Amazingly, this creator of great frescos had only one hand, having lost the other in an accident while conducting a chemical experiment as a student.

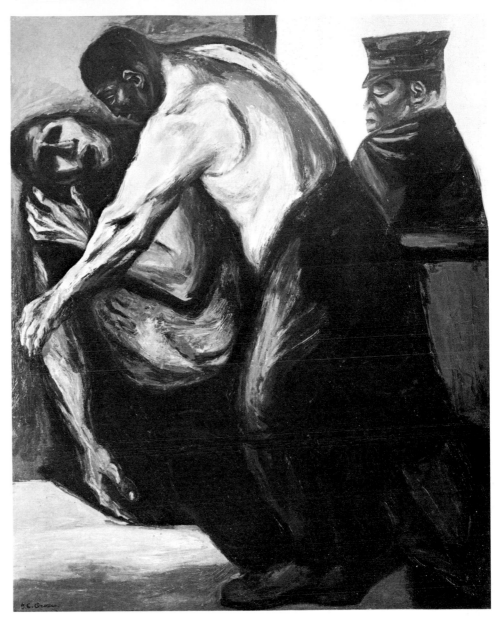

49 José Clemente Orozco, *The Wounded Soldier*

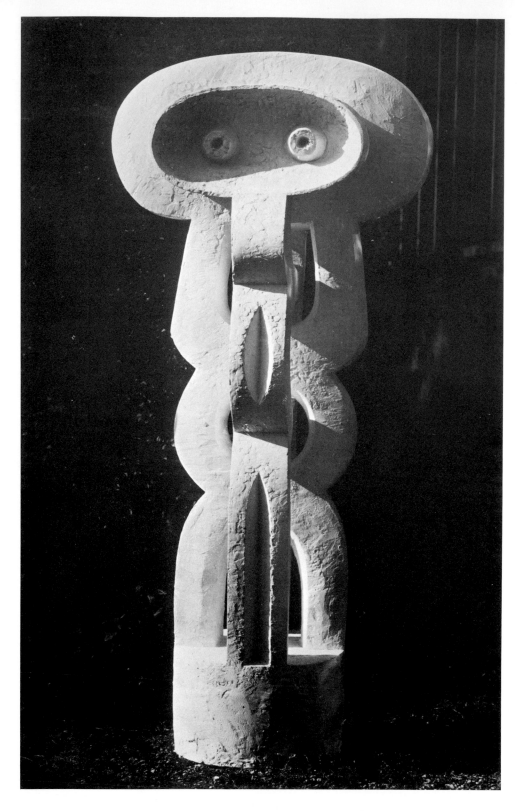

Following his early Cubist period, Jacques Lipchitz developed a more open, wiry style involving space as an integral element in the sculptures known as "transparents." Almost all of these pieces were done on a small scale (none over twenty inches high and most much smaller). Later, he developed a powerfully rhythmical, undulant, "baroque" style. Almost unique in his *oeuvre*, however, is the tall, brooding *Figure* begun in 1926 and completed in 1930. This monstrous image stands totem-like with hypnotically staring eyes, dominating its environment. It is the one example of a monumental work done in the manner of the small "transparents" and it demonstrates the artist's ability to integrate three-dimensional forms and space in a rhythmically organized plastic form of great expressive power. This particular version is the plaster from which at least two bronzes have been cast.

50 Jacques Lipchitz, *Figure*

Raoul Dufy, along with Othon Friesz and Georges Braque, came from Le Havre. He painted at first under the influence of Impressionism and of Van Gogh. In 1905, however, he saw Matisse's canvas *Luxe, Calme, et Volupte* and, as he later said, he "understood . . . the new *raison d'être* of painting." In 1906 he exhibited with the Fauves. After 1909 he painted for a number of years under the influence of Cézanne—whose work was a new revelation—and of Cubism. In the early 1920's, however, he arrived at the style which he continued to evolve throughout his career. It would not be amiss to suggest that designing textiles had a profound influence on his art. He first worked for the couturier Paul Poiret and then for the silk manufacturer Bianchini. Thus his livelihood was assured. At the same time he was free to develop his uniquely elegant, decorative painting style. With a combination of rich color orchestration and a calligraphic linear pattern he succeeded with works such as *The Gate* in creating masterpieces of pure decoration expressing a joyful mood. His works may lack the serenity and resonance of Matisse's, but they are always light, elegant, joyous, and exquisitely tasteful. He was never apologetic about his subject matter, and is reported to have remarked jokingly: "My clients buy my subjects from me; the rest is just thrown in."*

*Quoted in *Dictionary of Modern Painting* (New York: Paris Book Center, Inc., under the direction of Fernand Hazan), p. 88.

51 Raoul Dufy, *The Gate*

If any one artist can be credited with influencing contemporary welded metal sculpture, it is surely Julio Gonzalez. Born in Barcelona, his name belongs on a list of Spanish artists who emigrated to Paris early in the century and contributed in a major way to the development of "modern art." It is a list that also includes Picasso, Gris, and Miró.

In 1930 and 1931 Gonzalez (a skilled welder) gave Picasso technical assistance on his welded iron sculptures. At the same time, under Picasso's influence, Gonzalez' style became more abstract and he began to involve space as a primary sculptural element, as *Woman with a Basket* clearly demonstrates. The artist simplified certain key motifs—for example, the circle for the basket and metal strands for hair. Treating these themes in a linear way, he described volumes of space which became important elements in the total form of the work of art. Unlike the Constructivists or Calder, however, Gonzalez was always concerned with the human form as the basis for his images.

52 Julio Gonzalez,
Woman with a Basket

In contrast to the pure linear elegance and open form of *Woman with a Basket,* Gonzalez' *Daphné,* done the following year, is more rugged and planimetric in form. Undoubtedly based—as usual—on the human figure, it interrelates roughly surfaced, rectangular shapes built up vertically and culminating with sweeping, curvilinear motifs.

It may be true that Picasso stimulated the welded metal abstract sculptures of Gonzalez, but the latter artist developed the technique consistently and created a body of important works that have had a decisive influence on the course of twentieth-century sculpture.

53 Julio Gonzalez, *Daphné*

CYCLOTRON INVENTED BY E. O. LAWRENCE. BAUHAUS EXPELLED FROM DESSAU BY NATIONAL SOC

During the early thirties Picasso worked in a more free-flowing curvilinear style that was, nevertheless, Cubist in its flat planes and tightly integrated compositions. The major works of this period, such as *Girl in a Mirror*, are brilliantly colored and decorated surfaces. Yet the distortions of drawing often reveal a concern for the subject and express emotions and moods. *The Dream*, painted in 1932, is typical of this style (often referred to as "stained-glass Cubism"). The canvas presents an image of a sleeping female figure made up of broadly painted, intensely colored, curving shapes. The Cubist device of presenting different aspects of a subject simultaneously is seen in the combination of full-face and profile views of the girl who sits with head thrown back over a raised shoulder, eyes closed, and slightly smiling lips. The image is reminiscent of certain sensuous female figures by Ingres and Henry Fuseli. Thus decorative, expressive, structural, and even Surrealist qualities are fully joined in a single work of art.

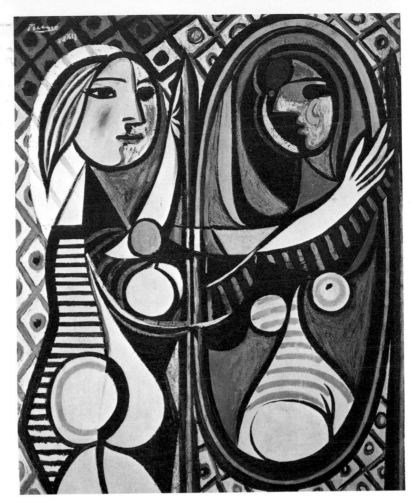

Pablo Picasso, *Girl before a Mirror*
The Museum of Modern Art, New York
Gift of Mrs. Simon Guggenheim

54 Pablo Picasso, *The Dream*

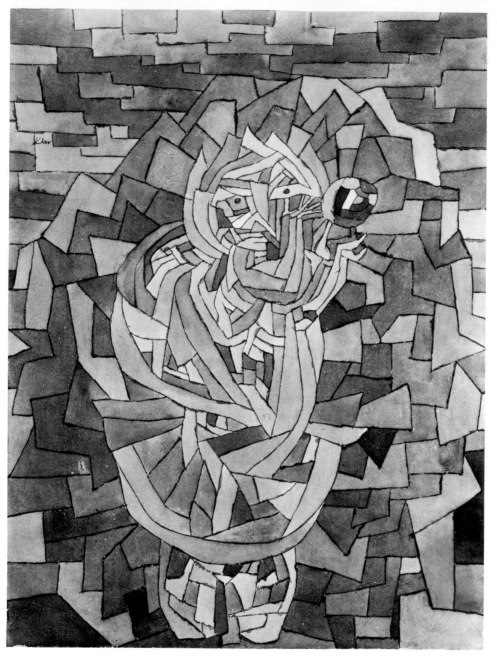

Rock Flower was painted by Paul Klee in 1932. It is one of his more elaborate water colors and bears some relationship to certain other rock pictures from the same period.

Klee has exerted enormous influence on the art of the twentieth century without participating in any of the major movements which developed in Paris. Although he bears some relationship to Cubism and to Surrealism, he was a member of neither group. His work is difficult to understand, for it contains many different styles, techniques, and motifs. Above all, it seems to be unrelated to all preceding art. Other artists— no matter how avant-garde—seem to derive from earlier or exotic sources. Klee, however, is perhaps the first modern artist to completely invent his art. In an almost Cartesian process, he began with the smallest, simplest mark and proceeded to build upon it an art that is varied and fully his own.

Music influenced Klee, as it did Kandinsky, Feininger, and other artists of the Blue Rider and then the Bauhaus. He constantly worked to create an expressive language of visual form. He wrote: "As a child plays at being grown-up, so the painter imitates the play of those forces which created and are still creating the world."

55 Paul Klee, *Rock Flower*

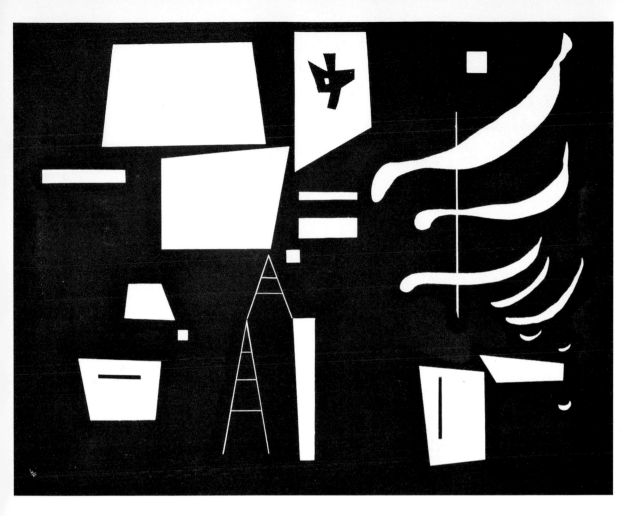

By 1932 Kandinsky's non-objective style had evolved toward more static and carefully balanced compositions. *Soft-White and Hard,* for example, presents a precise arrangement of motifs to create a complex and delicately counterpoised arrangement without suggestions of atmosphere or movements. A continuous, soft, black shape surrounds the hard, white ones, tying them together and providing the greatest possible contrast for them. The white geometrical motifs are repeated and varied, and a small square which appears just left of the center of the canvas serves as a key locking all the elements into place.

Certain areas seem to recede or advance in space providing optical illusions and delicately equated visual tensions and seeming

to predict efforts along similar lines by Albers, Vasarely, and other artists. Despite its modest size, this painting was regarded by Kandinsky as a particularly significant work in his later development.

56 Wassily Kandinsky, *Soft-White and Hard*

During the thirties America produced a number of artists who concerned themselves with subjects of social significance. Among the most gifted of these painters was Ben Shahn. Like Toulouse-Lautrec, he endows his fine art with an incisive linearity and poster-like flatness. In 1933 Shahn was working for the Public Works of Art Project, for which he did a series of eight tempera paintings on the Prohibition era. Among these, *Women's Christian Temperance Union Parade* is a particularly fine example of his mordant wit applied to such subjects. The delineation of character by means of acute line drawing borders on caricature. This is unquestionably didactic art—art in the service of a social cause. Yet is it unmistakably art, for, like Daumier and Goya,

Shahn has created a style in which form and content exist in an easy balance.

57 Ben Shahn, *Women's Christian Temperance Union Parade*

"The particular does not interest me," said Aristide Maillol; "what matters to me is the general idea." In this attitude and in his sculptures, he may come closer to the spirit of ancient Greece—pre-Phidian Greece—than any artist of the intervening centuries.

At almost forty years of age—after a period of painting and designing tapestries as a member of the Nabis movement—Maillol took up sculpture. He learned the techniques and achieved artistic maturity rapidly and his style hardly changed thereafter.

His art is the antithesis of the nervous energy and emotionalism of Rodin's. He did the female figure almost exclusively and, with very few exceptions, in static attitudes —often of repose.

Venus with a Necklace, cast in 1933, is one of several bronze castings of this figure. Completed in 1928, it demonstrates typical characteristics of the artist's works: a closed composition with broadly handled, massive forms which turn back on themselves; generalized and expressionless features; and a harmonious arrangement of sculptural rhythms.

Maillol was born, lived, worked, and died in the south of France where the influences of the Mediterranean and classical culture are strong. Like Renoir, the artist he most resembles, he was a sensualist and a pagan.

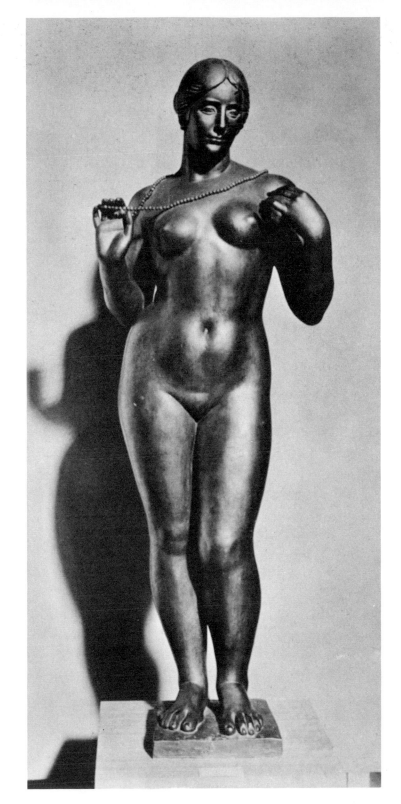

58 Aristide Maillol,
 Venus with a Necklace

Born in Switzerland, Alberto Giacometti came to Paris in 1922 and studied for three years under Bourdelle at the Académie de la Grande-Chaumière. From this point on, except for brief absences, he lived and worked in France. His earliest mature works were Cubist in style, and the influences of African and Cycladic sculpture were soon felt along with that of Lipchitz. During the late twenties he became acquainted with the Surrealists and in 1930 he joined the Surrealist movement—an association lasting just five years. It was during this period that he did such works as *The Palace at 4 A.M.* and *Invisible Object (Hands Holding the Void)*—which was the artist's last Surrealist sculpture. Like De Chirico, he renounced his whole Surrealist production. About this specific work he said, "I could have destroyed it. But I made this statue for just the opposite reason—to renew myself. Perhaps this is what makes it worthwhile."*

André Breton suggested in an essay that it was "an emanation of the desire to love and be loved, in quest of its true human object and in all the agony of this quest."†

The image of this strange figure bound to a rigid structure, yet emerging half-fearfully from its confines, and describing a void with its free hands, evokes in this writer the poignancy of human yearning to escape the cage of form constructed by reason and at the same time—paradoxically—to discover and encompass whatever lies outside the limited range of this order.

*Quoted in *Alberto Giacometti,* ed. Peter Selz (exhibition catalogue; New York: Museum of Modern Art, 1965), p. 243.

†Quoted by Marcel Jean in *The History of Surrealist Painting* (New York: Grove Press, Inc., 1960), p. 228.

Alberto Giacometti
The Palace at 4 A.M.
The Museum of Modern Art, New York

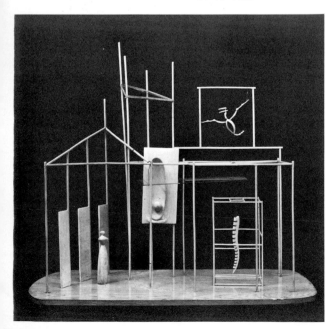

59 Alberto Giacometti, *Invisible Obje (Hands Holding the Void)*

Although they are all completely individualistic, Surrealists like Dali, Tanguy, and Magritte have developed consistent personal styles. More like Picasso, however, Max Ernst has moved rapidly from artistic idea to idea, allowing his style at each moment to be conditioned by his interests and his excitement.

Blind Swimmer, for example, is different in technique and image from early frottages and collages, as well as the later "shell," "forest," "horde," or "bird" pictures. The long, vertical, red, repeated bands create a visual pattern seeming to predict certain "Optical" paintings of more recent vintage. Yet the obvious difference is that Ernst does not exploit the possibilities of this method for creating illusions and visual tensions, and he clearly intends to evoke experiences outside the purely optical.

Two ovoid shapes move between the vertical bands: one, with a black "eye" moves smoothly and "swiftly" down the canvas, barely disturbing these bands; the other, all white, tries to move upward, but is caught crossways and held, forcing the bands out of position and creating rhythmical, linear patterns.

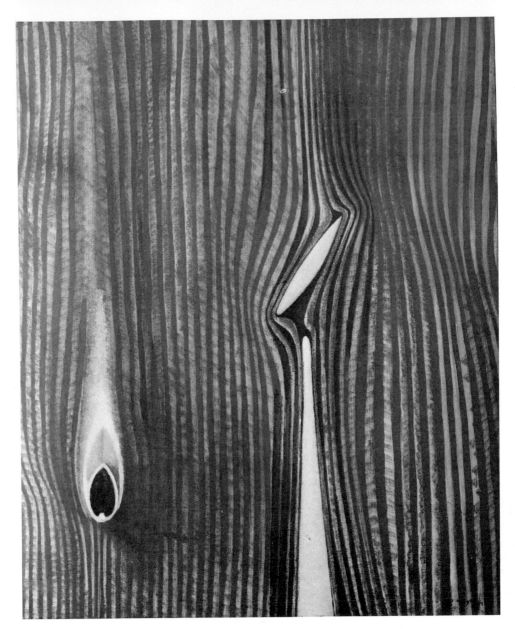

60 Max Ernst, *Blind Swimmer*

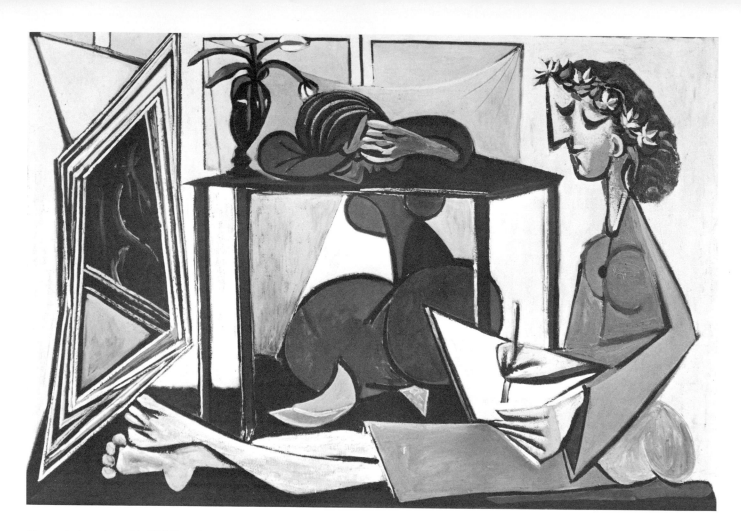

Picasso's *Interior with Girl Drawing* is not as tranquil as *The Dream*. The sleeping girl has been joined here by another female figure who sits before a mirror, drawing. The curves of the sleeping figure are contrasted with the more spare, angular form of the figure who is drawing. At this time Picasso was emotionally involved with Marie-Therese Walter, a young woman with a full figure, a warm, compassionate nature, and a legendary capacity for sleep. She and her sister appear at this time in a number of compositions of two women reading, drawing, painting, and sleeping. The influence of Cubism is still apparent in the two-dimensional treatment of the images and the development of a shallow space by overlapping planes. At the same time, the strong,

flat colors, distortions of drawing, and obvious concern for subject relate the painting to Expressionism and even in certain ways to Surrealism.

61 Pablo Picasso,
Interior with Girl Drawing

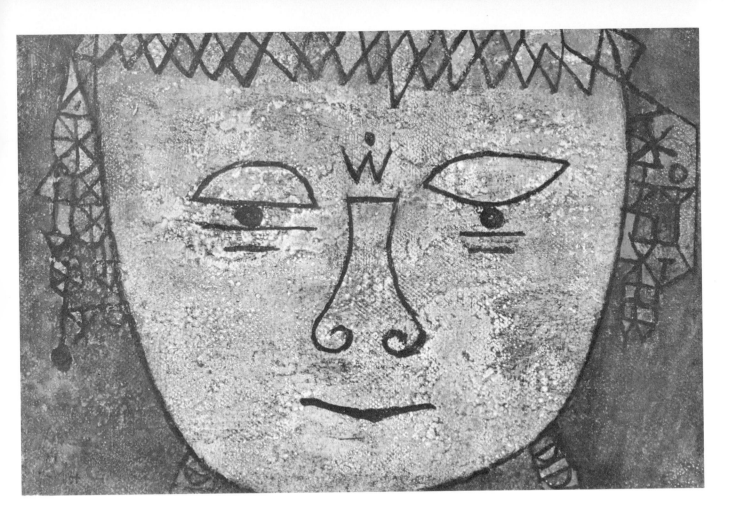

In 1935 Paul Klee did a small gouache on paper entitled *Child Consecrated to Suffering (or, . . . to Woe),* which demonstrates his incisive skill as an expressive linear draftsman, an exquisite colorist, and an artist with remarkable powers of intuition. It is true, of course, that Hitler had been in power several years and the future was becoming very clear. But the poignant image of the solemn man-child who accepts grief as a normal part of his existence is an image which was to be imitated all too soon by life.

Klee was convinced that his role as an artist was not to represent images of the outer world that his eyes had already taken in; it was to immerse himself in the world, allowing fullest scope for the unconscious formation of feelings, emotions, and all inner ex-

perience in response to the outer world, and to permit his artistic skills to bring forth visual images which must be considered as "metaphor(s) for the totality of the whole." Thus he conceived the artist to be an integral part of nature, creating within and through her, rather than an outsider attempting to represent her various aspects. A work such as this, therefore, does not present an accurate image of a real child; instead, it presents an expressive image which evokes a particular quality of experience about the world.

62 Paul Klee,
Child Consecrated to Suffering

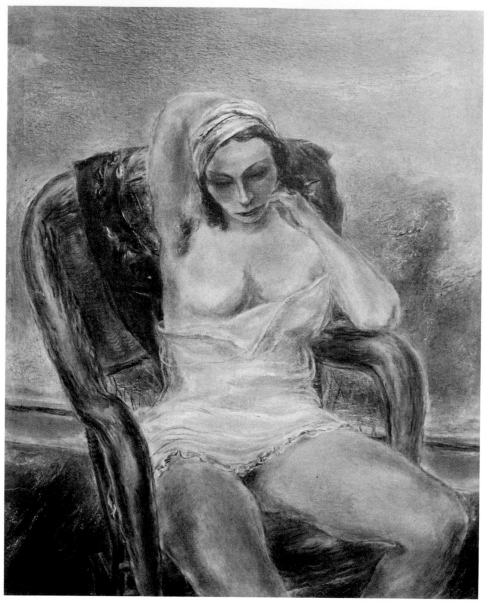

63 Yasuo Kuniyoshi, *Girl Thinking*

In the mid-thirties many American artists were involved with naturalistic themes of social import; the results were by no means all on a high artistic level. Among those who did create works of aesthetic significance and poetic content was a Japanese painter, Yasuo Kuniyoshi, who had come to this country as a young man. His early paintings were done under the influence of Chagall, and even his later, more naturalistic works retain certain overtones of fantasy. His more mature works are closer to Pascin's; although, like Edward Hopper, he was able to communicate the loneliness and nostalgia of modern urban life with great poignancy. His paintings of circus performers and meditative young women such as *Girl Thinking* recall the introspective mood of Corot's figure paintings. Kuniyoshi's style differs from Corot's, however, in being less formal and balanced, more linear, and with delicate, transparent glazes rather than opaque layers of color.

This artist joined certain compositional methods—such as tilting horizontal planes up to give them greater importance as shapes on the surface—with concerns for human character and problems. He does not seem to have been much impressed with the Western Renaissance tradition, and his sense of composition and design was apparently more intuitive than learned.

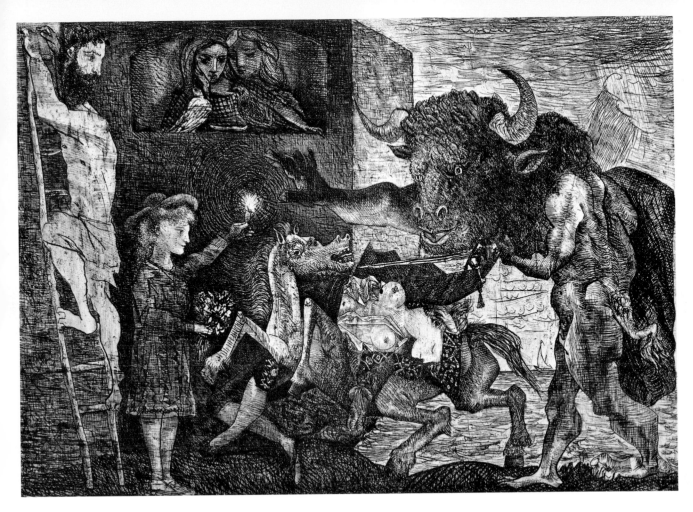

In 1936 Picasso created a complex, fearful, and yet somehow faintly hopeful, image. The Spanish Civil War had begun, Fascism was seeping across Europe—and, after a long visit in his homeland, the artist turned to the bullfight and to Greek mythology for images sufficiently terrible and rich in meaning to carry his feelings. The great man-bull form of the Minotaur (symbolic of virility and brutal, oppressive power) is the dominant figure in the etching *Minotauromachy*. On a seashore the beast advances into a shadowed corner toward the figure of a young girl. A female toreador lies stretched in death over a wounded and terror-stricken horse (the eternal innocent of the bull ring). The girl calmly lights the darkness with a candle and stands holding a bouquet of flowers and facing the monster, while a man (Christ?) tries to escape by ascending a ladder leading nowhere. In a window overlooking the scene, a pair of young women behind two doves calmly watch the drama. It is interesting to note that the Minotaur appears to be emasculated. Certainly Picasso never hesitated to represent genitalia and the image here almost demands it—unless the artist had a purpose for its omission. Thus the monster is brutal without being truly virile.

The following year the tragedy only hinted at here came to a monumental climax in the great mural, *The Bombardment of Guernica*.

64 Pablo Picasso, *Minotauromachy*

Pablo Picasso, *The Bombardment of Guernica*
Extended loan from the artist to
The Museum of Modern Art, New York

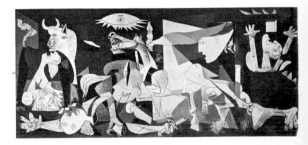

Georges Rouault was Gustave Moreau's favorite pupil. In the Symbolist master's studio he met Matisse and several other young artists who formed the group called *Les Fauves* (the wild beasts) around 1905. Rouault took part in the activities of the group but never shared the other members' interest in sharp juxtapositions of intense primary colors for maximum effects of visual and aesthetic shock. Also, unlike them, he was concerned with social and religious subjects, particularly the theme of human degradation and salvation.

Broad black lines define the shapes of figures in his works, and paint is applied in thick, successive layers building up crusts of pigment, with the undertones providing a richness and depth recalling the luminous, somber colors of Gothic stained-glass windows. It comes as no surprise to learn that at age fourteen the artist was an apprentice in a stained-glass studio.

Rouault often worked for many years on one painting, sometimes returning to re-work it long after it was first completed. *The Old King,* for example, was first completed in 1916. The artist worked on it again in the 1930's and finally brought it to its present state in either 1936 or possibly 1938. The heavily proportioned image with a powerful Semitic profile, inevitably calls to mind the proud tribal lords of the Old Testament, although, paradoxically, this stern, barbaric figure bears in his hand a delicate white flower.

65 Georges Rouault, *The Old King*

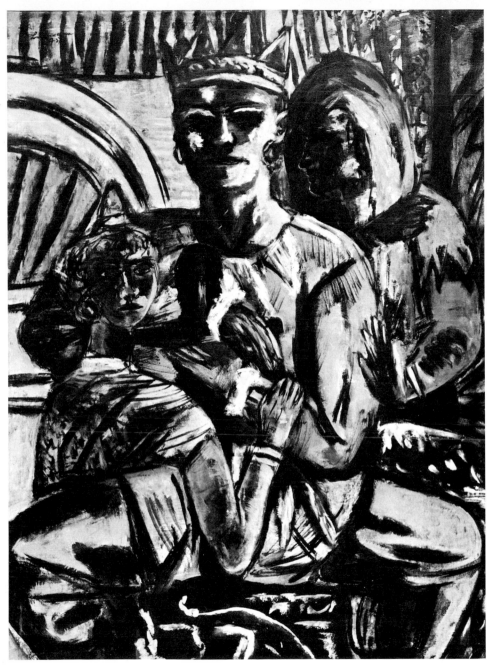

In 1937 Beckmann was living in Amsterdam, where he painted *The King,* a title which, unintentionally, invites a comparison with Rouault's painting, *The Old King.* Both painters were Expressionists, but Rouault was in the tradition of French Romanticism while Beckmann looked back to Dürer, Grünewald, Hans von Marees, and other German Expressionist artists of the past.

Distortions such as the child's distended shoulder and the spread legs of the figure of the king not only express the feeling of wrenching dislocations, but also achieve a more tightly integrated arrangement of shapes and the compression of the large, monumental figures into a shallow space too small to hold them comfortably. Thus, a sensation of repressed tension—which can also be found in much German medieval art—is expressed by relationships of shapes, distortions of drawing, and facial expressions. The deliberately heavy-handed, uningratiating paint surface is appropriately in the same spirit.

66 Max Beckmann, *The King*

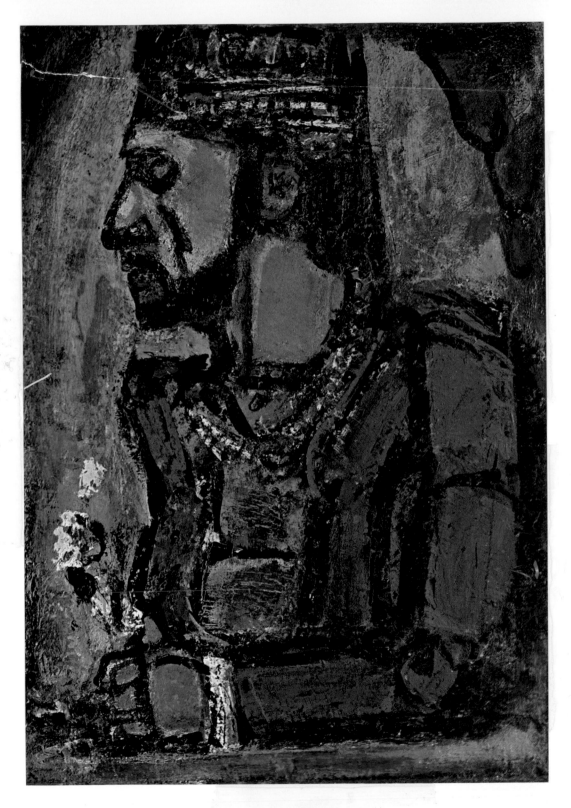

ESTABLISHED. INTERNATIONAL SURREALIST EXHIBITION HELD IN LONDON.

Alexander Calder is famous as the inventor of a form of sculpture made up of many attached parts which move in various directions when motivated by chance currents of air. He is not just an inventor, however; he is also a creative artist of great merit. Perhaps this is even clearer in his more traditional stabile sculptures such as *Whale*. Made of sheets of cut steel, welded and riveted together and painted black, the great form rears majestically up into the air. The smoothly curving contours suggest the uniquely supple, yet taut form of the whale without actually imitating its appearance. In this, as in other works, Calder creates biomorphic forms with modern materials and mechanical techniques, the whole ruled by a spirit of joyful play.

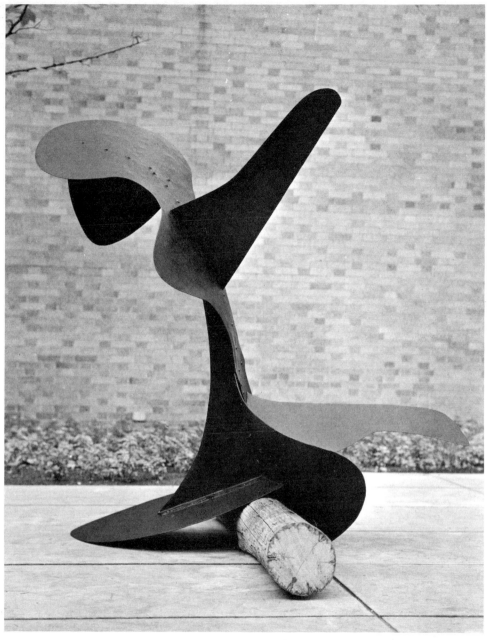

67 Alexander Calder, *Whale*

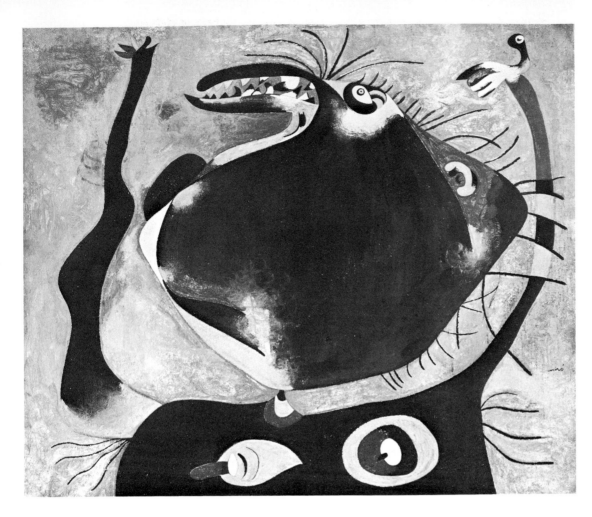

Miró, like the other Spanish artists living in Paris, regarded the intervention of the Fascist nations in the Spanish Civil War with fear and anger. Although he has never talked much about his art or his feelings, Miró's paintings speak eloquently for him. By this time the light-hearted humor of the *Carnival of Harlequin* has disappeared to be replaced by a savage spirit. The deformities of paintings such as *Head of a Woman* present a fearsome image of violence, incomprehension, and perhaps even madness. In this particular work the violently contorted visage with great gnashing teeth along distended jaws, as well as other brutal distortions, creates a figure suggesting terrible, rending cruelty. Yet the supplicating gesture of the arms and the curiously blank, red eye strangely invite pity. The fearsome subject is as always, exquisitely painted.

68 Joan Miró, *Head of a Woman*

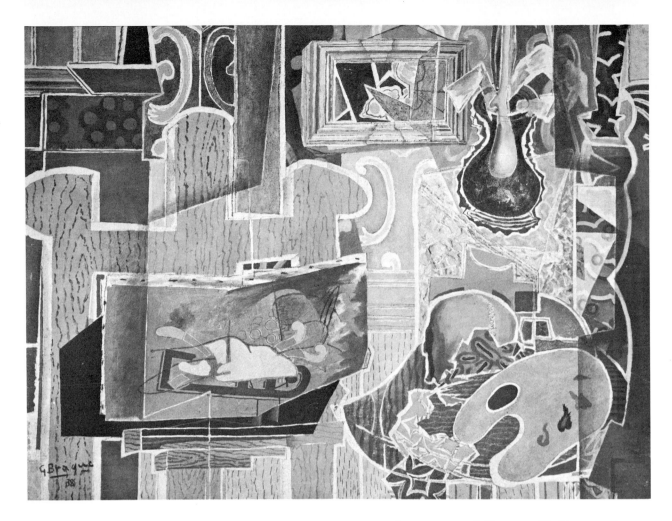

Unlike the Spaniards Picasso and Miró, Braque continued to be involved with the problems of painting rather than politics. During the 1930's he completed a series of masterly still lifes. *Studio with Black Vase* is among the most complex and fully integrated of those compositions. The artist's enormous skill in orchestrating somber colors, rich textures, and elaborate patterns is seen at its highest level in this painting. The images, as well as areas of surrounding "space," are designed and organized in relation to the flat plane of the canvas. Areas that are in the background also play an important role on the surface. Yet the complexities of composition are masterfully resolved in an over-all unity. Braque takes a place in the pantheon of French classical painters as an artist of supreme sensibility, measure, clarity, and balance. He is a legitimate heir to the poetic classicism of Poussin, Watteau, and Cézanne.

69 Georges Braque, *Studio with Black Vase*

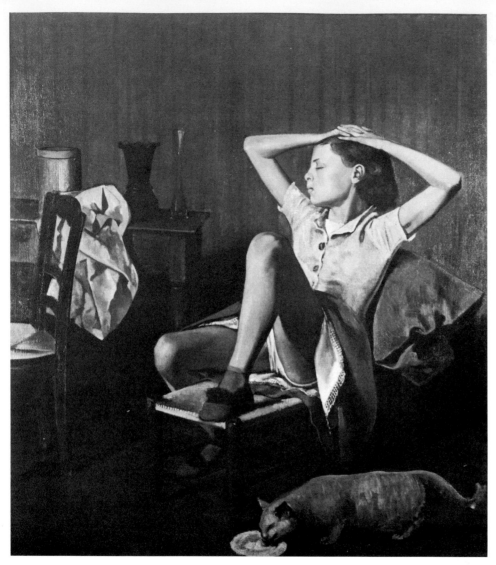

In an age of independent artists Balthus (Balthasar Klossowski) stands out in his uniqueness. He has remained a representational painter with a careful, tight technique for rendering three-dimensional forms in an organized space. These features are not responsible for his importance, however, for many lesser artists of conservative temperament display the same characteristics. It is Balthus' ability to isolate and present a poignant moment as though it were fixed for eternity that is singular. In many of his canvases, such as *Le Rêve,* it is the flavor of nostalgia—longing for a half-forgotten, bittersweet, and by no means pure, time that he evokes. It is childhood—or rather adolescence—that often provides his subject matter—a time of paradox when instinctive knowledge and erotic emotions go hand in hand with innocence. The clothing and body of the figure are those of a young girl, but the profile and expression are a woman's. A cat crouches at her feet greedily lapping a dish of cream. Is it her familiar? Or does the artist only intend to suggest a simile between female and feline natures?

70 Balthus, *Le Rêve*

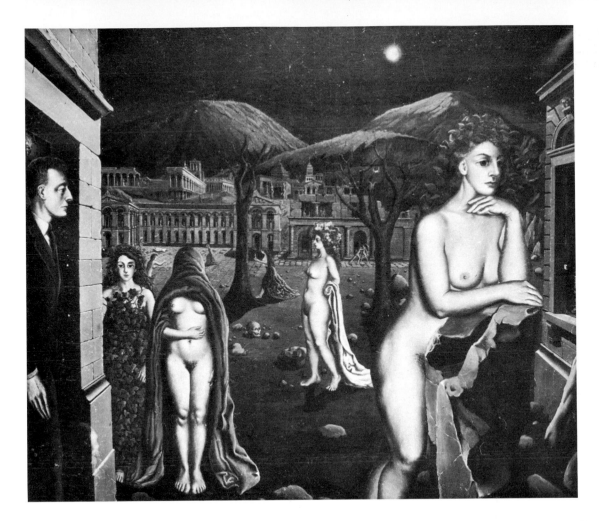

Surrealism has developed in two major directions: the first based on the technique of automatism; the second on dream imagery —sometimes called Veristic Surrealism. The second kind is largely indebted to the early paintings of Giorgio de Chirico and includes artists such as Max Ernst (in some of his works), Yves Tanguy, Salvador Dali, René Magritte, and the Belgian, Paul Delvaux. This last artist began his career in an expressionistic idiom under the influence of Ensor. Around 1930, however, after seeing works by De Chirico and Magritte, he began to work in a Veristic Surrealist way. From that point on his works deal with a few major themes: railroads, skeletons, classical architecture, fully clothed male figures, and nude or semi-nude females.

The painting *La Ville Endormie (The Sleeping Town)* includes several of these motifs. Empty, partially ruined, classical structures are seen at the foot of mountains and behind a group of figures moving like somnambulists across a moonlit stage. Voluptuous nude women encased in vines or trailing them from their hair are juxtaposed with dead trees. A figure encased in vines except for her exposed face and shoulders stands with a blank expression next to a nude figure completely exposed except for head and shoulders which are covered by a shroud. The boulders which are strewn over the ground are interspersed with skulls. A fully clothed, sober male figure (a self-portrait of the artist?) stands in a doorway to the left and gazes unseeingly out on the

71 Paul Delvaux,
La Ville Endormie (The Sleeping Town)

scene. Life and death are the themes consistently counterposed.

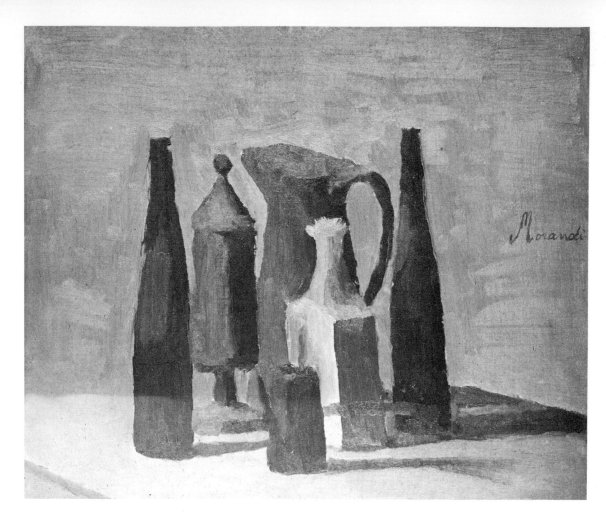

After spending several years around the time of World War I as a member of the *Scuola Metafisica,* led by De Chirico, Giorgio Morandi has devoted himself to the exploration of one theme—the still life, only allowing himself an occasional landscape.

In contrast to the complex, richly patterned and textured compositions by Braque, Morandi's simple arrangements of bottles, pitchers, and glasses depend entirely on subtle nuances. They are painted in a limited range of earth colors with a clear and orderly arrangement of lights and shadows that is reminiscent of the quiet poetry of Chardin's paintings. In *Still Life* the artist has adjusted the shapes, colors, and tones as precisely and judiciously as did, for example, Mondrian. The image of a sober and hushed atmosphere seems to invite quite contemplation of the idea that beneath the exterior flux on the surface of the world, an order exists which applies to the humblest parts of life as well as the most exalted.

72 Giorgio Morandi, *Still Life*

"Romantic realism" was a strong strain in American art throughout the 1930's. Among its most vigorous practitioners was Walt Kuhn, an artist who had played an important role in organizing the Armory Show in 1913 and had advised John Quinn on the formation of his important collection of modern art.

Kuhn was largely self-educated but obviously owed much to Cézanne and to Derain. He often painted circus performers —acrobats, clowns, and musicians—figures that have frequently served as symbols of the artist. He imbued the images of these inhabitants of the fringe areas of society with a solemn dignity implying a seriousness far beyond their role as entertainers. The uniform, pose, and title of *Lancer*, for example, suggest a parody of the traditional military portrait. The level gaze, solemn mien, and heavy forms, however, make it clear that this is neither a frivolous display of wit nor satire.

73 Walt Kuhn, *Lancer*

STARTS WHEN GERMANY ATTACKS POLAND. RUSSIA SIGNS NON AGGRESSION PACT WITH GERMANY.

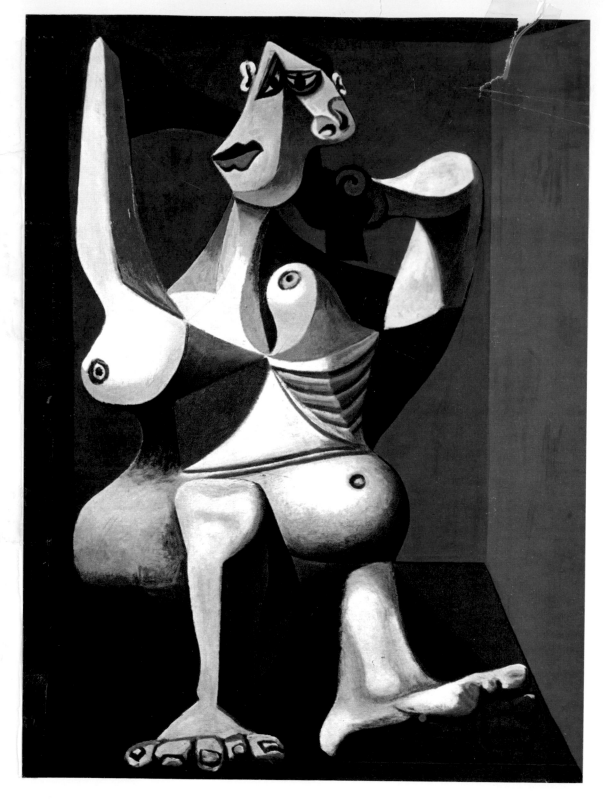

1940 WINSTON CHURCHILL BECOMES BRITISH PRIME MINISTER. LEON TROTSKY ASSASSINAT

Like the etching *Minotauromachy,* the painting *Woman Dressing Her Hair* by Picasso seems to share the anguished spirit of the *Guernica.* The print was done earlier and predicts it; the painting was done later and is an elaboration of ideas contained in the forms of the mural. The violent disfigurements of the nude were probably triggered by the artist's emotional reactions to the political events then occurring. It is by no means a "war picture," but it refers to the anxieties and general psychological state of the artist at the time. In this canvas—the most significant of a series of furious works that he did during the first year of the war— the deformations of the brutalized figure are emphasized by her almost pitifully coquettish gesture in arranging her hair. She sits awkwardly in a tightly confining space in which her movements are restricted. Dark green walls and a purple floor surround the swollen, clumsy, and pallid form. Two monstrous feet are thrust out before the hideous body, and the twisted head has the snout of a beast in place of a nose. Like the *Guernica,* this work demonstrates the artist's incredible ability to endow banal images and symbols with significance and potency through the intensity of his passion.

74 Pablo Picasso, *Woman Dressing Her Hair*

MEXICO. GERMAN BLITZKRIEG DEFEATS DENMARK, NORWAY, HOLLAND, BELGIUM, FRANCE. ITAL

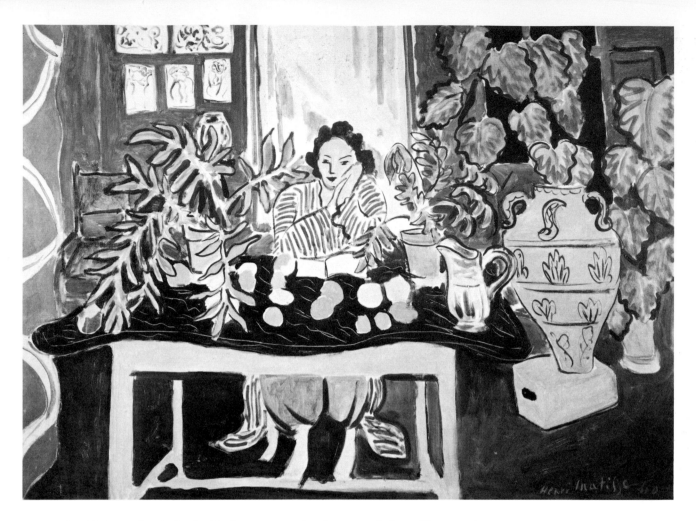

During the thirties and early forties Matisse opened up the rich possibilities of his earlier style. His aim, as always, was to create pictorial equivalents of natural forms that functioned in a richly decorative and exciting visual way both in a two-dimensional and shallow three-dimensional way. *Interior with Etruscan Vase,* for example, brings together a number of motifs that are familiar from other works by the artist; among them are the large-leafed plants, marble-topped table, and woman in Oriental costume. These elements are organized in a masterly way to provide both a tightly controlled development of space and a decorative treatment of the surface. The floor, for example, is tilted up so that it becomes a plane parallel to the picture plane even while it remains the ground plane. The same is true of the table top and the base for the large vase. Of particular interest are the skillfully designed spaces between the images—for example, the open areas beneath the table, between the tabletop and the vase, or between the large vase and the one behind it and to its right. Perhaps the true extent of Matisse's daring and his mastery of composition and of drawing can be glimpsed in details such as the distorted silhouette of the large vase causing it to lean inward or the already-mentioned base for the vase, and the way its upper edge just meets the rounded corner of the table while the handle of the pitcher on the table overlaps the vase. This one small area of the still life alone contains visual tension and a counter-

75 Henri Matisse,
Interior with Etruscan Vase

point of space and surface worthy of Cézanne.

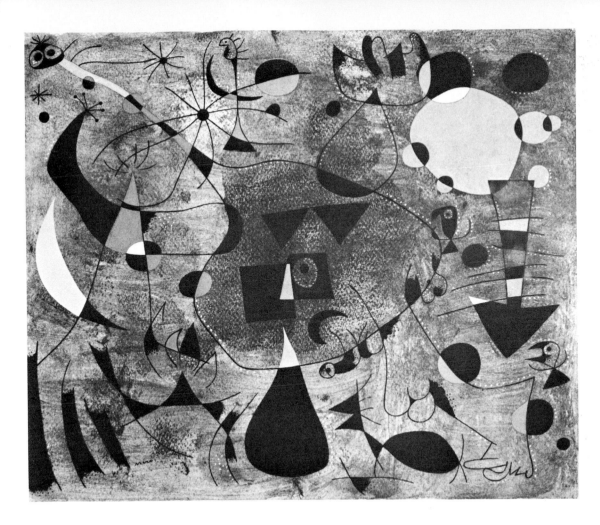

During 1940 and 1941 the Spanish artist Joan Miró worked on a series of twenty-three paintings—a group known as *Constellations*. The earlier ones were painted in Varengeville in Normandy, but most were done in Palma de Mallorca and Montroig in Spain, where the artist fled from the German occupation. They are uniformly small and are painted in gouache and oil on paper. Women, birds, and stars are the pervading motifs of these curiously "musical" paintings.

Seventh in the series is *Wounded Personage*, painted at Varengeville. Like the other early paintings of this series, figures are easily apparent. It is the only one, however, bearing a title and images suggesting unhappy circumstances. The large, distorted male figure serving as the central and controlling element in the composition is slightly reminiscent of the wounded and kneeling female figure in Picasso's *Guernica*. The peculiar hollow-eyed head at the end of the grotesque stalk of neck, the bent leg extended behind, and the upraised arms and distended fingers all serve to suggest a sense of fear as a large, sharp arrow pitilessly descends. Still, the starry night, moon, and hills retain the magical flavor of this series, and the unhappy subject is unique within it.

76 Joan Miró,
Constellation: Wounded Personage

Woman with Blond Armpit Combing Her Hair by the Light of the Stars is another of the early compositions in the series of twenty-three *Constellations,* using large figures and celestial bodies. It demonstrates the almost ecstatic spirit of the entire series. Compositionally complex, a cluster of circles and star shapes painted in opaque colors fill the delicately toned ground, and the grotesquely distorted image is defined with an elegant line.

About the *Constellations,* the artist later remarked: "At Varengeville-sur-Mer, in 1939, began a new stage in my work . . . about the time when the war broke out. I felt a deep desire to escape. I closed myself within myself purposely. The night, music, and the stars began to play a major role in suggesting my paintings. Music had always appealed to me, and now music in this period began to take the role poetry had played in the early twenties."*

*J. J. Sweeney, "Joan Miró: Comment and Interview," *Partisan Review,* No. 2 (February 1948), p. 210. Quoted in James Thrall Soby, *Joan Miró* (New York: Museum of Modern Art, 1959), p. 360.

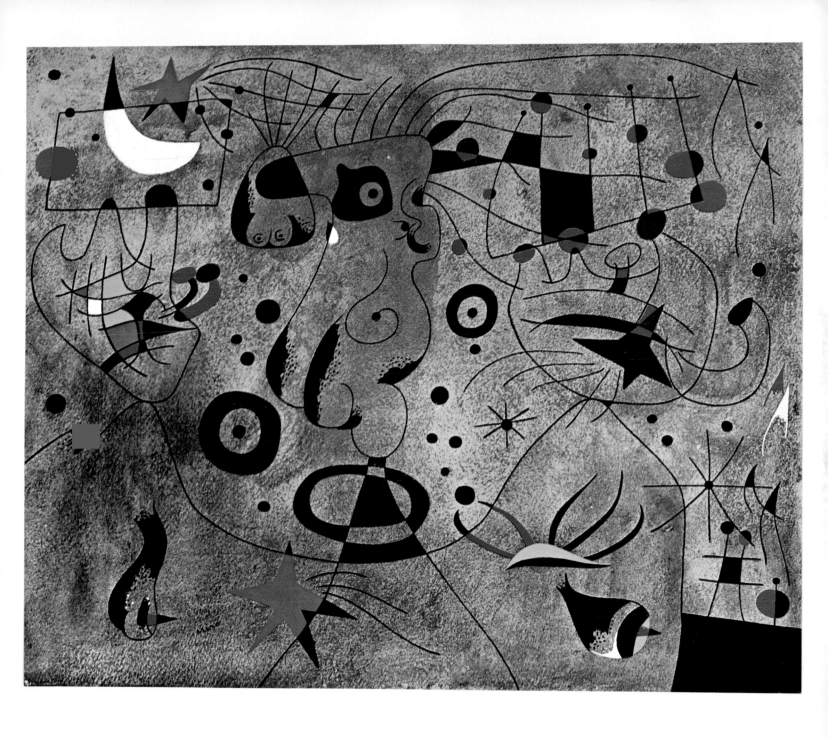

77 Joan Miró, *Constellation:*
Woman with Blond Armpit Combing Her Hair by the Light of the Stars

To use a political event as a dividing point in a survey of art may seem arbitrary, but, in fact, the event had a direct influence on artistic developments. In the early 1930's Nazi oppression brought an abrupt end to avant-garde art in Germany. France was the immediate beneficiary of the exodus of talent from middle Europe—as it had gained earlier when artists such as Kandinsky and Chagall left the Soviet Union. This traditional sanctuary for refugees was itself invaded, however, as the armies of Fascism swept westward, and many of the artists crossed either the Channel to England or the ocean to the United States. Léger, Mondrian, Lipchitz, Ernst, Tanguy, Masson, Matta, Gabo, Chagall, and Breton, along with others joined Hans Hofmann, Marcel Duchamp, and Josef Albers who had been in this country for some time. Other German artists who came to these shores included Beckmann, Kokoschka, Grosz, and Feininger (who, of course, had been born here).

The Surrealists came in large numbers since they were vigorously anti-Fascist and would have had short, unhappy lives left had they remained in Europe. The story has been told many times of how they influenced the American artists who created a movement rather inappropriately called Abstract Expressionism (with some reason it has even been suggested that this kind of painting would be better named Abstract Surrealism). There is no question that direct contact with artists that had heretofore been known only as names (usually attached to reproductions in imported art magazines) had a great impact on the Americans and influenced their development. However, it should be remembered that gifted American artists such as Sheeler, Stella, Weber, Hopper, Davis, and Kuniyoshi were working in this country and abroad throughout the 1920's and 1930's.

The major contributions to the new American art, however, came from Cubism and Surrealism. To the Cubist attitude toward space, surface, and pictorial form, the Americans joined, in varying degrees, Surrealist spontaneous, automatic, and intuitive methods for probing the subconscious. Cubism thus contributed a particular view about formal structure, while Surrealism provided the basis for a methodology and a concern for content. As with Surrealism, there could be no unifying style. Gorky, Pollock, Motherwell, Baziotes, Rothko, Gottlieb, De Kooning, and Guston, for example, all developed styles entirely different from one another. Meanwhile, Albers, Ad Reinhardt, and others stood firmly opposed to all Surrealist and Expressionist aims, steadily developing and refining purely abstract styles.

At first most of these Americans treated totemic and mythic images purely in the Surrealist spirit, but as time went on they became increasingly abstract. Many of them worked, and in some cases continue to work, easily in a region

96

where images sometimes developed to a point where they were discernible—or even obvious—and sometimes did not. This does not seem to be of great importance, for they have been more concerned with content expressed in a "metaphorical"* than in an explicitly descriptive or symbolic way.

In 1942 Motherwell and Baziotes participated in the International Surrealist Exhibition in New York. During the early forties two galleries in New York—Julian Levy Gallery and Peggy Guggenheim's Art of This Century—showed Surrealist art and gave one-man exhibitions to Motherwell, Gorky, Pollock, Hofmann, Baziotes, Rothko, and other Americans of this group. In 1948 Motherwell, Rothko, Baziotes, and Newman formed an art school entitled "Subjects of the Artists" which in turn gave way to "The Club," a place where the artists met, talked, and put on their own programs.

For twenty years, beginning around 1940, the "New York School" or Abstract Expressionism dominated the art of this country and much of the Western world. However, artists such as Davis, Tobey, Hopper, and Dickinson in America and Dubuffet, Giacometti, Balthus, and Henry Moore in Europe, created important art of other kinds. It was still Matisse, Braque, Rouault, Léger, Chagall, and the ubiquitous Picasso, however, who continued to dominate the European stage in the period immediately following the war. In Germany, the Nazi "experiment" left an artistic wasteland that is only now beginning to show signs that life still exists there. Elsewhere, there have been some indications of a rejuvenation of the Italian genius, while Britain has experienced a vigorous and lively period of creativity.

In recent years several different movements and styles have bid to succeed Abstract Expressionism as the dominant movement in art. There has been a return to romantic figurative subjects on the West Coast of the United States; a re-emphasis on "hard-edged," geometrical abstractions by many artists; and in quick succession the development of "Pop" and "Op" art. None of these, however, has yet demonstrated the same order of power to excite the imagination and stimulate creative activity as did Abstract Expressionism.

In summary: the twentieth century opened with a fantastic burst of creativity which lasted about twenty years—through the advent of Surrealism. The following twenty years was a period of consolidation, digestion, and artistic breath-catching. The twenty years following World War II marked another burst of creative activity which was based on a synthesis of some of the major ideas developed during the first period. It added, however, a spirit of raw vigor beyond any of the earlier movements. Perhaps this was due in part to the American environment or the American ideal which had been forged in revo-

*In this sense "metaphorical" refers to forms of visual art which—because of the feelings and meanings commonly associated with their components—seem to roughly parallel the subjective experiences of the artist in response to the world; the forms are thus, in a sense, analogous to such experiences and can be considered as their "visual metaphors."

lution and tempered on the frontier. (It must be remembered, however, that Gorky, Hofmann, De Kooning, Rothko, and others were actually born in other parts of the world.) These artists began with the conviction that they would never achieve popular or commercial success. They were willing—even anxious —to commit themselves completely to art, risking everything that they had mastered technically as well as all traditional solutions to problems of composition. They embraced the notion that the work of art is the expression of a subjective "experience" which occurs simultaneously with the creation of the work, that it is the articulation of an "idea" during the very process of its formation and in its own unique "language" of visual forms. Further, this is an attitude that implies that there are possible formal solutions for almost any conceivable set of propositions. The artist may begin to work with only a general notion of what he is going to do. The first spontaneous and even random acts indicate a character and certain relations which provide the general conditions upon which the work will develop. As it progresses from an early stage of disorder toward a state of order, unplanned events often occur—which may, of course, indicate subconscious compulsions on the part of the artist. Some of these are rejected, while others are accepted and contribute to the form and character of the evolving work of art. As order develops, however, there is less and less opportunity for such chance effects.

Thus, the *act* of creating works of art becomes a matter of crucial importance. The process is "open" and involves the artist in a complex evolution consisting of a search for solutions to multiple, interacting, and flexible problems. The solutions at which he arrives and, even more, the problems that he selects, reveal the nature and intensity of the artist's experience of the world—which includes, of course, the very work of art that he is creating. Above all, it is his intention to have his "style" develop as the appropriate means for his expression, thereby rejecting any preconceived notion of style. If this attitude and this art have brought an end to traditional painting and sculpture—as is sometimes suggested—then it has also established a new basis for art capable of much further development.

The twentieth century has thus provided a field on which another battle in the ancient war between the defenders of classical order and intellect and the partisans of romantic feeling and emotion can be fought often without the armor—or camouflage—of subject matter. Although the issues are far more complex than they seem at first, it is still clear that serious differences of method and belief separate artists such as the early Kandinsky, Miró, Pollock, Gorky, De Kooning, Guston, and Dubuffet from those such as Mondrian, Lissitzky, Albers, Reinhardt, Herbin, and Vasarély. Considering only the appearance of the finished works of art, the first group is generally more painterly; brush stroke and a sensuous paint surface are important expressive tools for the artists. The second group tends to place greater emphasis on exactly defined shapes enclosed by continuous contours and flat, opaque colors. The first

98

group tends to suggest a loose, amorphous, or ambiguous kind of space; the second leans toward precise (if complex) methods for suggesting space, or emphasis on the flat surface. The character of works by the first group seems to suggest freer and more spontaneous actions during the process of painting, while that of the second implies more carefully planned and controlled activity. The first seems expressive of feelings, emotions, and moods; the second, of order, of the mind and logical construction.

Such simplifications may, of course, mislead as easily as they elucidate. Yet, if regarded—as they are intended—as rough, general definitions or poles around which various art objects, activities, and theories cluster, they can be helpful. As the reader will recognize, they are related to Henrich Wölfflin's often-abused notions concerning the Baroque and Classical styles. The Poussinist-Rubenist controversy and that between the followers of Ingres and of Delacroix is thus brought up to date. And the arguments are just as cloudy and just as far removed from the major question of artistic merit as they have ever been. In the final analysis it does not matter for art whether an artist is committed to the power of the intellect or of the id, transcendental idealism or existential angst. No more than it matters whether he was committed to the idea of the glory of Athens, the immortality of the Buddha or of Christ, the mystery of woman, the gallantry of Spanish captains, the elegance of the French court, or the ideas of freedom and brotherhood. What does matter is that, under whatever banner, he is committed to art and makes art.

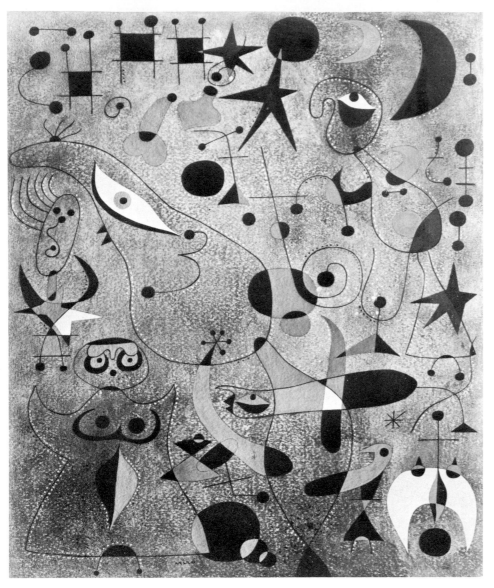

Miró continued working on the *Constellations* during 1941 while living in Palma and Montroig. *Awakening at Dawn* is not as dense a composition as most later ones. Like all the works in this series, it was done in gouache on a background of thinly applied oil paint on paper. The images defined by lines are more definite than in most of the others, and several figures, as well as the familiar stars and moons, are discernible. The device of dots along the contours of the figures is used here for one of the first times.

It is almost incredible that at this tragic moment in history Miró could have so completely withdrawn from outside events and created such lyrical images. It is as though the worst having happened, the artist rejected pessimism and illogically discovered new possibilities for the expressions of humor, joy, and therefore, hope.

78 Joan Miró, *Constellation: Awakening at Dawn*

Picasso's *oeuvre* could serve as a visual encyclopedia of the major stylistic developments in the art of the twentieth century, including Romanticism, Cubism, Expressionism, Surrealism, and Neo-classicism, among others. Although he was not the creator of the style in every case, his works often overshadow others through their imaginative power and inventiveness.

His protean genius has periodically refreshed itself by a return to natural appearances. Even his most representational works, however, are imbued with a poetic spirit taking them well beyond the range of simple naturalism. In 1941, at a time when he created a number of violently distorted, anguished works, he also did the fresh and charming *Portrait of Madame Eluard*. Painted in soft, light, grayed tones, the fragile, girlish beauty of Nusch, the wife of the Surrealist poet Paul Eluard, is defined with direct brush drawing. The half-closed eyes and softly curving lips give her a gentle and enigmatic expression recalling—in spirit at least—Leonardo's most famous portrait. This is but one (although probably the finest) of many portraits that Picasso did of the wife of the poet who was one of his most intimate friends.

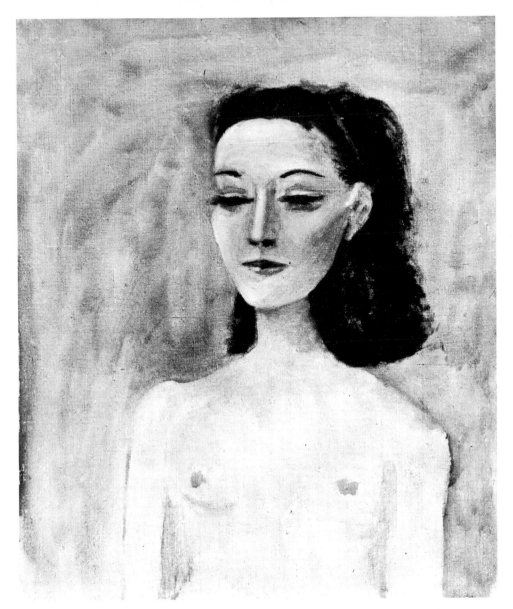

79 Pablo Picasso, *Portrait of Madame Eluard*

Jacques Villon developed a rigorous compositional system when he was a leader of the *Section d'Or* group of Cubists in the years just before World War I. Later, his art evolved slowly into what might be described as a lyric Cubist style. It joins a precise, linear, geometrical structure—derived from Cubism—with a high-keyed, "sweet," yet, at the same time astringent palette. Light plays a major role in his paintings; it is suggested by juxtaposing clear, bright hues to create the effect of over-all illumination rather than by contrasts of light and shadow.

In 1941 Villon was living on a farm in the country where he painted a number of canvases using the theme of man's basic relations with the earth and the seasons. Apparently revolted by contemporary political events, he sought a more archaic condition to reaffirm his faith in humanity. It is not a romantically bucolic world that he painted, however; it is a world of order, clarity, and balance; and it is formally related to works on similar themes by Poussin and Cézanne.

Potager à la Brunié is probably the artist's major work of this period. The tones of almond green, violet, pink, and gray are held firmly within a geometrical structure of lines defining the forms of trees, buildings, and figures working in the rows of the kitchen garden of the title and, at the same time, creating an "abstract" order on the surface.

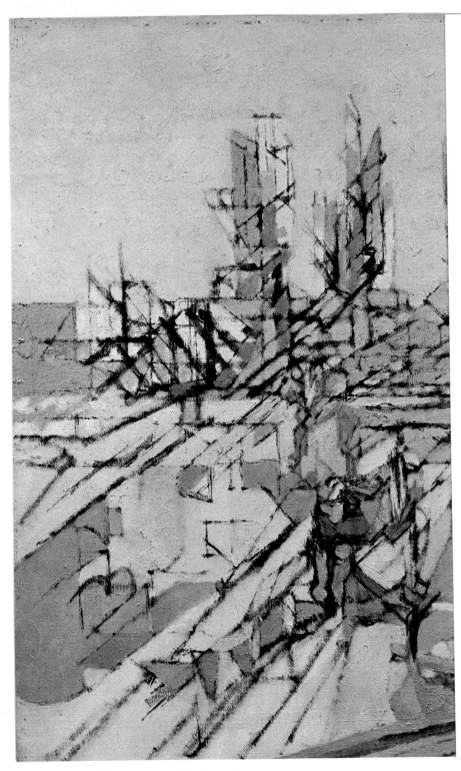

80 Jacques Villon, *Potager à la Brunié*

In the early forties while the young artists later to be known as Abstract Expressionists were beginning to exchange ideas with the European Surrealists who were in this country, Edward Hopper continued to hold the public's attention and to do some of his best work. *Nighthawks* demonstrates this artist's ability to reveal with poignancy the personal loneliness that is so much a part of modern, highly organized urban existence. The composition is typically clear and ordered. It involves the figures of a counterman and three customers in an all-night cafe with empty stools, windows, and streets echoing the empty faces of the lonely figures whose lives touch briefly and accidentally. Other works by the artist have similar themes—for example, an all-night gas sta-

tion attendant, a single figure in a cheap hotel room, a pensive theater usherette standing alone in a corner off an aisle, and an empty main street on an *Early Sunday Morning*. Whenever there are groups, as in *Nighthawks,* each figure is still psychologically alone. Hopper is a poet who sings of the sad paradox of man, increasingly isolated in a world in which his numbers are multiplying and in which the techniques of communication become ever more efficient.

81 Edward Hopper, *Nighthawks*

Joseph Cornell has never been part of any doctrinaire movement. His art was Surrealistic before he had any contact with Surrealism. He invariably demonstrates a sense of precise order and balance, as well as exquisite color, without having had any training as a painter. For many years he has lived in semi-isolation just outside New York City, never traveling and without the stimulation of a constant exchange of ideas which so many artists find essential for their artistic existence.

Cornell has simply created collages and "boxes." The boxes have often been made in series, each sequence devoted to a theme which involved the artist at the time. Thus, there is a group of "Bird Sanctuaries," of "Dove Cotes," "Soap Bubble Sets," a "Hotel de l'Etoile" series, and one of "sand boxes" among many others.

The boxes with "Medici Boy" titles all include details of reproductions of a Renaissance, perhaps Mannerist, painting. The enigmatic *Medici Slot Machine,* for example, includes a three-quarter image of this figure centrally placed and surrounded by other objects, including rows of reproduced heads of the same image. Among other objects are marbles, a child's block, jacks, a compass, and a fragment of a plan of the Palatine Hill in Rome. Various systems for interpreting such fragments have, from time to time, been advanced. Whatever the intentions of the artist may be, however, viewed together within the magical, mysterious, timeless and soundless atmosphere which they evoke, poetry is the inevitable result.

82 Joseph Cornell, *Medici Slot Machine*

The *Boîte-en-Valise (Box in a Suitcase)** is, on the face of it, a miniature museum dedicated to a collection of the works of Marcel Duchamp, but it is more than that: it is a Pandora's Box, the contents of which mirror the nature of the catalytic effect the artist has had on the art of the last half-century. Juxtaposed with the paintings and objects that have made Duchamp famous—even notorious *(Nude Descending a Staircase* or *The Fountain)*—are lesser-known studies and drawings which give insight into the gestation and development of his ideas. The

*The *Boîte* is a record of works of art. Major works such as *The Bride Stripped Bare by Her Bachelors, Even* could not be included here, but this important record of such works has been included as a reminder and a substitute.

Large Glass (The Bride Stripped Bare by Her Bachelors, Even) left "definitively unfinished in 1923, dominates the collection even in a small plexiglass version. Its development can be traced in a series of paintings reproduced in the *Boîte: Virgins and Brides* of 1912, the *Chocolate Grinder* of 1913, and the *Nine Malic Molds* of 1914-15.

Included also are photographs and reproductions of the "ready-mades"—utilitarian objects such as the *Bottle Rack* (1914) or a snow shovel *(In Advance of the Broken Arm,* 1915) which are transformed into aesthetic objects by the choice of the artist. Duchamp did not create or make the object, but he chose it, and by means of a title or a signature has created the "situation" in which we see the object. The implications

83 Marcel Duchamp,
Boîte-en-Valise (Box in a Suitcase)

of this "aesthetic shift"—artistic creation as an exercise of choice, not dependent on style or technique—is crucial to the development of art in the twentieth century.

Duchamp's wit and humor are implicit in almost all of his creations. A prime mover of Dada, his humor both antedated and outlasted the era (1916-1924) of that movement. Most typical of his wit are the "assisted" or "corrected" ready-mades: *L.H.O.O.Q.* (1919) which combines a visual prank on the *Mona Lisa* with a verbal one in French and *Apolinere Enameled* (1916-17) made from an advertisement for Sapolin Enamel.
R. W.

Roberto Sebastian Antonio Matta Echaurren, born in Chile of French and Spanish descent, is a visionary painter of extraordinary power. In 1939 he immigrated to the United States from Europe—where he had joined the Surrealist movement—and made contact with several younger American painters. In 1941 he visited Mexico, where he was impressed by the brilliant sunlight, colors, and certain harsh landscapes. Following this trip, his "inscapes" took on a bright, hot tonality with oranges, yellows, and greens dominating. *The Earth is a Man* is a major canvas of this period and the artist's first really large picture. The fantastic landscape appears to heave and split under a lurid, apocalyptic sky.

Surely no such scene was actually witnessed by the artist except in his mind's eye. Yet such a doomsday vision may well have been inspired by the volcanic landscapes and burning sunlight of Mexico. Thus, it seems clear, all images—even the most rigorously geometrical abstract—derive ultimately from the artist's visual experiences of the outer world. Yet, it is equally obvious that it is a view invariably conditioned by the temperament, imagination, experience, and interests of the artist. It is—in short— the artist who is revealed in the work of art and who, in a sense, tells us in this way what the world is like for him.

84 Roberto Matta (Echaurren),
The Earth Is a Man

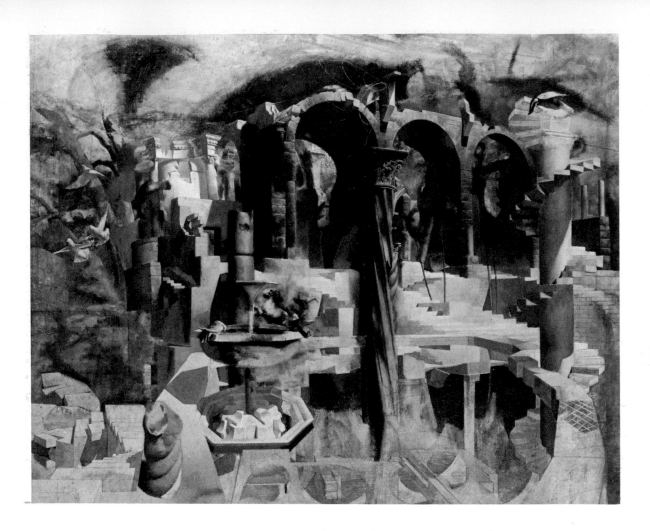

Edwin Dickinson, an American painter of
decidedly romantic leanings, worked on the
canvas *Ruin at Daphne* for ten years without
ever bringing it to completion; yet its un-
finished state only contributes to the per-
vading spirit of mystery and ruin. The images
and even the style are reminiscent of the
background area in Leonardo's great, un-
finished masterpiece, *Adoration of the
Kings*. There is a similar concern for the mys-
terious effects of light and shade, the same
ambiguous merging of complex architec-
tural forms and living trees, and even a small
Leonardesque horse. Although the iconog-
raphy is ambiguous, the mood of ruined
grandeur is unmistakable.

85 Edwin Dickinson, *Ruin at Daphne*

Jackson Pollock is probably the best known of the Abstract Expressionist artists. As with Van Gogh, his flamboyant character contributed much to his fame—as did his method of tacking large canvases to the floor and dripping paint on them from above.* It is the finished paintings alone,

*Whether colored marks are made on a surface with a brush, stick, knife, fingers, or dripped does not in the long run matter so far as its aesthetic value is concerned. All these methods and many more have been used in the past with success. Only convention and pre-established values determines that one may be more suitable than others. Certainly the singularly vigorous and elegantly "whipping" lines, and the rich textures built up by them in Pollock's "drip" pictures could hardly have been achieved by other means.

however, that are responsible for his growing reputation years after his tragically early death.

During the early 1940's Pollock, like a number of other American artists, took a serious interest in mythological subjects. Whether myths were the inspiration for his paintings or were suggested to him during the process of painting, is a moot question. If such works were created in a way consistent with the aims and ideas that he expressed, however, then the latter must be the case. These paintings precede the fully abstract "drip" canvases and still contain discernible images.

The story of the unnatural mating of Pasiphaë, a wife of Minos, King of Crete, with a great white bull, leading to the birth

86 Jackson Pollock, *Pasiphaë*

of the Minotaur, is the subject of one of Pollock's most important works of this period. Picasso has used the image of the legendary half-human, half-bull figure a number of times as a symbol of brutal, destructive power. Pollock apparently preferred the ideas of uncontrollable passion (divinely inspired) and the incongruous yet ecstatic union of beauty with primal energy. Thus he painted *Pasiphaë* rather than the Minotaur.

Jean Dubuffet gave up a career as a success-
ful wine merchant to return to painting.
Following the liberation of Paris, he painted
three versions of jazz musicians of which
Grand Jazz Band (New Orleans) is the major
example. The artist is—as were the Dadaists
—opposed to the esoteric postures of tradi-
tional "culture." "Art," he once remarked,
"is rarely nowadays a free celebration. . . . It
has become, instead, a game of ceremonies
. . . its true and only terrain is rapture and
delirium . . . it should be stripped of all the
tinsel, laurels, and buskins in which it has
been decked . . . once disencumbered, it
will doubtless begin again to function—to
dance and yell like a madman, which is its
function, and stop putting on pretentious
airs from its professor's chair."*

Raw colors, a frieze-like composition,
and an incisive delineation of archaic-
appearing figures produce a trenchant and
amusing image. Like Klee, Dubuffet, with
great skill, adapts the expressive qualities of
primitive art and of children to his own
sophisticated and serious ends.

*Jean Dubuffet, quoted in *The New Decade.*
 (New York: The Museum of Modern Art, dist.
 by Simon and Shuster, 1955), p. 17.

87 Jean Dubuffet, *Grand Jazz Band*

Antoine Pevsner and his brother, Naum Gabo, contributed much to the idea of sculpture as structure involving space and implying time, rather than as volume displacing space. These two artists regenerated the Russian Constructivist movement and organized a Constructivist exhibition in Moscow in 1920 when avant-garde art still had the blessing of the new Soviet government. The philosophy of this movement depended largely on the logic of engineering. "Eiffel," Pevsner once remarked, "was the first Constructivist." The Realist Manifesto, which he signed in 1920, contains the guiding principles of his art.

Construction, completed by Pevsner in 1944, illustrates such ideas. Made of metal rods and strips welded together to create geometrical planes interrelated in a complex bisymmetric form, it also involves light, calculated by the artist as he manipulated the metal rods and planes which are reflecting surfaces. Light thus serves for the sculptor the role that color normally does for a painter. (Pevsner did, after all, begin his career as a painter.) He has always preferred metals, such as bronze, which reflect light, causing one to be aware of the surface, rather than the transparent and translucent plastics favored by Gabo.

88 Antoine Pevsner, *Construction*

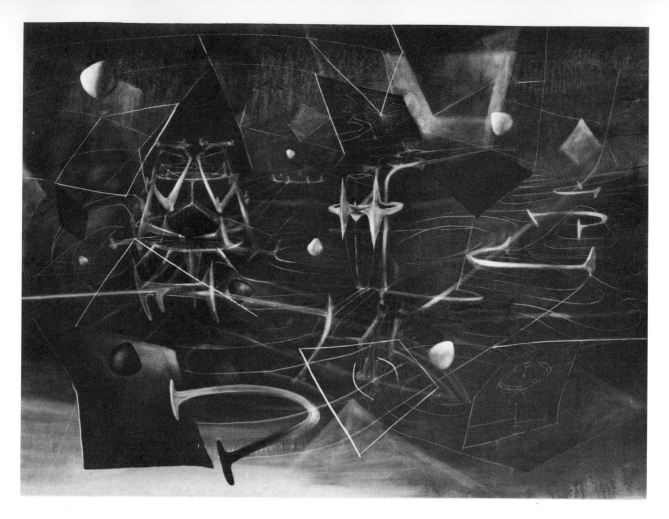

In the early 1940's, Roberto Sebastian Antonio Matta Echaurren was in the United States as the youngest member of the group of refugee Surrealists. More than any of the others, Matta acted in a liaison capacity between the older Europeans and the group of younger Americans to become known as Abstract Expressionists (he was particularly close to Gorky and Motherwell). Matta remained a Surrealist, however, and his paintings invariably include images that function symbolically.

To Escape the Absolute, painted in 1944, suggests the deep space that is so often a part of Surrealist compositions. Typical of Matta, however, is the luminous character of this space and the numerous linear iconographic elements which fill it. Linear pat-

terns had appeared in his paintings at least two years earlier, but are much more fully developed here. They occasionally form planes and even become three-dimensional in some instances. In certain areas lines, planes, and bone-like forms converge to hint at fantastic, demonic creatures— biomorphic images, but with mechanical overtones. The elaborate network of lines may have been originally inspired by an exhibition of non-Euclidean geometry seen by the artist in Paris in 1937, or perhaps in the web of white cords which filled the main gallery of the 1942 Surrealist exhibition held in New York.*

*William Rubin, Introduction, *Matta* (exhibition catalogue; New York: Museum of Modern Art, 1957), p. 7.

89 Roberto Matta (Echaurren),
 To Escape the Absolute

Finally, the title and the painting itself seem to imply that it is by a continuous act of self-definition that man invents himself and his world to escape the flux of a non-differentiated universe.

Born and raised in Holland, Willem de Kooning still betrays an old-world attitude toward influences on his art. Rather than insist on his uniqueness, he has modestly acknowledged the influence of Gorky and —through Gorky—of Miró, Picasso, and Ingres. Yet the truth probably is that there was a two-way, back-and-forth flow of influence between these two friends.

Around 1940 the figure of a woman began to play an important role in De Kooning's compositions. In 1944 he completed one of the most elegant of these early figures called *Pink Lady*. Painted in a thin technique, it is both linear and "painterly." Its colors are those that have always been favored by the artist: reddish pink, green, and yellow. The spirit seems almost rococo, even though the image begins to evidence traces of the vulgarity and cruelty of later versions of the same figure.

90 Willem de Kooning, *Pink Lady*

In contrast to the baroque spirit of De Kooning's painting, Fernand Léger developed a style using images of massive immobile figures and precise, machine-like forms interlocked in tightly integrated compositions recalling the works of artists such as Giotto, Piero della Francesca, Jacques Louis David, and Seurat. *Big Julie,* painted in 1945 while the artist was in this country, dramatically demonstrates his admiration for the mechanical forms and dynamism of the New World. He is reported to have remarked: "... in America all is rough and strong like the climate." Long before the existence of "Pop" art he expressed admiration for the virile "bad taste" of the commercial culture of America and he insisted that he did his best work in this country. *Big Julie* is the culminating version of the "Bicyclist" series done during 1944-1945.

1945 YALTA CONFERENCE TAKES PLACE. MUSSOLINI KILLED. HITLER DIES, PROBABLY BY

91 Fernand Léger, *Big Julie*

In 1913, at the age of nineteen, Stuart Davis exhibited five water colors in the Armory Show in New York. This event provided his first opportunity to see at first hand and be influenced by avant-garde European art. In 1928 and 1929 he was in Paris, and from that point on his work is clearly in the Cubist tradition.

Most of his compositions, like Léger's, use motifs such as billboards, posters, store fronts, and other paraphernalia of the commercial world. Crisp shapes and intense colors contribute to the staccato, "jazzy" character of these works, evoking the analogous qualities of modern American popular culture. The flat shapes which make up the composition of *For Internal Use Only* contrast with Léger's weighty, modeled forms; although the mature works of both artists are derived from Cubism, they use bright flat colors and similar themes. The French painter seems to have been impressed with the driving power and rough strength of America, while the American delighted in its sharp, syncopated rhythms —its vitality and energy.

Davis has written: "I have enjoyed the dynamics of the American scene for many years, and all my pictures . . . are referential to it. They all have their originating impulse in the impact of the contemporary American environment."

92 Stuart Davis, *For Internal Use Only*

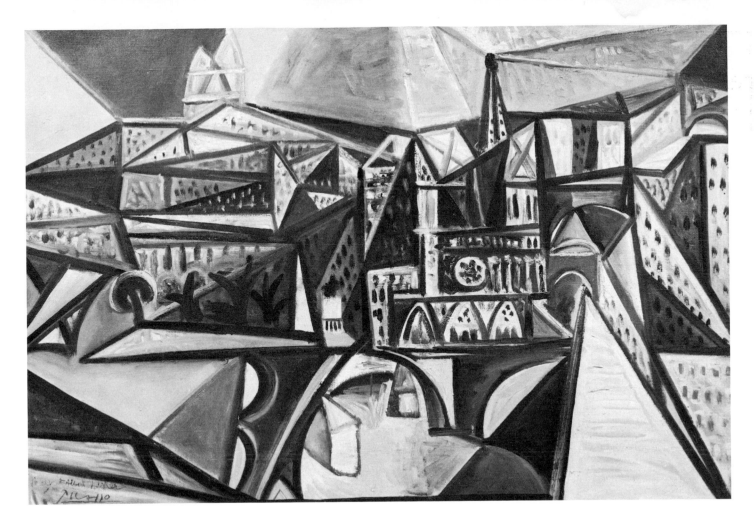

During the closing months of the war in
Europe, Picasso began to do paintings of the
city of Paris. In particular he did the *Ile de la
Cité, Paris* and the surrounding city. How-
ever, he arbitrarily rearranged the land-
scape and the layout of the buildings so
that, for example, the Madeleine joins the
Cathedral of Notre Dame in one view.
Painted in shades of gray, the buildings,
bridges, river, and quays are defined by
heavy lines forming a pattern of angular
shapes; and the rapid brush of the artist has
created various patterns and textures loosely
suggesting those of the natural forms.

Always sensitive to events around him,
and expressing his feelings in his art, Picasso
here seems to have been going through a
period of relaxed and optimistic confidence.

93 Pablo Picasso,
Ile de la Cité, Paris

94 Pierre Bonnard, *Dark Nude*

Pierre Bonnard died in 1947 at the age of eighty. Just three years younger than Toulouse-Lautrec, he has at times been wrongly considered to be a second-generation Impressionist. His method and his aims were entirely different from those of Monet, Renoir, Pissarro, and company. The light, rich colors that he applied—like the Impressionists—in small patches were not intended to convey a convincing impression of nature and light, but rather to create a rich, mosaic-like surface, primarily decorative in character. Where the Impressionists aimed for objectivity of vision, Bonnard was subjective and sensuous.

This artist was one of the few in history who had a long and consistently productive career, and whose work always remained on a high level of quality. Of equal interest are his landscapes, his intimate paintings of quiet, bourgeois interiors, and his opulent nudes. Like Degas, he painted the female nude in unguarded moments in the bath or bedroom. Unlike the older artist, however, he was obviously sympathetic with his subject. *Dark Nude* is one of the most richly colored of all these canvases. Background and figure meet on the picture plane in a richly resonant orchestration of warm, luminous tones. "Accurate drawing," as usual, is sacrificed to the demands of color and of design.

Bonnard, like the other Nabis, was much influenced by the art of Gauguin and by his theories as conveyed by Paul Serusier. More than the other members of this group, however, he was also impressed by the late works of Monet, the sensuous surfaces of Renoir's canvases, and above all by the flat, decorative qualities of Japanese prints.

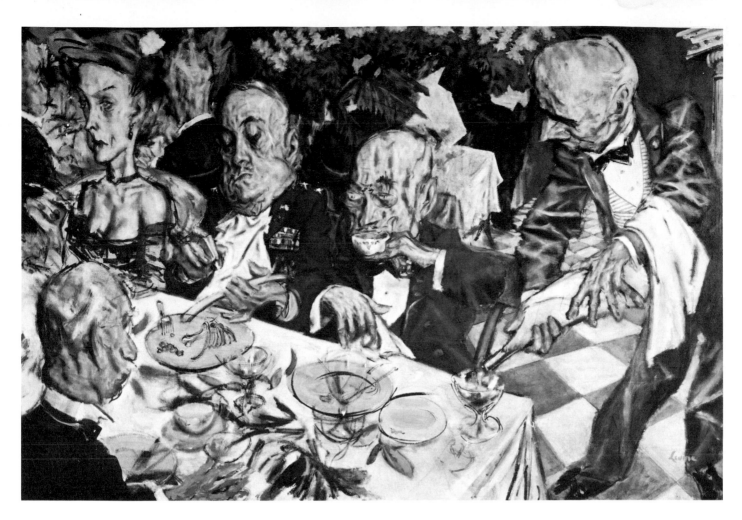

The years immediately following World War II offered many subjects suited for the bitter, satirical paintings of Jack Levine, one of the younger artists to achieve prominence with paintings devoted to social problems. Politicians, war profiteers, and the upper echelons of the military were among his favorite targets at this time. *Welcome Home* is a biting, ironical comment on the fatuous, self-satisfaction of certain kinds of "big brass" following the war.

Social comment and satire have often been used by artists, but only rarely have these efforts resulted in works of high artistic merit. Levine is important precisely because, like Daumier and Goya, he is first of all a painter. Stylistically and technically his art is related to that of German Expression-ists such as Kokoschka and certain sixteenth-century Mannerists such as El Greco and Tintoretto, as his distortions of drawing and space, his particular use of glazes and scumbles, and his fluid, sinuous brushwork testify.

About this painting, the artist has said: "That painting actually isn't so much of an attack on the army as an expression of great joy at getting out of the army. . . . In a word, this painting . . . is a comic Valentine to the upper echelon of our armed forces."

95 Jack Levine, *Welcome Home*

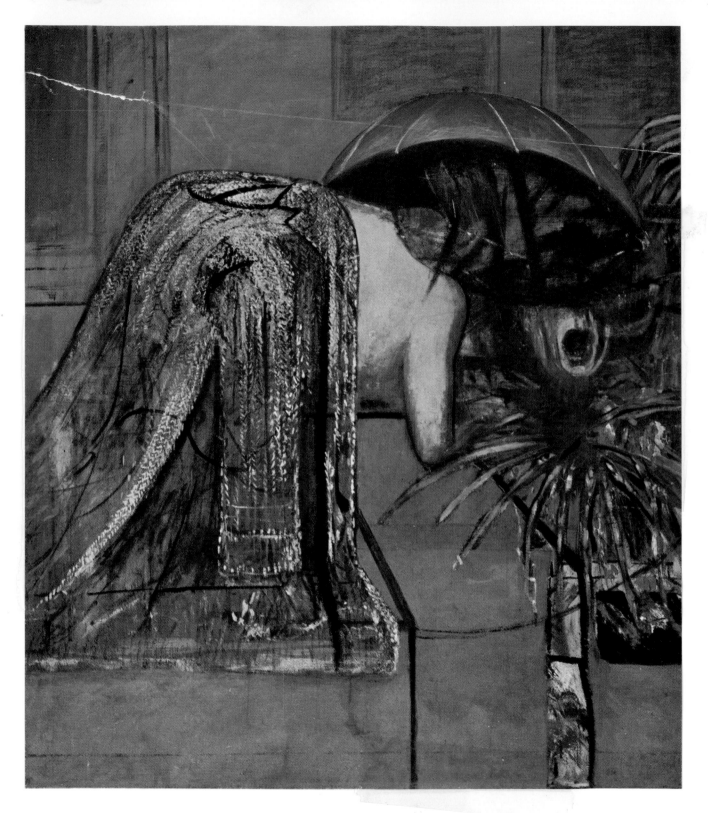

T NUREMBERG. CIVIL WAR BEGINS AGAIN IN CHINA.

Francis Bacon is a self-taught painter in the tradition of Goya and Van Gogh with obvious influences from Surrealism and certain kinds of paintings by Picasso. There are also distinct similarities between his work and that of his friend Graham Sutherland. Perhaps the fairest description of their relationship, however, is one that also applies to that of Picasso and Braque during the early Cubist period: there was a cross-fertilization rather than a one-way influence.

Bacon's bizarre figures are wrenched out of shape, twisted, and disjointed; mouths gape in soundless screams, and sometimes even headless bodies appear. The repugnance and horror such images inspire are probably the result of responsive chords being struck in our own subconscious. It is difficult at first to understand, for example, why an umbrella, a spikey plant, and a peculiarly textured garment in an early work, *The Magdalene,* should seem so nasty. A closer look reveals that a disembodied head with gaping mouth rests above the spikey leaves of the plant which echo the ribs of the umbrella and suggest the legs of some repulsive insect or, perhaps, a splash of blood. The scaly texture of the garment is reptilian, and between the disembodied head and the garment is an area of thick, pulpy, pallid flesh: the upper part of a human body bending over from the waist.

The image is loathsome, but—the artist would probably reply—no more so than reality.

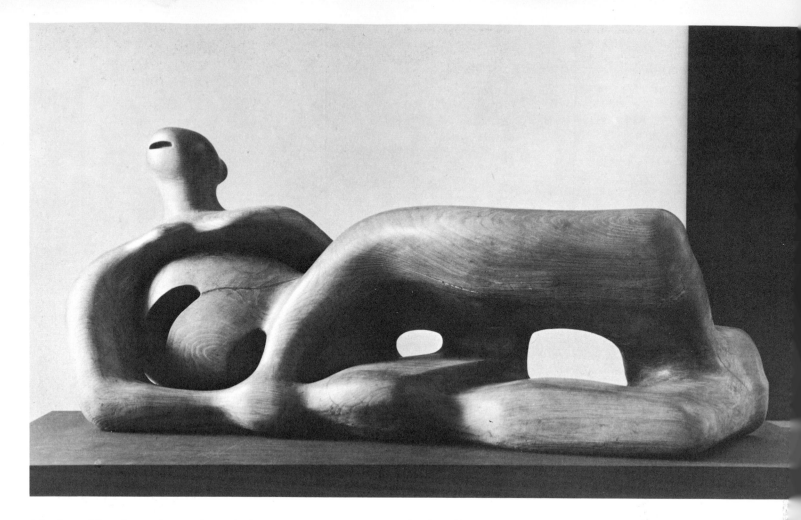

A basic problem for modern sculptors is the integration of space and form. Calder describes space with his mobiles; the Constructivists defined volumes of space in architectonic structures; the British sculptor Henry Moore involves space by opening up holes in his biomorphic images. *Reclining Figure* is one of the major works on a theme that the artist has carried out in many versions in wood, cast metal, and stone. The human figure is defined in a series of rhythmical relations between solid forms and voids. The open areas are developed with as much consideration as the positive masses. Formally, this work demonstrates Moore's involvement with the problem of correlating internal and external forms. Iconographically, it illustrates his continuing concern with a female image suggesting the ancient theme of the "Great Mother."

This artist has always been interested in natural forms such as bones and pebbles: objects which—especially when shaped by time—seem to possess a significance for human experience. Such things have influenced his sculptures, but only when they can be related to his "form interests at the time." In a sense, then, Moore has accepted the Surrealist notions of the hidden significance of natural shapes, the central role of intuition in perceiving such meanings, and the analogous character of primitive and mythic images.

Note: Condition of the sculpture necessitated withdrawal from the exhibition.

97 Henry Moore, *Reclining Figure*

Arshile Gorky was among the American artists who were in contact with the Surrealists during the early forties. At this time they brought together Surrealist notions concerning automatism, subconscious imagery, and the role of myth in art with a Cubist-based tendency toward abstraction. During the mid-forties and early fifties the art of these Americans reached maturity. In 1947 Gorky completed a number of his most important works, among them a large drawing entitled *Summation,* two versions of a painting called *The Betrothal,* and the painting *Agony.*

This enormously gifted Armenian-born painter was a long time arriving at a fully developed personal style. His earlier works were strongly influenced by Cézanne, Picasso, Miró, and Stuart Davis. Around 1943, however, he began to work in a more direct and spontaneous way, and by 1947 he was absolute master of his means. An enormously skillful draftsman and a sensuous colorist, his images (like Miró's) are lively and vaguely suggestive of a personal mythology based (like Chagall's) on childhood memories.

The Betrothal, II is painted in thin, rapidly brushed layers of cream, yellow-orange, white, light blue, and lavender. The biomorphic shapes—often sexually suggestive—are defined with sure, clean contours. The images are, in this case, rather easily identified. For years Gorky had been fascinated with the image of a horse and armored rider. He kept a photograph of Uccello's *Battle of San Romano* pinned to his studio wall, and he had done numbers of sketches of the subject. In this painting the main figure, occupying the left-center foreground area, is of a horse and rider. The light, warm, sensuous tonality of the painting is invaded in the lower right-hand corner by dark, ominous tones similar to those in *Agony.*

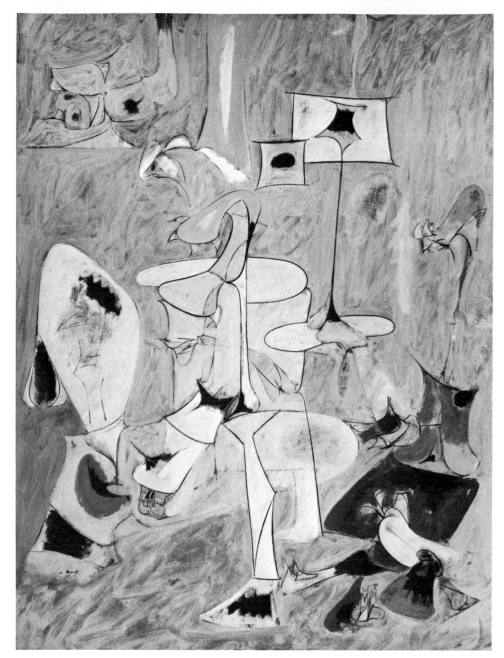

98 Arshile Gorky, *The Betrothal, II*

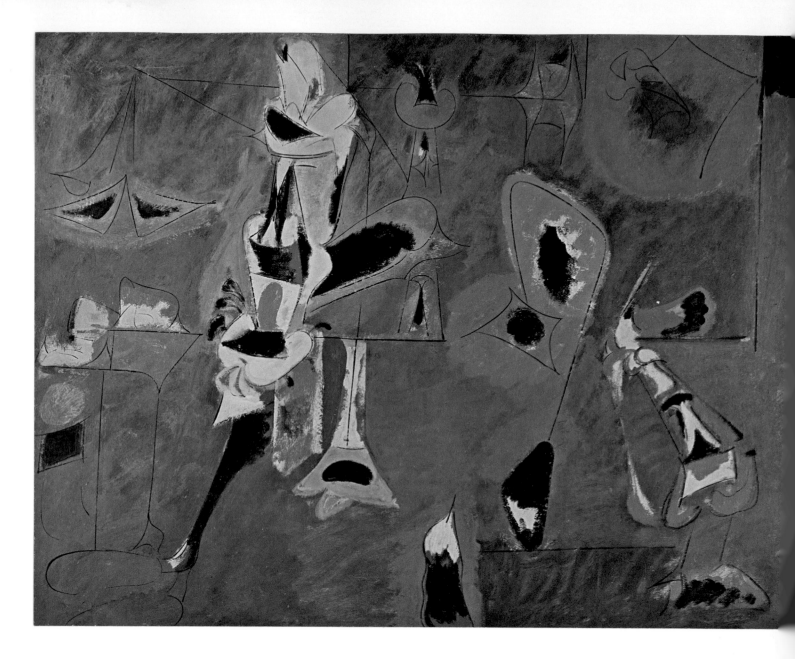

The smoldering reds and purples, cold yellows, and blacks in *Agony* establish a dark and tortured mood. The space appears to be enclosed (perhaps the interior of the family home of Gorky's wife) and filled with fearful shapes. This was a period during which a succession of catastrophes occurred, culminating with the artist's suicide in 1948. In 1946 his studio burned, destroying much of his work, and he was operated on for cancer. During the year that followed he underwent irreparable blows to his physique as well as to his domestic life. Finally his neck was broken in an accident, depriving him of the use of his painting hand. The work of art communicates nothing specific about those cumulative tragedies, although they must have conditioned the character of the painting through the state of mind and mood of the artist. This is of secondary importance, however, for many artistically undistinguished and even vulgar works have also been produced in sincere attempts to express such emotions.

99 Arshile Gorky, *Agony*

Gorky and Jackson Pollock were largely responsible for the birth of Abstract Expressionist painting in America. Yet, like Picasso and Braque in relation to Cubism, they remained aloof, for the most part, from all attempts to organize the movement itself or any activities related to it. Gorky remained essentially Surrealistic. Pollock pursued his own unique method based on the Surrealist notion of automatism. The early totemic and mythic images such as occur in paintings like *Pasiphaë* gave way in 1947 to complete abstractions painted in a freely swinging method of dripping paint onto large expanses of canvas placed flat on the floor. *Cathedral* is the first of his major works to be completely liberated from representational images. It is also the first instance in which Pollock introduced silver paint as a color along with oils and duco. The artist repeatedly expressed his belief in the act of painting itself as a source for the content and meaning of the work of art. In a sense, the freely dribbled or flung paint of these works is the visual evidence left behind of the vigorous and graceful movements of the artist.

The idea of a painting created like an oration, through a series of preparatory sketches and drawings always with the final effect in mind, has been completely given up. The structure of the work of art is determined during the process of its creation. It is a form determined by the actions of the artist working with the exigencies of the moment. Like the process of life, that of painting is conceived as being open; chance and the actions of the artist provide the way to the final work of art. Thus, the form created—invented every step of the way—is far from the realization of a pre-existing idea; indeed, the idea comes into being with the form.

Cathedral is chaste in color and upsurging in movement. The elegant, rhythmical, flickering surface is an open, aerated web of pigment that has not begun to coalesce into new images as happens in *Out of the Web* of two years later or the climactic *Blue Poles* from 1953.

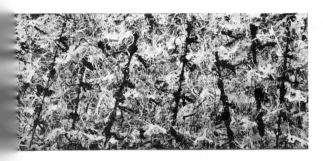

100 Jackson Pollock, *Cathedral*

Jackson Pollock, *Blue Poles*
Collection Mr. and Mrs. Ben Heller
(Photo: The Museum of Modern Art, New York)

Perhaps the last important influence from France on the art of the United States was Matisse's late *découpées* (cut paper pictures). The forthright designs, sharp-edged shapes, clear, intense colors, and frank acknowledgment of the flat surface in these lyrical works had an impact on artists such as Robert Motherwell. The technique was dictated to some extent by the artist's arthritic condition, but the spirit of a sensuous joy in life is perhaps clearer than ever before in works such as *Bunch of Yellow Flowers*.

Also clear is that Matisse is a pictorial artist and not a decorator. Even in a technique and a material that—more than just lending itself to decoration—almost forces the artist to work in purely decorative terms, he has made pictures—the exact equivalent of easel or mural paintings. Even more, it must be recognized that in this last burst of creativity, the artist solved completely the problem of dealing with pictorial form on a flat surface in an extremely shallow suggested space. This problem presents some difficulties in certain earlier works but with the large *découpées* Matisse demonstrates himself its absolute master.

101 Henri Matisse, *Bunch of Yellow Fl*

David Smith's sculpture parallels in some ways the canvases of Abstract Expressionist painters—particularly in its open and daring spirit. Like Roszak, he pioneered in the use of welded metal (although both followed Julio Gonzalez and Picasso in this technique) and in bringing together certain characteristics from Cubism and from Surrealism. His early postwar sculptures, such as *Royal Bird*, were often linear, like drawings in metal (recalling certain works by Gonzalez and Lipchitz), thus involving space as a major element in their form. The spikey, aggressive character of this sculpture and its image are characteristic of the works of this period and contrasts with the massive forms and power of his later abstract sculptures.

Although the artist acknowledged a technical debt to Gonzalez, his works are more robust than that of the Spanish artist. Both learned their skills as industrial welders, but Smith helped build big American locomotives, while Gonzalez began as a fabricator of wrought-iron objects.

102 David Smith, *Royal Bird*

103 Theodore Roszak,
Recollection of the Southwes

Theodore Roszak, *Spectre of Kitty Hawk*
The Museum of Modern Art, New York

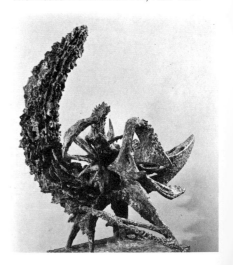

Among the sculptors associated with the Abstract Expressionist movement, Theodore Roszak is distinguished by a combination of technical skill, romantic themes, and a controlled method. The very nature of the problems attendant on the making of sculpture, particularly the recalcitrance of the material, determine that it cannot be done as freely and spontaneously as painting. Roszak has always worked out his images in drawings and carefully controlled their realization in metal. He has remarked: "There is a constant interaction between material and ideas and there is no denying that the work of the hand can itself inspire ideas. This incidental effect of the material is valid when it keeps a proper relation to the whole. The ideas it suggests are accessory to the inner creative effort that is in control."

Recollection of the Southwest brings together rough, spikey motifs suggesting wings, beaks, and bones. The sculpture does not tell a story, but its form, image, and material seem, like *Spectre of Kitty Hawk,* to imply a connection—or parallel—between the cruel, aggressive aspects of nature and our technological age. Roszak makes it clear that for him forms do not evolve during, and out of, the act of creating; rather, they are preconceived and go through a process of development and metamorphosis that is largely conceptual, although partially conditioned by the material. Perhaps his emphasis on formal structure grew out of his own earlier work when he was strongly influenced by Constructivist ideas and methods.

Although Constructivism received much of its early impetus from the efforts of Vladimir Tatlin, it was Pevsner's brother, Naum Gabo, who was mainly responsible for fully working out and defining the theories and methods of this movement in the period just after World War I. In the years that followed, the two brothers gradually evolved individual styles as they refined the original Constructivist ideas—ideas dealing mainly with the definition of space as a major element in sculptural form through the use of new materials and the application of engineering principles.

In 1948 Pevsner created *Construction in the Egg,* a complex organization of curved planes and spaces based on an egg shape. Bundles of bronze rods organized in curving sheets define the complicated, intricately interacting planes. Both light, reflected from the metal surfaces, and space play major roles in the total form, while the egg motif relates the notions of cell and growth to that of form.

Ad Reinhardt, an American painter of the same generation as the Abstract Expressionists, has steadfastly opposed all Surrealist and Expressionist influences, to remain an abstract painter in a severely classical tradition. *Abstract Painting, 1948* is a mural-sized canvas in which precise, rectangular shapes and clean, flat colors reveal a "purist" attitude which has been constantly refined as the artist has simplified his compositions and his palette. The intense hues of this canvas and their relations create visual tensions similar to, but preceding by many years, the wave of so-called "Optical" painting. Later works by Reinhardt are simpler in composition and are often painted in analogous hues (in some instances a single color) with extremely close values.

The artist has written: "Perhaps pure painting is a direct experience and an honest communication. Perhaps it is a creative completeness and total sensitivity related to personal wholeness and social order because it is clear and without extra-aesthetic elements." Thus serious artistic expression for this artist is purely aesthetic—at least it is aesthetic before it is anything else.

105 Ad Reinhardt, *Abstract Painting*

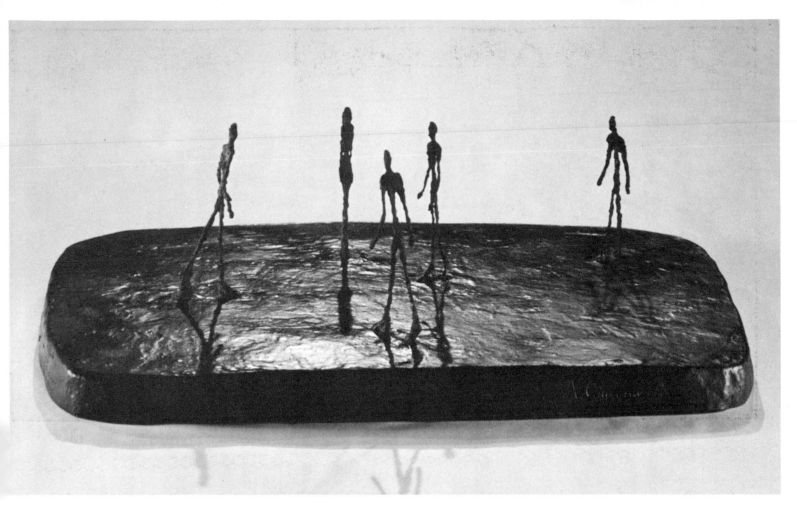

Like many contemporary sculptors, Alberto Giacometti conceived space as one of the major elements of sculpture. He did not, however, define it with a complex structure (Constructivists), describe it with moving parts (Calder), or open holes in his forms (Henry Moore). "Space is hollowed to build up an object," he wrote, "and in its turn, the object creates space." This is to say that simply by being there the form measures and gives scale to the space around it. Several figures define a more extensive and complex space. The problem is technical and artistic but also psychological and even philosophical. Rodin's *Burghers of Calais,* for example, are united psychologically by an intense, single purpose. The world in Giacometti's time, however, has

been vastly expanded and depersonalized. The problem has become one of unifying individual forms compositionally, relating them spatially, and at the same time expressing the profound sense of aloneness and anxiety which "existential" man feels as he confronts a universe without comprehensible limits, form, or purpose. Most poignant in his aloneness is the city-dweller—the man who lives within large and complex social, political, economic, and architectural structures, yet dwells in psychological isolation.

City Square is one of a number of small group sculptures in which the positions of the figures relative to each other and their role in defining space is a primary consideration. As Sartre has remarked, "It forces one to look at it from a distance for only

106 Alberto Giacometti, *City Square*

then can the spatial character of the sculpture be seen." The rough, corrugated surfaces and blank, expressionless faces give the attenuated figures a particularly uningratiating character which contributes to their air of remoteness from one another and from the observer.

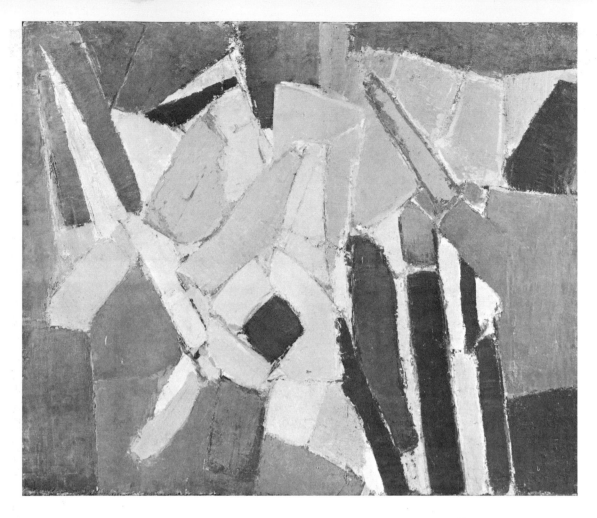

Nicolas de Staël, a French painter of Russian birth, brought a classical, Mediterranean spirit to post-war art in France. After a period of abstract painting based partly on the geometrical compositions and lyrical colors of Orphism, De Staël returned to representational forms. It is clear, however, that long before 1952, when this return became evident, his compositions were no longer completely abstract.

Rue Gauguet, painted just before his so-called return to nature, reveals De Staël's typical method of applying paint in heavy layers—almost as though with a trowel—to build up the broad planes of his composition. The precisely related and balanced tones of gray and rhythmical sequences of shapes create an insistent resonance and a structural order which take such paintings beyond the elegance and pure decoration that has characterized much Western European painting in the years since World War II.

107 Nicolas de Staël, *Rue Gauguet*

Jean (Hans) Arp, one of the founders of the Dadaist movement in Zurich, was the most versatile artist of that group. The negativism and destructive elements in Dada were not congenial to his nature, however, and in the mid-twenties he joined the Surrealist movement in Paris. Although André Breton's leadership was apparently too rigid and doctrinaire for Arp's taste and he did not remain a member of the group, certain aspects of the Surrealist position concerning man's relationship with nature have always remained incorporated in his attitude.

It was not until around the early thirties that Arp began to do free-standing marble sculptures. From then on, however, he has continued to work in this medium as well as making cast bronzes and relief sculptures. One of the simplest yet most profoundly expressive of all the marbles is called *Silence*. It recalls no specific natural forms, yet its warm tone and subtly modeled curves seem almost to breathe. It is an evocation not of a thing, but of a poetic quality of human experience.

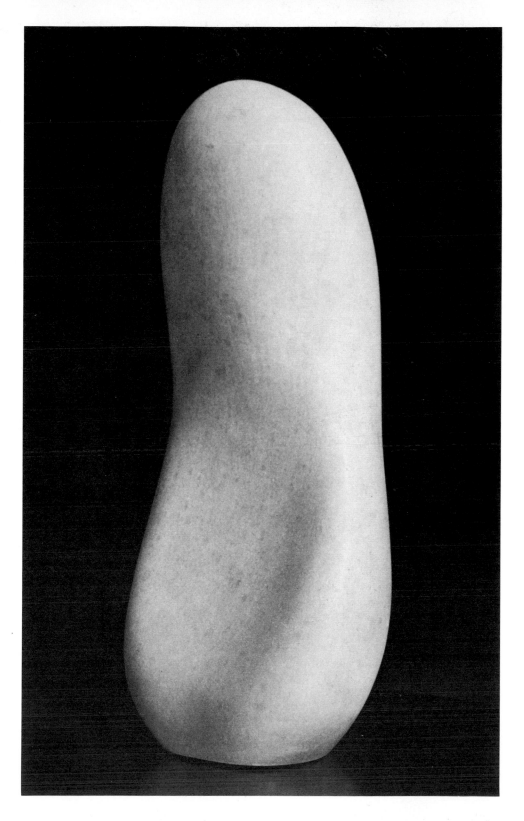

08 Jean Arp, *Silence*

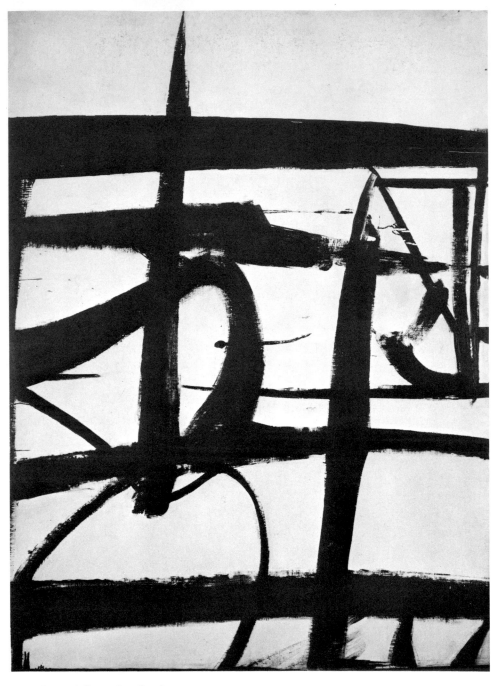

Franz Kline's compositions are usually made up of wide, black bars and flat, white shapes. Often, as with De Staël, it seems that the image must be related to nature—perhaps has originated there. This is not of great consequence, however, and if true, the image was usually lost during the process of developing numerous sketches and of manipulating the paint.

The edges where the black bars and white shapes meet are frequently abrupt, but there are occasional rough or fuzzy areas where they merge. The opaque pigment emphatically establishes the flat surface of the canvas and the white shapes have a prominence on that surface, which paradoxically denies their role as space behind the black structure. In Kline's most successful canvases, such as *Cardinal,* the vitality of the black and white image is created by visual tensions which also contribute to its order.

109 Franz Kline, *Cardinal*

Andrew Wyeth stands in the romantic-realist tradition of American art. Son of the famous illustrator N. C. Wyeth, his works depend largely on literary values. He has been relatively unaffected by developments in Western art during the early twentieth century, being neither much involved with the formal qualities of painting nor with subconscious images. On the other hand, he is concerned with the visible aspects of the world and with human problems and relations.

The Trodden Weed is painted in the artist's usual meticulous technique, reproducing every detail of appearance. The particular success of this work however, depends on a degree of ambiguity in the "story" allowing some latitude for the viewer's response and interpretation. The booted legs of a solitary figure are seen striding through a field, treading a long, elegant, and delicate weed underfoot. The painting does not seem to deal with deliberate destruction of natural beauty as one might at first think; instead it depicts accidental, if careless, destruction. The implications concerning the relationship of man and nature reflect a sense of spiritual malaise relating Wyeth to artists as different as Hopper and Giacometti.

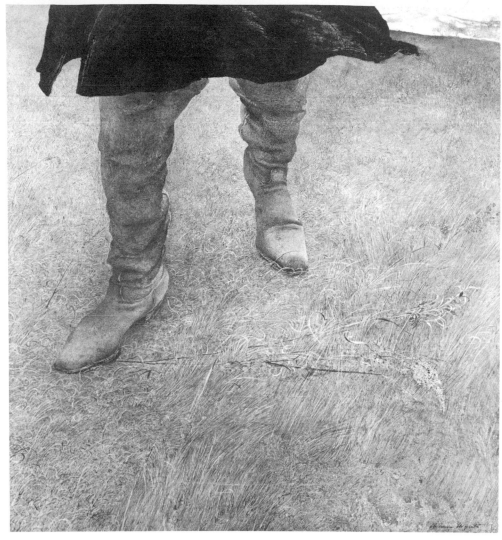

110 Andrew Wyeth, *The Trodden Weed*

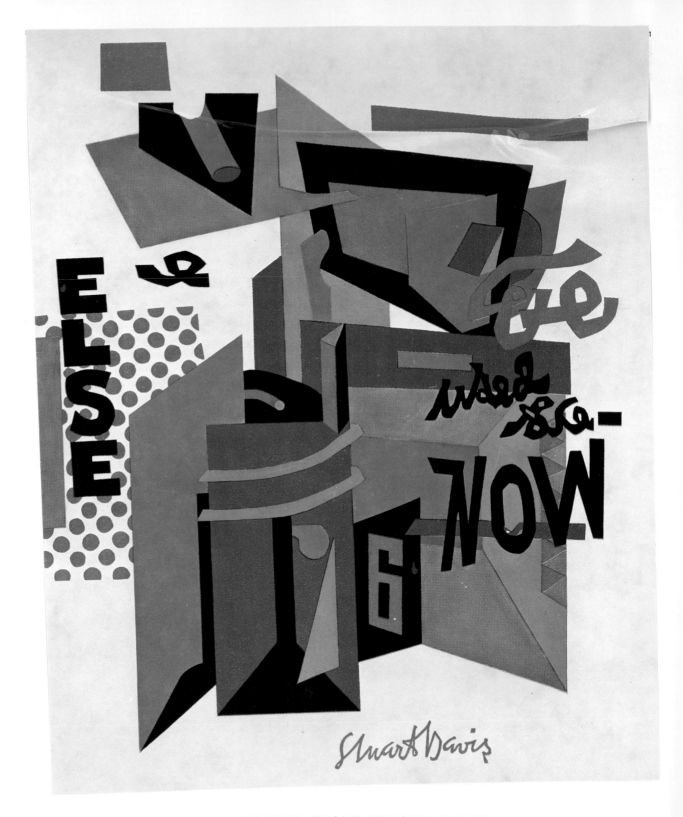

Stuart Davis

Owh! in San Pao by Stuart Davis is another of the works of the 1940's and 50's when his art was at a peak of brilliance and clarity. As usual, he took motifs from the modern, urban, commercial landscape which he found constantly stimulating. He adapted lettering and other devices taken from bill-boards, signs, and posters, thus preceding ''Pop Art'' by many years. His canvases of this period are painted in high-keyed, in-tense hues with sharp contours and angular shapes evoking the staccato rhythms, vi-tality, and brilliance of big city life and the jazz music that he loved.

111 Stuart Davis, *Owh! in San Pao*

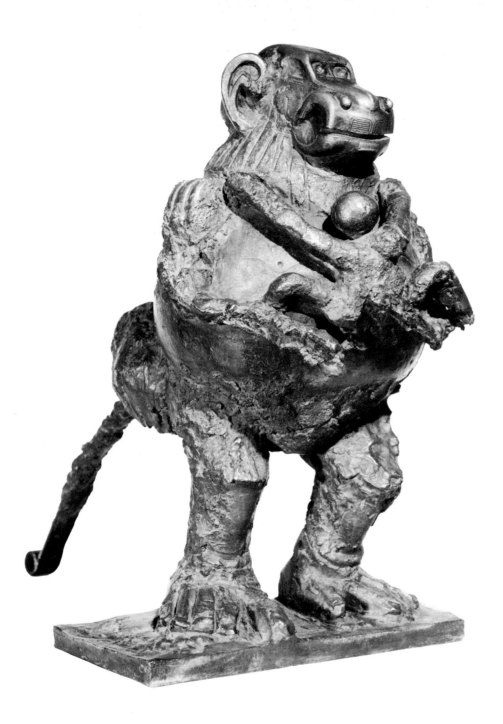

Picasso was now creating in a happy and playful spirit, doing paintings such as the mural-sized *Joie de Vivre* and sculptures such as the *Monkey and Her Baby*. The latter is one of the most amusing of all his works, as well as being a vigorous image of fertility and a marvelously "sculptural" form. As he so often does, the artist joined various objects with clay, completing a new image which was then cast in metal. The head of the monkey, for example, is two toy automobiles, the tail is a spring, and the body is a large pot (or ball).

If Picasso had never painted, made prints, or pottery, he would remain an important figure in the history of art as a sculptor. From around 1906 on, he has worked sporadically at this art, completing a large number of important works over the years. It is only possible to mention such works as a Cubist *Woman's Head* from 1909; the *Glass of Absinthe* from 1914; the *Metamorphosis* from 1929; an abstract welded metal *Head* dated 1931; a magnificent female *Head* from the early thirties; the *Skull* and *Man with Sheep* from the early forties; the *Goat* from 1950; several cast metal still lifes of flowers from the early fifties; and the group of *Bathers* from the mid-fifties; as well as many others.

112 Pablo Picasso, *Monkey and Her Ba[by]*

The only artist who truly challenges Picasso for the right to be considered the dominant painter of the first half of the twentieth century is Henri Matisse. He is an artist who reminds one of Mozart in that his art seems to possess the capacity to expand almost indefinitely in depth and range. Like many of the truly great artists of history, he found in his old age hitherto-untapped reserves of creative energy. Crippled with arthritis, he developed an incredibly vigorous and joyful style in the technique of découpage (cut paper). Lying on his back in bed, sketching with charcoal fastened to the end of a stick, on paper suspended overhead and working with cut shapes colored with gouache according to his directions, Matisse created some of the most joyous and noble compositions of this, or any other, time.

In 1951 he designed murals, chasubles, windows, and furniture decorations for the Dominican Chapel at Vence. These gay designs, like that for a window *Poissons Chinois,* demonstrate the lyrical splurge of the splendid twilight of this artist's career. They also bring to a fitting conclusion the Fauvist tendency (which Matisse initiated) to juxtapose broad areas of pure tone to create the most lively and intense effects. Matisse soars blithly above the dark and fearful events of his time. His art is a perpetual challenge to the pessimistic mood and sense of estrangement and anxiety that sometimes seem to dominate the age.

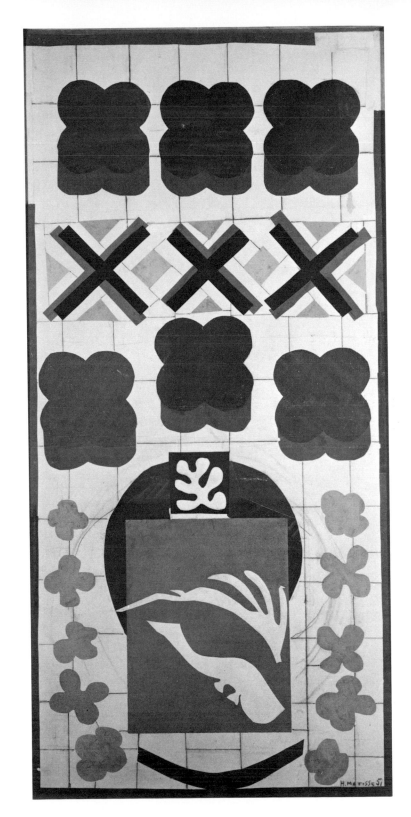

113 Henri Matisse, *Poissons Chinois*

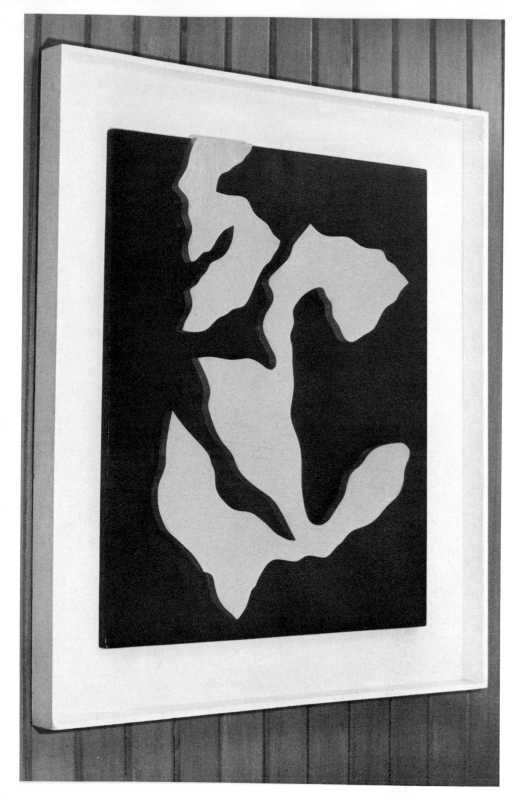

In addition to sensuous marble and cast bronze sculptures in the round, Jean Arp has from the beginning made reliefs. Usually these are of cut-out and painted wood but more recently they have frequently been of metal.

The early reliefs and cut-paper collages often used squarish or rectangular shapes, reminiscent of Mondrian's early abstractions. Later reliefs such as *Configurations* are made of more gracefully curving shapes similar to those of the free-standing sculptures. Implicit in all Arp's work, however, is the ambition to create forms as ingenuously and non-intellectually as does nature. Man is himself a part of nature and his artistic products, according to Arp, must aim at a humble recognition of that position rather than attempting to bend nature to his will by force of intellect. Thus the forms that this artist creates recall natural forms, but do not imitate them.

114 Jean Arp, *Configurations*

Among American painters who came to prominence during World War II, Willem de Kooning has an important position. A close friend of Arshile Gorky while that artist was alive, he possesses the same order of ability as a draftsman, as well as being a distinctly "painterly" artist. As Sam Hunter has suggested in his book *Modern American Painting and Sculpture,* the "headlong, linear" style of De Kooning probably derives originally from Surrealist automatism. With De Kooning, however, this method reveals a concern about direct action taken in the present world, rather than a trust in the efficacy of the method to reveal subconscious images. Such painting renounces the notion of pre-existing, encompassing period styles. The idea of style is accepted as valid in an individual sense only. Each artist invents his style as he chooses his problems and acts to solve them. Indeed, the artists often aim to reinvent their style with each new work. Thus, a paradox (and bad paintings) results whenever artists try to adopt the appearance of the Abstract Expressionist "style." For there is no such thing; there is only a way of thinking and acting in art—and in life.

During the late forties and early fifties De Kooning became increasingly involved with the theme of a female figure. *Woman II* is one of the major canvases in this series. Some are elegant and "rococo," others (like this one and *Woman I*) are "baroque" in the sweeping vigor of the brushwork and the ample forms. Sometimes the figures are clearly defined; at other times they are almost lost in the complex of interweaving brush strokes. A great deal has been written about the significance of these brassy, vulgar figures with vapid expressions and cowlike bodies, but whatever the implications of the images may be, they are invariably painted with vigor, sureness, and elegance.

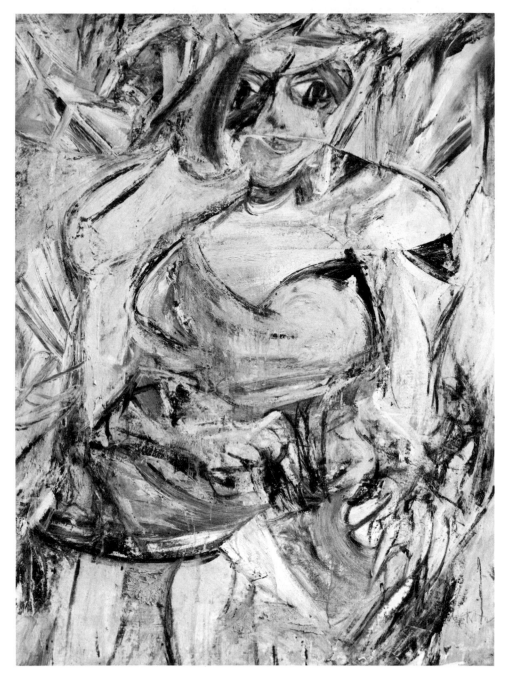

115 Willem de Kooning, *Woman II*

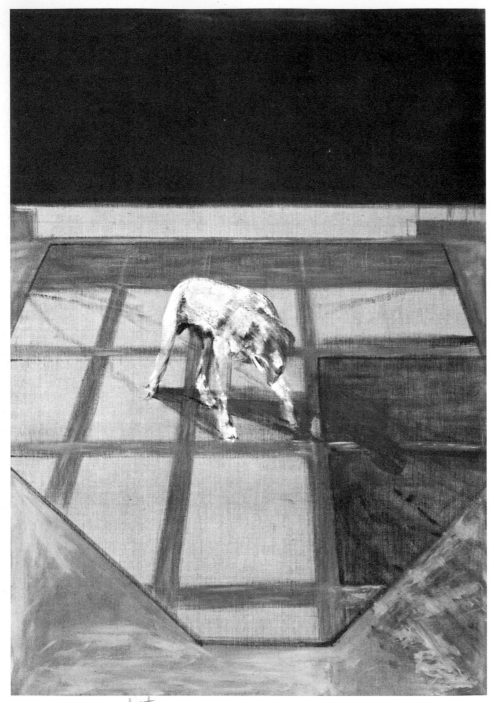

A more malevolent image is *Dog* by the British artist, Francis Bacon. The slightly blurred form of the virulent "cur" stands alone in the center of a strange grid beneath a lowering black sky. The image corresponds to nature; this is not a monster, but a dog. Yet it breathes the air of the grotesque. It is a fearful, nasty, disgusting brute that has nothing in common with, for example, Balla's little, trotting dog. Partly, one's response is due to its hyena-like posture, blurred features, and lopping tongue. The repulsive character of the image is reenforced by the cold colors and the viscous quality of the paint. Like Edgar Allen Poe, Bacon uses the grotesque, the loathsome, and the macabre as subject matter for his art. And, also like the writer, he is an artist of power and skill.

116 Francis Bacon, *Dog*

Graham Sutherland's works also contain macabre images revealing the same Surrealist origins with overtones of traditional British Romanticism as those of his compatriot, Francis Bacon. Among them are distorted vegetable, mineral, and insect forms. When he began visiting the Mediterranean region regularly after the war, he found a whole new world of subject matter in the gnarled roots, tangled bushes, twisted trees, prickly stems, and jagged leaves that abound there. They provided the basis for the strange part-crustacean, part-vegetal figures that he invented. Even when he has painted what appears to be a semi-human image such as *Head III,* for example, it metamorphoses into an insect or reptilian figure. The cruel mouth (sharp beak and teeth), flat, anxious eyes, and cold, acerb colors contribute to its malevolent character. Such images are pictorial metaphors referring to the artist's inner experiences inspired by nature.

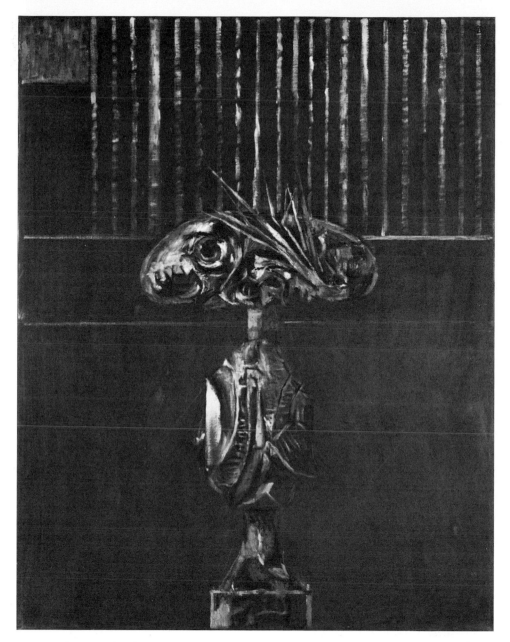

117 Graham Sutherland, *Head III*

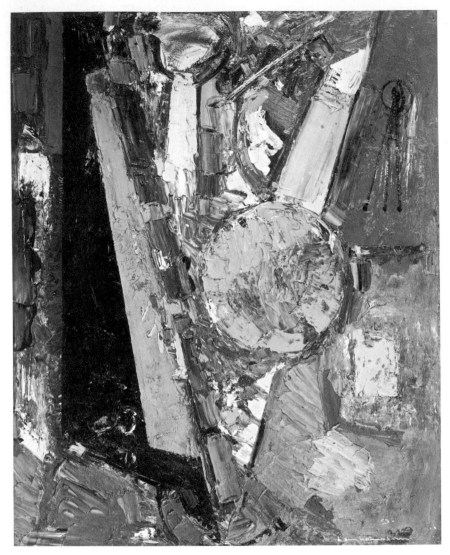

118 Hans Hofmann, *Composition No. 10*

Two German-American artists—Joseph Albers and Hans Hofmann—have exerted a direct influence on American painting in the twentieth century, yet their points of view and styles are diametrically opposed. Albers, student and professor at the Bauhaus, is precise, clear, orderly, and methodical, while Hofmann, follower of the Secessionist movement in Germany, is vigorous, ebullient, spontaneous, and emotional.

After studying and working in Munich, the Bavarian mountains, Italy, and France, Hofmann came to the United States in 1930. He taught first at the University of California, then at the Art Students League in New York, and finally founded the Hofmann School in New York in 1934 where he had many students who later achieved outstanding success.

Hofmann's techniques and methods vary considerably from work to work. Some are thinly painted and linear while others appear to have had the pigment trowelled on. In all his canvases, however, there is a sense of vigorous action and of space.

Despite its relatively modest size, *Composition No. 10* fully demonstrates Hofmann's attitude, particularly concerning color. Brilliant reds, blues, yellows, and greens are applied in a heavy impasto, creating flat planes that establish the picture surface. These dissolve at certain points along their edges into small, irregular, broken shapes providing transitions for the larger areas that are otherwise distinct from—even opposed to—one another.

The vigorous upsurge of the dominant V-shape is here balanced by the self-enclosing, hovering circle. In a judicious counter-statement to the colorful, painterly, over-all character of the composition, an incisive, linear motif repeating the V-shape in inverted form and with another circle at its apex appears in the upper right-hand section.

"Art," says Hofmann, "is for me the glorification of the human spirit . . . The deepest purpose of art is . . . to keep the spirit of man lastingly young in a world constantly fluctuating. Art must counterbalance the banal weight of everyday life; it must give us the constant aesthetic joy we need."*

*Quoted in *Dictionary of Abstract Painting* (New York: Tudor, 1957), p. 190.

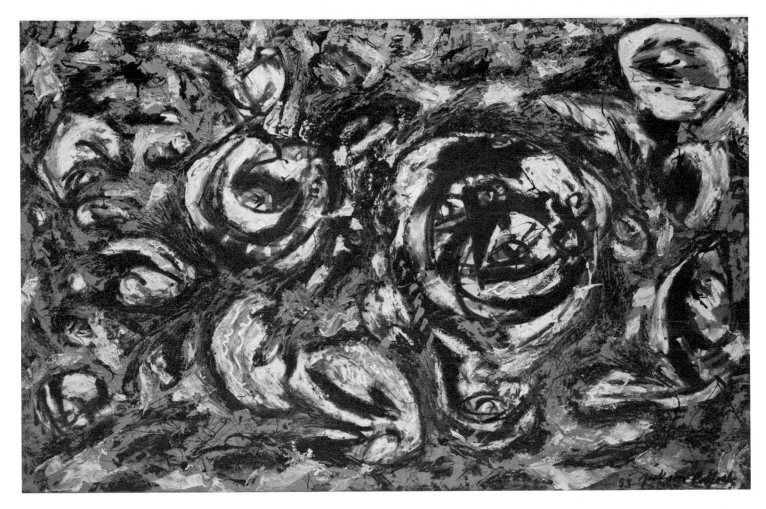

Following the period of totemic imagery and that of completely abstract, spontaneously painted "drip" pictures, Jackson Pollock did a series of canvases worked with a heavier, more dragging hand. The lines of the earlier paintings are thickened and in certain areas coalesce to create shapes vaguely suggesting images. Perhaps Pollock went through a process paralleling that of Cubism some forty years earlier: a stylistic and methodological evolution proceeding from representation toward abstraction and finally on to the re-emergence of images. In both instances, however, the figures of the last phase were no longer derived from nature or conceptions about nature; it was rather the configurations of the paint which stimu-lated images in the mind of the artist and which he then developed.

The repeated swirling shapes of *Ocean Greyness,* for example, along with the cold, gray tones inevitably evoke the sensation of surging movements which accord with the suggestion of the title.

Cubist methods of defining space on a flat surface by means of overlapping and merging planes parallel to the picture surface and Surrealist emphasis on spontaneity and intuition in the creative act as a means of discovering forms and images in the human subconscious were both fully accepted by Pollock. Thus, compositional order and content evolved and were "discovered" during the process of painting.

119 Jackson Pollock, *Ocean Greyness*

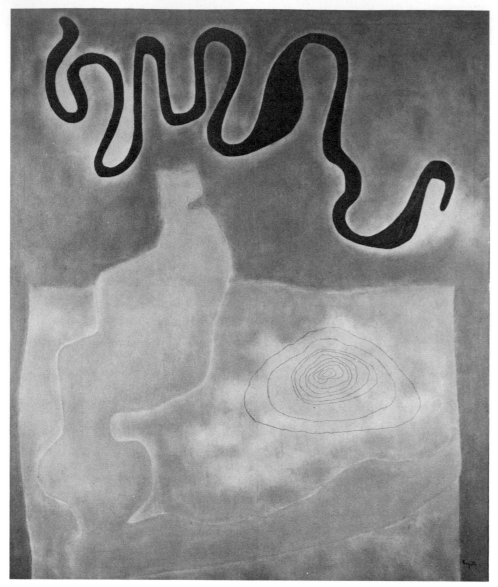

Among the original Abstract Expressionists was William Baziotes, an artist more influenced by the doctrines of Surrealism than most of the others of this group. Closer in method and style to Gorky than to Pollock or Hofmann, his paintings—*Congo,* for example—are developed with thin glazes and scumbles of color emphasizing contours and creating irregular, flat shapes which evoke a sensation of living forms without actually representing them. His works are always highly controlled in execution and demonstrate a consistent evolution of personal style.

"Look back—look now, poet, to your friends. There they stand in the past. The lonely village eccentric—Cézanne. The pathetic mad Van Gogh. The arthritic suffering Renoir, who could say, 'the pain passes, but the beauty remains.' And in our day, is there not something grand in the aged Matisse dreaming his dream of the joy of life? Or the famous and wealthy Picasso, painting the furies of the heart that only those condemned can ever feel? Or Miró, singing his fantastic songs about the moon, when all men walk with their eyes cast upon the ground? There they stand, artist—your friends.

"And when the demagogues of art call on you to make the social art, the intelligible art, the good art—spit down on them, and go back to your dreams: the world—and your mirror."*

*From "The Artist and his Mirror" in *Right Angle,* III (June 1949), p. 23. Quoted in the catalogue, *New York School,* p. 11.

120 William Baziotes, *Congo*

Robert Motherwell has always retained an affinity for French Symbolism as well as for the art of Matisse. During the early 1940's he was largely responsible for developing ties between the emigré Surrealists and some younger American artists. At this time he did much to bring together Cubist-derived concerns about pictorial space and surface with Surrealist notions about subjective experience as a source for artistic content. The continuing respect for pictorial form and surface composition have served as a control on the raw power of the paintings from his "Elegy" series. There are now more than one hundred of these works, all composed of the same basic elements: black, vertical bars compressing lozenge or egg shapes between them on a white ground.

Motherwell's use of literary titles reflects his insistence on the metaphorical content of his art. The form of the work refers to the artist's subjective experience, and the title provides a kind of clue to the event that stimulated that experience—it tells what the artist felt "this way" about. Thus, he involves extra-artistic considerations in his canvases while avoiding explicitly literary images.

In *Elegy to the Spanish Republic XXXIV* the broad, irregular, black shapes hang down from the top of the canvas compressing the lozenges between them. A few drips of black pigment run into carefully worked out and heavily pigmented white shapes. Small areas of ochre, red, and blue only emphasize the stark blacks and whites that are defined with uncompromising clarity. Responses to the painting must almost inevitably be described in such terms as heavy, grave, threatening, despairing, solemn, ominous, and dignified. These no more than roughly indicate the "direction" of the picture's content, however, for painting is the artist's medium of expression and his meaning is inevitably couched in its terms.

Mallarme's Swan, for example, is lighter and more elegant, seeming to parallel in spirit the French Symbolist's poem "The Dream."

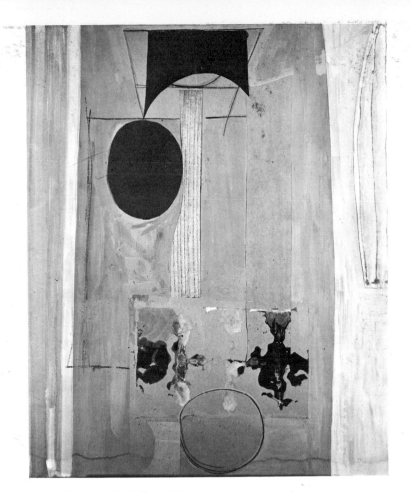

Robert Motherwell, *Mallarmé's Swan,*
The Cleveland Museum of Art

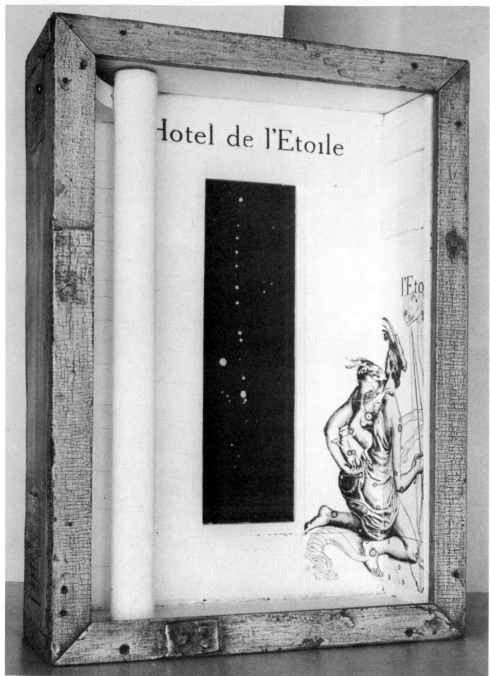

Auriga is a northern constellation containing a brilliant star Capella. Auriga was known as the "charioteer" to the ancient Greeks and was symbolized by a man in a sitting or kneeling posture with a goat and kids in his left hand and a bridle in his right. Among Joseph Cornell's boxes bearing the legend "Hotel de l'Etoile" is one of particular beauty entitled *Night Skies: Auriga*. The astrological sign to the right measures its complexity against the serene clarity and simplicity of the white column to the left. Between, through a long, vertical aperture are seen the dark night sky and crystalline star group. Black night, brilliant stars, white column, and myth combine to create a magical atmosphere.

123 Joseph Cornell, *Night Skies: Auriga*

There are no complex symbols, astrological charts, astronomical maps, architectural plans, or other furniture in the box entitled *Night Owl*. There is only the sober, white, glowing image of the owl within the dark, rough-textured interior of the box and the frame of bark. The essence of the fearsome, night hunting bird is suggested in the direct, ingenuous expression of a child which cuts through to the heart of the matter, yet it is controlled by the taste and intellect of a mature artist.

124 Joseph Cornell, *Night Owl*

Twenty-one round, white plates of various sizes move in numerous directions describing volumes of space and presenting innumerable combinations of the major theme. *Snow Flurry, May 14* may well have been inspired by precisely the event indicated by the title. Calder is often inspired by experiences of such natural phenomena. His masterly control of a complex system involving a multitude of interrelated movements has never been better demonstrated than in this major work. Again—it bears repeating—Calder is the inventor of a new art, a sculptural art involving space and movements in various directions partially determined by the artist's control over connections among parts, and partly by chance in the form of random movements of air. The mobile is a work of art and a system symbolizing the perfect synthesis of man and the natural world—of intelligent control and random, chance events.

125 Alexander Calder,
Snow Flurry, May 14

Of the British sculptors who emerged in the immediate postwar years, few have retained the human figure as a subject. Reg Butler, the eldest of this group, however, has been absorbed with the figure throughout the evolution of his style, never abandoning it. Trained as an architect and with extensive experience as an ironsmith, his first sculptures were spindly, spidery figures forged and welded from iron rods and bars that showed the influence of Moore, but even more particularly, of Julio Gonzalez. In the 1950's he began to develop a fuller, more corporeal treatment of the human figure. The Manipulator is one of the early examples of the move towards closed, modeled forms and sensitive surface treatment which he has since extensively investigated. Two modes of thinking exist side by side in the work of Reg Butler and can be seen in The Manipulator: one is a rigid, linear construction carried over from earlier works; the other is a solid, organic treatment of volumes usually reserved for the human figure. In his slightly earlier, well-known project The Unknown Political Prisoner, these two modes are separate and isolated. In The Manipulator, however, there is an active interplay between the two, creating a tension and tautness reflected in the gestures of the figure.

The figure suspended in space remains a constant and enduring theme for Butler: "... all my life I have only been concerned with four sculptures: a girl figure—usually standing, a man—usually small headed, usually doing something, a kite figure—'figure in space'... and boxes."*

Another constant factor in the sculptor's development is the displacement of the "center of gravity" and the creation of an upward drive by the energy of gesture. In The Manipulator the upward glance of the figure, suspended in space on a tenuous network of lines, creates a sensation both disturbing and profound. It is disturbing because the traditional pyramidal organization of "weight" is apparently reversed; profound because the strained upward look and the ambiguous—and ominous—"machine" in the manipulator's hands imply a paraphrase on the human condition which cannot be ignored. R. W.

*Letter to Addison Page in Reg Butler: Recent Sculpture (New York: Pierre Matisse Gallery, 1962), p. ix.

Reg Butler
The Unknown Political Prisoner
The Museum of Modern Art, New York
Saidie A. May Fund

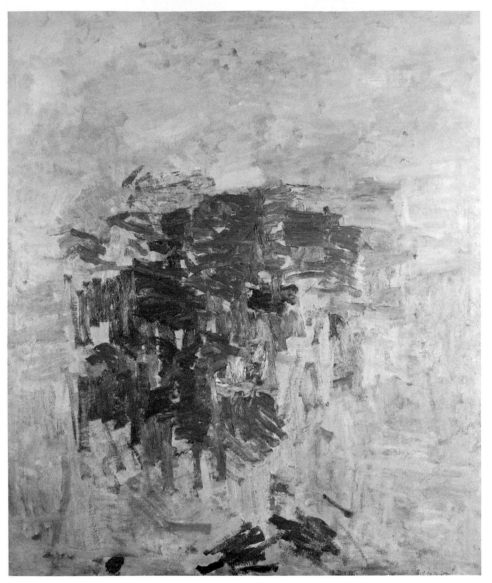

Philip Guston shares the interests and attitudes of certain of the Abstract Expressionists, particularly regarding the actual process of painting. For these artists, the drama involved in the creative act has replaced concern for the appearance of the finished work. The constant necessity of making choices of crucial importance while working, and the willingness to risk all that one had already achieved and mastered while repeatedly venturing into new areas of expression are of central importance. Guston's work at this time is particularly related to that of Pollock and De Kooning, two other painters for whom brush stroke has always been a major expressive element. In the early fifties, his brushwork was light, sensuous, and flickering compared with the swirling movements of Pollock and the vigorous, choppy strokes of De Kooning. Around the mid-fifties, the period of *The Room,* there seems to have been a tentative search for the solid volumes that the artist had earlier preferred; at this time, however, they coalesced within the shimmering surface suggesting space and light. The brush strokes became firmer, broader, and were compacted into denser areas of color somewhere near the center of the canvas and bleeding off toward the edges.

127 Philip Guston, *The Room*

Louis Bleriot was the French inventor of the airplane. Robert Delaunay painted a large *Hommage à Bleriot*. Joseph Cornell's box *Bleriot* is a visual poem created by the artist because Louis Bleriot existed and acted with a certain heroism, and Cornell knew about him.

The open space of the box is invaded only by the clean form of the wooden trapeze and the coiled spring. Like Brancusi's *Bird in Flight, Bleriot* is a visual metaphor, illogically but poetically evoking the essential experience of mechanical flight. Perhaps the trapeze suggests the eternal yearning of man to fly, perhaps the spring implies mechanics, perhaps the bare box symbolizes space; but in the hands of a lesser artist perhaps the result would be a dull bit of prose rather than a poem, an homage to a man's heroic conquest of the air.

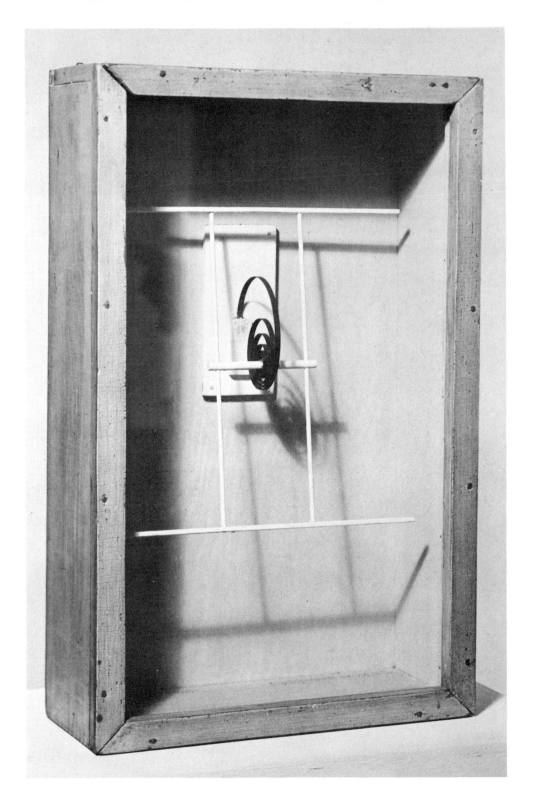

128 Joseph Cornell, *Bleriot*

STAEL DIES.

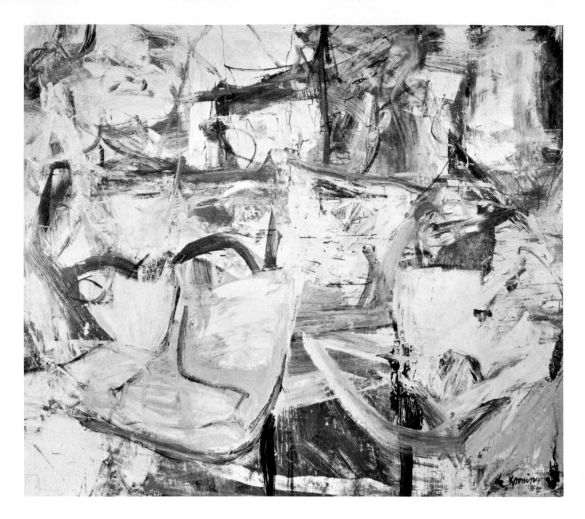

During the same period, the mid-1950's, De Kooning's paintings became more abstract. At first they seem completely so, but soon it appears that images are probably present even if not explicit. In *Saturday Night* hints of figures and space are defined by the interaction of planes. As many as three figures seem to be present—although it might be argued that they are read into what are only abstract shapes and colors. Finally, one recognizes that with such artists this is not a central question. Their paintings may be considered as either abstract or figurative, for the content and quality of the paintings does not depend on a "story" told by means of iconic images; it is rather the flashing movements of the bravura brush, the structure composed of integrated planes, and the

129 Willem de Kooning, *Saturday Night*

quality of color that provide the painting with "meaning," and these are present whether or not one sees figures.

There is no question about images in paintings by Jasper Johns; they are present and obvious. The mysterious and evocative *Target with Plaster Casts, Large White Flag,* or *Grey Alphabets,* for example, present exactly what the titles say. In the last instance, this is a series of lower-case alphabets running horizontally and vertically across the canvas and painted in tones of gray. The images chosen by this artist are almost invariably trite and mundane: numbers, targets, flags, maps, and alphabets. They are subjects that in life are normally flat, precise, and hard-edged; yet they are rendered by this artist in a technique that rivals Abstract Expressionism in painterliness. There seems to be a basic paradox in this vigorous and elegant painting of signs and signals that are clichés. One is reminded of stories (no doubt apocryphal) about actors who have moved their audiences to tears while reciting the alphabet.

Such painting, however, is far more than a simple *tour de force.* Implied is an attitude that is "cool," detached, emotionally uninvolved. The Abstract Expressionist painters claimed to make works of art with profound and poignant content while also being abstract. Johns might claim the contrary: that he makes works of art devoid of content while using signs, signals, and symbols with explicit meanings and (in the flags at least) inherently emotional connotations.

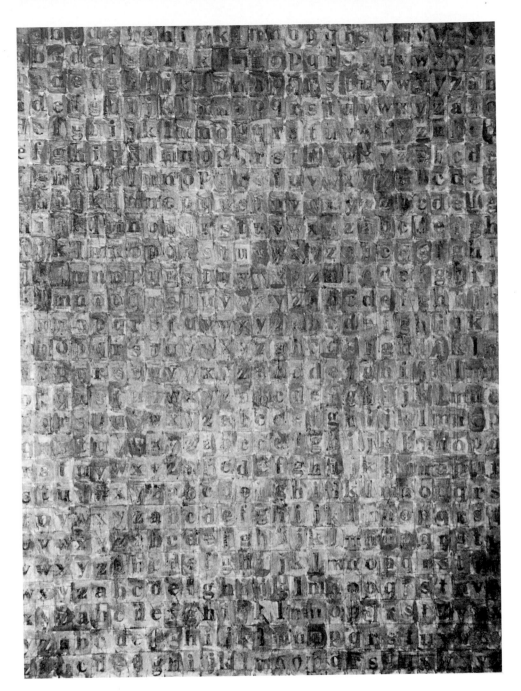

130 Jasper Johns, *Grey Alphabets*

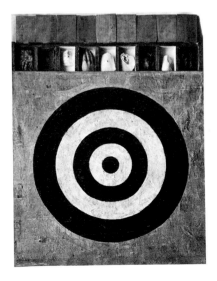

Jasper Johns, *Target with Plaster Casts*
Collection Mr. and Mrs. Leo Castelli

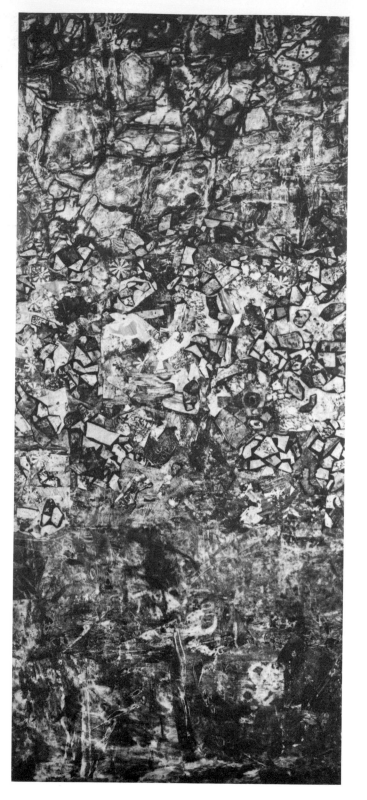

Dubuffet had started painting again during World War II. At first he did rough, primitive-looking, "brutal" figures. Since then he has worked in several different manners, concentrating on a few specific themes. In addition to the "Jazz Band" series he has done street scenes, portraits, a "Corps de Dame" series, "Texturalogies," collages made up of butterflies' wings, and collages of pieces of cut, painted canvas making up landscapes. *Lit de Debris au Pied du Mur* really belongs to this last group. The composition) as with Pollock's "drip" paintings) is diffused. There is no particular center of interest, and the complex surface is an overall pattern made up of small, crisp shapes and broad, soft shapes, cut-out shapes and painted shapes. Gradually one becomes aware of petal-like images, then eyes, and finally a multitude of minute figures and fragments of images.

Thus Dubuffet first engages the observer's attention, then draws him into the work of art by allowing him to take part in it, psychologically, through his discoveries and inventions.

131 Jean Dubuffet,
Lit de Debris au Pied du Mur

Josef Albers, one of the members of the faculty at the Bauhaus, has for many years worked to achieve the most varied and startling effects with what seems to be the simplest of means. In addition to the *Variants* of recent years, Albers has also done a long series of paintings entitled *Homage to the Square*. In this series of different-sized panels, the artist has painted over and over again squares within squares—sometimes three squares, sometimes four. They are uniformly closer to the base of the frame than to the top and sides. By varying the hues and values with which the squares are painted Albers suggests all manner of variations of movement, and of tensions. In some instances the squares seem to move in a series of steps back into the surface of the painting or out from it. In other examples, such as *Star Blue,* the values (degree of lightness or darkness) and the intensity of the hues are very close and appear to create visual vibrations. In *Star Blue* the blue square in the center and the yellow-green square are of almost exactly the same intensity, thus seeming to attract one another, creating a singular visual tension across the intervening cold green square. Which comes forward and which recedes? They seem to vary constantly, as an ambiguous but strongly felt space is suggested by means of relationships of values, intensities, and hues.

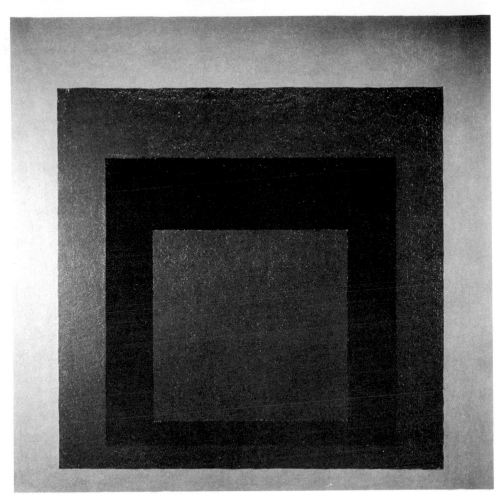

131a Josef Albers, *Homage to the Square: Star Blue*

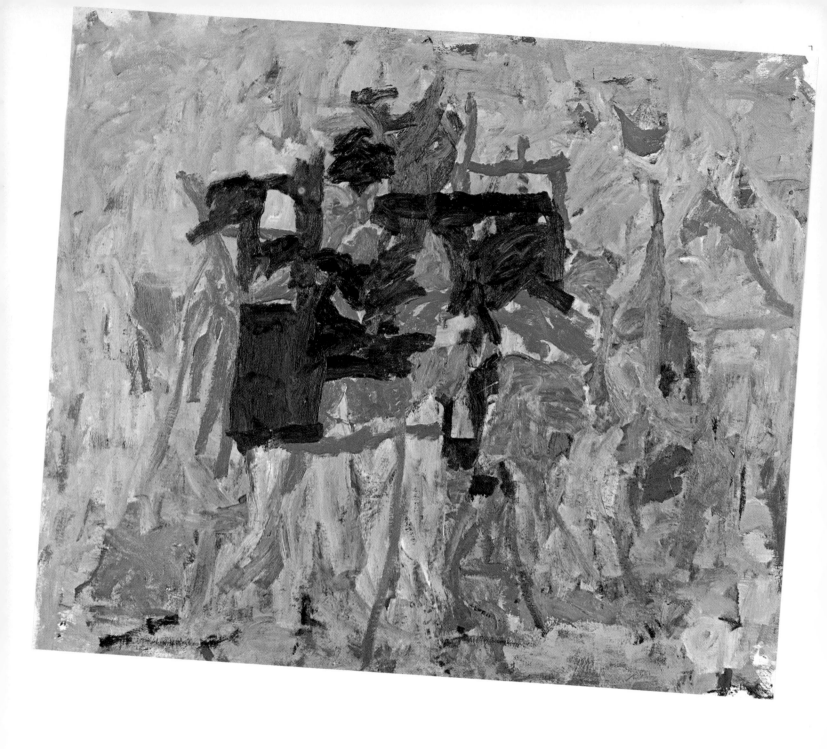

132 Philip Guston, *Sleeper I*

The rosy tones of Philip Guston's early abstractions were soon invaded by emerald greens and then by cold blues and grays, blacks, and blood red. The lightly flickering brush strokes became broader and heavier, coalescing into shapes, often suggesting figures.

In *Sleeper I,* for example, the brush strokes overlap and intermingle, creating grayed half-tones and blurred edges implying a quiet mood—perhaps of reverie—which is interrupted by the harsh blacks and reds. If such a work is the direct articulation in paint of the artist's feelings, then it suggests that for Guston the world had taken on a more somber and ominous tone. The work of art must finally be recognized, however, as an expression which acts in turn as a stimulus for experiences which each viewer must conclude for himself.

ITED STATES LAUNCHES ITS FIRST EARTH SATELLITE.

Since Degas—or at least Redon—no one has handled pastel with as much skill as Adja Yunkers. Born in Latvia and trained in Russia, Germany, and France, Yunkers came to the United States in the late forties and found himself allied in method and purpose with the American Abstract Expressionist painters. In the late fifties he completed a series of large pastels, which in scale, density of tone, complexity, and strength of composition are exactly comparable to oil paintings.

As *Sestina II* demonstrates, in this artist's hands the medium is painterly rather than a method of drawing with color. In a manner close to that of Guston's, the vigorous, rhythmical strokes of color interweave and coalesce to suggest images that seem to emerge from shadows and then recede as one tries to perceive their definition.

The title refers to a form of blank verse, invented by an eleventh-century, Provençal troubadour. It was a form used by Dante and Petrarch, cultivated in sixteenth-century France, seventeenth-century Germany, and then revived in the nineteenth century. Considering the rigorously ordered structure of this form, one might expect to find its formal counterpart in the visual work of art. Instead, however, it seems to have been the romantic spirit of the troubadour that interested the artist.

132a Adja Yunkers, *Sestina II*

Auguste Herbin was a painter who belonged to the generation of Cubists. After a short period under the influence of this movement, however, he returned to representational painting until 1926, when he began to work in a severe geometrical style related in spirit to that of Mondrian. Unlike Vasarély or Albers, Herbin was not primarily concerned with visual illusions based on color relations. Also, unlike Stuart Davis, whose art his own superficially resembles, he does not derive his shapes from the outer world of appearances. Herbin was a practitioner of that form of abstraction called "Concrete." Based on the theories of De Stijl, but using more varied geometrical shapes and colors, paintings such as *Lier* aim toward a rigorously logical and impersonal style. In this instance the basic motifs are the circle, triangle, and rectangle. All trace of the "handwriting" of the artist is carefully avoided. With these few elements repeated, varied, and echoed, the artist constructed a complex order, essentially flat, but with some slight development of space by means of overlapping shapes and the relative intensity of colors.

133 Auguste Herbin, *Lier*

In the 1940's Adolph Gottlieb joined Robert Motherwell and Mark Rothko in forming "The Subjects of the Artist" school in New York. The evolution of Gottlieb's mature abstract style begins about the same time with the "pictographs," using mythological and totemic images. In the early fifties he began doing "Imaginary Landscapes" with abstract shapes arranged to suggest a ground plane and sky. In the late fifties he began the important series of "Burst" pictures.

The "Bursts" are invariably composed of a disk hovering above an irregular, jagged shape. The canvases are large and the color, relative proportions, complexity, and density of the two shapes vary. They are compositionally related to the imaginary landscapes preceding them, but are less complex and more vigorous in spirit.

Exclamation is one of the first and most firmly constructed of this series. As with the others, however, the two areas are in dramatic conflict: a simple, still oval hovering above an irregular, energetic, jagged shape. Some observers have seen in these abstract figures ominous overtones of "the bomb"; others have thought they might imply male and female principles. The artist, however, seems content to regard them as abstract forms whose significance is restricted to the visual and painterly.

134 Adolph Gottlieb, *Exclamation*

Born in Los Angeles, reared in Japan and America, Isamu Noguchi went to Paris in the late 1920's to work in Brancusi's studio. This experience, enhanced by earlier training as a craftsman, was decisive for Noguchi. Its effect can be discerned in his *Woman with Child,* which owes much to Brancusi in the general conception of form and finish. Equally important, but not as immediately apparent, is the influence of Surrealism. Unlike Cubism, Surrealism is not a stylistic or formal phenomenon. It is an active process of confrontation: the animate and inanimate, dreams and reality, organic and inorganic are fused, the differentiation made between them dissolved. The artist uses whatever stylistic or formal means he finds suitable to achieve his ends. A "magical object" is created, charged with associations that evoke human responses. The *Woman with Child* is such a "magical object," able to yield continuously new implications with the greatest economy of means.

While this economy of means leads to simplification of form, Noguchi is not interested in pure abstraction. "Art has to have some kind of humanly touching and memorable quality. It has to recall something which moves a person—a recollection, a recognition of his loneliness, or tragedy, or whatever is at the root of his recollection. . . . It's the privilege of the artist to make his own translation, his own distillation of what moves him."*　　　　　　　　　R. W.

*Isamu Noguchi, in Katherine Kuh, *Artist's Voice* (New York: Harper and Row, 1962), p. 175.

135 Isamu Noguchi, *Woman with Child*

The possibilities opened up by the metal sculptures that Picasso and Julio Gonzalez did in the 1930's are still being explored by a generation of sculptors. One of the most original is Robert Müller, who began by studying with Germaine Richier. He soon evolved a style of his own, however, of which *Aaronstab* is one of the most powerful statements. Unlike many of his contemporaries, the constructive or fragmentary aspect of Müller's sculpture is completely subsumed under the creation of an organic entity: the whole becomes greater than the sum of its parts. The metamorphic aspect of most of his work is here even hinted at in the title. For the barren rod of Aaron *(Aaronstab)* in the Bible "was budded, and brought forth buds, and bloomed blossoms, and yielded almonds."

The effect of this transformation would be practically unthinkable in stone or wood. Iron is, in a sense, anonymous and the various "found" iron objects and shaped iron sheets, once incorporated, lose their individual identity and origin to make up another object obeying laws of its own. But the effect of the sculpture on the viewer is not only based on the fascination of this metamorphosis. Purely as an object in space, the *Aaronstab* sets up a series of powerful tensions, actively pushing and pulling at space to create an almost physical contact with the viewer. The sharp projections and pincer-like shapes evoke associations of hostility and menace. Yet the components never assert themselves. They are part of a manifold process of unfolding, of transformation, or change. R. W.

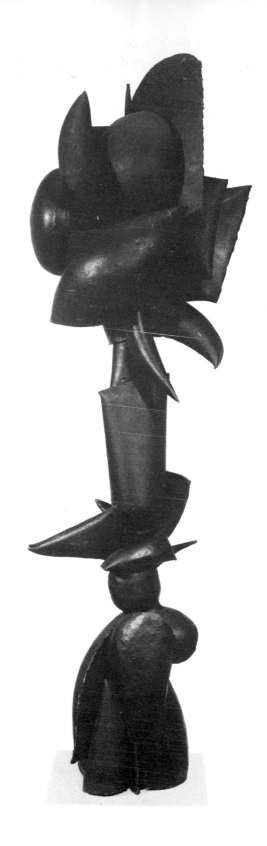

136 Robert Müller, *Aaronstab*

Hans Hofmann's technique varies considerably, but his paintings always give evidence of a direct, expressionistic approach to painting. The artist is primarily concerned with visual tensions established by opposing forces and their resolution, without diluting the strength of the main elements. *Smaragd Red and Germinating Yellow,* for example, opposes a flat rectangle of slightly acid yellow and a roughly painted background of deep reds and blues. The rectangle establishes the flat plane of the canvas and suggests severe, geometrical precision. The roughly trowelled-on background of rich pigments implies a contrasting romantic and emotional attitude and also suggests movement and space. A series of transitional passages rise upward and move sideways to the right from the rectangle. Thus diametrically opposed areas— and attitudes—are brought to a state of balance in tension and a resolution without compromise is effected.

137 Hans Hofmann,
Smaragd Red and Germinating Yellow

Richard Diebenkorn worked in an abstract style for several years before returning to figurative painting. Whether figurative or non-figurative, however, his works invariably define an ordered space with clarity and precision. They are painted broadly, not with a crusty impasto like Rouault's, nor variations of thickness as with Hofmann's, but with a uniform surface of flat areas of color.

The reintroduction of figurative themes brought with it a specific content. Like Hopper, Diebenkorn reveals concern for the aloneness—and loneliness—of man in the world. The older artist concentrates on vignettes of urban life, however, while the younger is more concerned with broad, flat, landscapes as settings for his figures.

Interior with Book, for example, defines clearly and exactly an interior space and a barren landscape. Within the enclosure are evidences of human inhabitance: a chair, table, plate, and open book. No figure is visible, but the human presence is felt. A peculiar and poignant atmosphere is created by these simple implements within the enclosed space and the vast, flat landscape outside. Both areas are bathed in a strong, clear light, creating a pattern of lights and shadows that contributes to the compositional order.

138 Richard Diebenkorn, *Interior with Book*

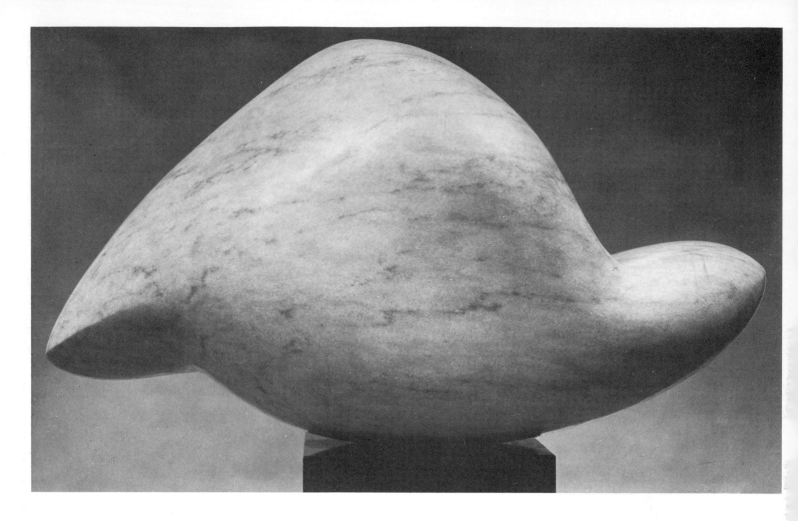

Jean Arp, as one of the original Dadaists and later a Surrealist, is theoretically allied to Giacometti, although their works are entirely dissimilar. The rough surfaces and air of anxiety in the Swiss artist's sculptures are replaced by Arp with smoothly polished, sensuously curved marble and bronze abstract forms. In appearance, they seem close to Brancusi's works. However, the older artist was concerned about revealing the essence of a particular subject, while Arp's intention has always been to create forms as gratuitously as does nature. He has aimed toward a sense of assimilation with nature, and to create forms that are entirely organic. They sometimes resemble figures, particularly with female attributes; often they suggest shells or rocks; and there are also plant-like forms which metamorphose into human images. The subtly curved form of *Fruit d'une Pierre (Fruit of a Stone)* seems almost to breathe. The simple, elegant curves and warm color suggest an organic nature while the hard material itself is, of course, unorganic. Thus the nature of the image—as well as the title—suggests a union of the living and non-living. In itself, this is not unusual since most sculptural representations of human or animal figures attempt to breathe the air of life into non-organic substances. Arp, however, has attempted to express in an abstract form the notion of the union of all existing things.

139 Jean Arp,
Fruit d'une Pierre (Fruit of a Stone)

Naum Gabo had laid the foundation for Constructivism with the sculptures that he did while living in Norway in the years 1915-16. In 1920, after having returned to Russia in 1917, he drew up the *Realist Manifesto* establishing the theoretical basis of the movement. During the same year, he produced what is probably the first modern kinetic sculpture. Since those early days, his work has never ceased to be constructivist in character. This is to say, his sculptures are neither modeled nor carved—they are constructed in engineering terms.

As works like *Linear Construction No. 4* demonstrate, he is concerned with the problem of rendering space visible, of making it the very material of his sculptural forms. In this instance the fine strings—or wires—create complexities of modeled space while preserving transparency of form.

For Gabo, however, his works are more than illustrations of scientific principles; they are in a sense models of the universe— the universe that science has revealed. "Those mentally constructed images are the very essence of the reality of the world which we are searching for."* Thus, although his means are entirely different, his aims parallel those of many Abstract Expressionist painters: to create metaphors of personal experience that will provide insight to the real nature of the world.

*Naum Gabo, from a lecture, "On Constructive Realism," delivered at Yale University, 1948. Quoted by Carola Giedion-Welker in *Contemporary Sculpture* (New York: George Wittenborn, Inc., 1955; from *Documents of Modern Art* series directed by Robert Motherwell), p. 160.

139a Naum Gabo, *Linear Construction No. 4*

Giacometti's *City Square* suggests the personal isolation of social man; the *Walking Man* evokes the overwhelming and mournful sensation of his total aloneness. Stepping forward fearfully, arms and hands held rigidly at the sides, with a blank expression and an excoriated body, this life-sized, emaciated figure is a veritable portrait of alienated, *Angst*-ridden, Existential man.

140 Alberto Giacometti, *Walking Man*

1960 JOHN F. KENNEDY ELECTED PRESIDENT OF UNITED STATES. FRANCE EXPLODES NUCl

Morris Louis, a painter of the same genera-
tion as the Abstract Expressionists, arrived
at a full realization of his mature style a few
years later than they. Of that group Mark
Rothko seems to be the only one to whom
Louis can be related. The parallel is re-
stricted, however, to the use of thin stains
of color that are absorbed by the canvas;
the "image" created by Louis differs con-
siderably from that of Rothko.

In 1959 and 1960 Louis' art was in process
of transition from freely flowing shapes to
stripes—or pillars—of glowing color. At this
time he painted a number of canvases with
irregular bands of color moving freely across
one another, creating what have been called
his "floral" compositions. The sensuous
veils of color in *Beth,* for example, compose
an elegant arrangement of glowing hues
and somber half-tones.

Louis' transparent and translucent shapes
overlap to create the illusion of a series of
movements back into space. It is a method
that contrasts with Rothko's parallel shapes
which contribute to the illusion of a project-
ing, rather than receding space. Louis main-
tained a more consistent "mood" than
Rothko. Although some of the canvases
from 1958 and 1959 appear rather somber,
the generally prevailing "feeling" is one of
lyrical joy.

141 Morris Louis, *Beth*

Following the first, vigorous black and white abstractions, Franz Kline's paintings often took on a softer, more "atmospheric" character. In a number of canvases, he even re-introduced color. His most successful efforts, however, still appear to be the "hard," energetic, black and white works such as *Turin.*

The composition is a structure of thrusting diagonal black lines and sweeping curves moving through the whites and breaking these areas up into exciting patterns which play a kind of visual counterpoint to the black bars.

Perhaps more than any other painter Kline created vigorous compositions that seem to explode off the surface of the canvas into the surrounding space. The black bars and open white shapes appear to move on and off the picture plane, rather than being contained within its edges. In a sense, such paintings continue Impressionist concerns with the fragmentary and the momentary, although they are related even more clearly to the driving force and energy of Futurist works.

142 Franz Kline, *Turin*

A Canadian working in Paris since 1946, Jean-Paul Riopelle brings an air of vigor and generosity to the post-war school of Paris. He began as a young man by painting landscapes, and many of his works still vaguely resemble nature. They are abstractions, however, which, as *Terre Promise* demonstrates, emphasize thick, rich pigment and a unique method of troweling it on in short, blocky strokes of the knife. It adds a creamy white to the usual rich colors, and the paint forms a heavy, unbroken membrane across the surface. The choppy rhythms of the blunt strokes contribute to a pattern of larger movements resulting finally in the suggestion of full-blown, explosive force.

Like the American Abstract Expressionists, Riopelle was influenced by Surrealism. It was after reading André Breton's *Surrealism et la Peinture* that he began to paint abstractions. And it was at this time that he began to conceive painting as a spontaneous action taken under compulsion from the unconscious regions of the mind.

143 Jean-Paul Riopelle, *Terre Promise*

Elegy to the Spanish Republic, 54 is another major canvas in the long series by Robert Motherwell devoted to this theme. The artist has also worked in a lighter spirit, and such lyrical works as *Mallarmé's Swan* contrast with the heavier "beat" of the "Elegies." Within the limits of the simple format, however, great diversity is accomplished. They range from "hard," severe, flat works such as *Elegy No. LV* to relatively "soft," curved, shapes and compositions which hint of space and atmosphere. Both the paintings included here tend toward the "hard" end of the scale. Number 54 lacks the colors of Number 34, but there are indications of space and atmosphere in the softly brushed areas along the top edge and beneath the right-hand black lozenge

or egg shape. Two such shapes are compressed between the bars on the right side and one between those on the left, creating a sense of oppression.

Sources for the images have sometimes been suggested: prison bars and the hollow black eyes of the imprisoned or the sex organs of a bull nailed to the sunlit wall of the ring. On the other hand it is insisted that they are no more than rectangular and oval shapes organized in a certain way.

The artist, however, has expressed his concern with content in the following words: "I take an elegy to be a funeral lamentation or funeral song for something one cared about. The 'Spanish Elegies' are not 'political,' but my private insistence that a terrible death happened that should not

144 Robert Motherwell,
Elegy to the Spanish Republic, 54

be forgot. They are as eloquent as I could make them. But the pictures are also general metaphors of the contrast between life and death, and their interrelation."* Again, he said "My Spanish Elegies are . . . free association. Black is death, anxiety; white is life, éclat. Done in the flat, clear Mediterranean mode of sensuality, but 'Spanish' because they are austere . . . Or so I suppose. Who really knows"?†

*Quoted in *An Exhibition of the Work of Robert Motherwell* (exhibition catalogue; Northampton, Mass.: Smith College Museum of Art, 1963), under repr. no. 16.
†*Ibid.*, p. 21.

Henry Moore has long been obsessed with the theme of a reclining female figure. From the first versions done in the early thirties to the most recent, he has evolved this image steadily toward an ever more obvious and convincing sculptural analogy between the figure and a landscape. *Three Piece Reclining Figure,* for example, presents a massive image in three sections, which also suggests rough cliffs, caves, and hills. The female figure is particularly apt for the metaphor, and Moore has fully developed the possibilities provided by its concavities and convexities. Indeed, as is usual for this artist, the holes and spaces have as much formal significance as the solid masses.

Earth and woman are thus joined in a poetic image that is probably as old as man himself. It is indeed a cliché so old and worn that only a great creative artist could invest it with new life and return to it something like its original authority.

145 Henry Moore,
Three Piece Reclining Figure

Eduardo Chillida first studied architecture
in Madrid before devoting himself to sculp-
ture. He worked in clay and stone before
discovering that steel was the material best
suited to his talents. He worked in Paris
from 1948 to 1951 and it was there that he
first began working in metal.

 He forges the steel himself and, as in
Whispering of the Limits, uses the metal
bars in an almost calligraphic way. It is an
austere sculpture, without detail and with-
out bulk—a bare, linear, structural form.
The metal bars are whipped, bent, torn, and
crumpled almost as though some giant ar-
tist had run rampant in a steel mill. It is an
art which in itself symbolizes man's enor-
mous new-formed industrial powers to wrest
materials from the earth and bend them
easily to his will.

146 Eduardo Chillida,
Whispering of the Limits

Richard Stankiewicz is a legitimate heir of artists such as Kurt Schwitters, Julio Gonzalez, and Picasso. Schwitters accepted the flotsam of a commercial culture as the raw material for his *Merz Constructions* and *Merzbau,* while Stankiewicz uses the cast-off metal of an industrial civilization for his sculptures. Gonzalez was the first artist to systematically develop welded metal techniques to make open sculptural forms; Stankiewicz does the same, but his materials and techniques are less refined and more robust. Picasso has used whatever material happened to be lying around to create images that are often witty—such as the *Monkey and Her Baby;* Stankiewicz stays with industrial junk to create visual puns that are humorous and often have a sardonic edge.

The works of each of these European artists have a certain elegance of style, while the American's sculptures, such as *Untitled Piece No. 1961-18,* use rougher materials and are more direct in technique. As with David Smith, he probably has a larger percentage of failures than European counterparts such as Robert Müller. His successes, however, have a vigor that could never be achieved by any means other than his typically straightforward boldness.

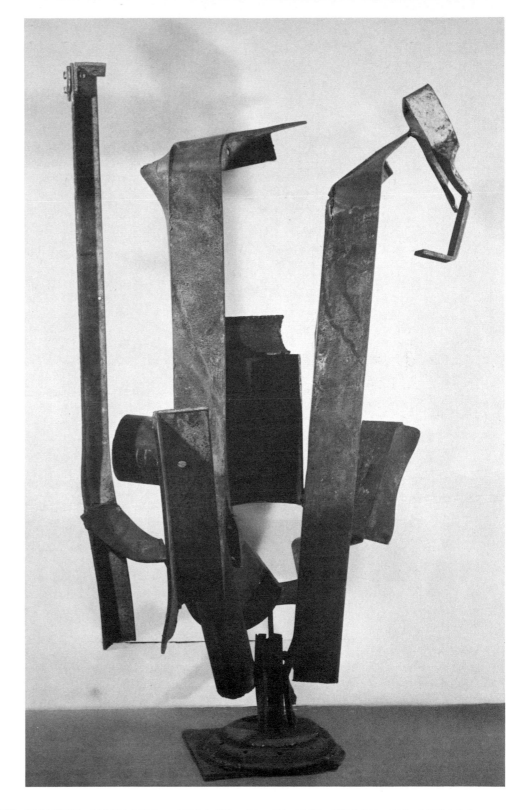

147 Richard Stankiewicz,
Untitled Piece No. 1961-18

OLD, SECRETARY GENERAL OF THE UNITED NATIONS, KILLED IN PLANE CRASH IN AFRICA.

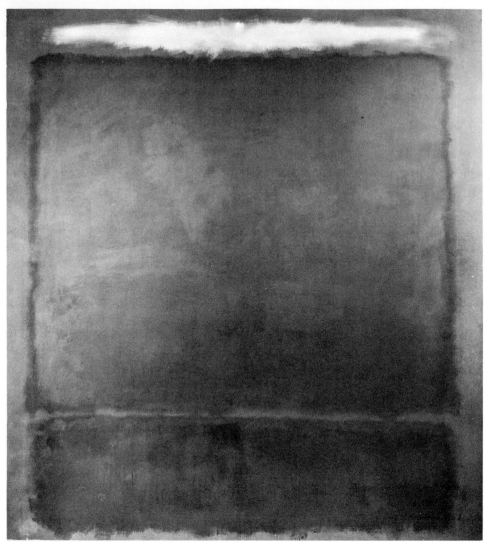

148 Mark Rothko, *No. 118*

One of the group of American artists called Abstract Expressionists, Mark Rothko has created a body of paintings that is completely different in appearance from that of "action painters" such as Pollock and De Kooning. The brush stroke is not an expressive element here. It is the total image, occupying the entire field of the painting surface and which cannot be in any way dissected for closer study without destroying the form and meaning of the work of art, that is all important.

The paintings of this artist's fully developed style normally have a similar format: thinly painted rectangles placed one above the other on a toned ground. There are usually from one to four rectangles of varying proportions, position, color and density. Yet, with just these few elements, Rothko has created works of art expressing emotions ranging from the expansive, "joyful" orange and yellow canvases of the early fifties to the "brooding" blue, green, and brown paintings of the later fifties and the "ominous" plum and black works of recent years.*

No. 118 is an early example of the last kind. Painted in successive thin glazes and scumbles† of color, it seems to deny the firm, flat surface of the canvas. Further, the soft edges of the rectangular shapes tend to mitigate any sense of specific and measurable forms as they appear to hover in (and to create) a felt, but ambiguous, space. The intense, luminous tones, applied in thin, successive layers, seem to radiate beyond the confines of the canvas edge, creating a special "atmosphere." As Rothko has truly said about his paintings: they "are nothing but content." The perceiver only need give up the fruitless search for specific images and a "story" to realize that such works of art communicate intensely *felt* experience.

*The evolution of this artist's work was not as simple and linear as is implied here. Only a suggestion of the variety of his works has been given.

†A glaze is a thin, transparent or transluscent layer of a darker color applied over a lighter area. A scumble is a thin application of a lighter tone worked into or over a darker area.

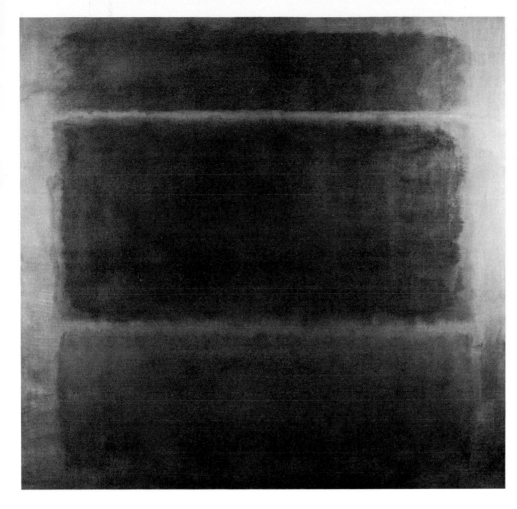

In *Red Maroons* the thin light strip at the bottom of *No. 118* has disappeared to be replaced by a brown, horizontal rectangle "bleeding off" on the bottom edge. Values are close, yet the intensity of tone is so great that in the proper light the painting seems to glow and throb with life. The large, thinly painted, black, central rectangle is drawn insistently upward by the magnetic pull of the deep red shape above. The thin glazes and scumbles create overlapping veils of color to suggest unmeasurable space. The blurred edges and intense colors combine to create an image that is impalpable yet undeniably present. Perhaps it is reasonable to say only that Rothko creates an atmosphere, if the word is understood in both its physical and psychological sense. It is a deep, glowing, expanding, brooding atmosphere—an atmosphere which seductively betrays a mood of anxiety.

149 Mark Rothko, *Red Maroons*

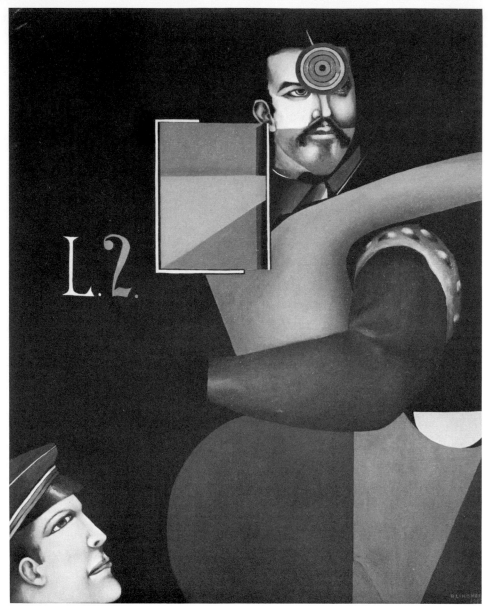

150 Richard Lindner, *Louis II*

Following a childhood and early career spent in Nuremberg, Berlin, and Munich, Richard Lindner left his native Germany in 1933, going first to Paris and finally in 1941 to New York City. After a successful career as a commercial artist in this country, he devoted himself entirely to painting after 1950.

His works betray the influence (which he acknowledges) of Giotto, Léger, and Balthus. Like them, Lindner is concerned with large, broadly painted figures and emphasis on tightly interlocking shapes and smoothly modeled figures. As with Balthus, his images are often erotic and even perverse.

Peculiarly his own, however, are the coarse, stocky figures with their curiously "doughy" look. Some of the vulgarity and crudity of such images can be traced to traditional Bavarian art. But the distortions are also due to his deliberate satirizing of German and American types and "culture."

Louis II is an imaginary portrait of a nineteenth-century Bavarian king and patron of the arts, Ludwig (Louis) II, whose close friendship with Richard Wagner caused something of a scandal. An abortive betrothal to a Bavarian duchess and the extravagant festooning of the Bavarian landscape with castles led to Louis being judged insane and deposed. A few days later he committed suicide.

Lindner here represents him as a handsome, young, beardless man in the embrace of a curiously geometrical figure. He is without hands and his forehead is covered by a target. Thus the king, whose physical strength was great, is held by a female-like, yet hard and unyielding figure; he is powerless without hands, and his brain is a well-marked target. In a corner the artist appears as a young German student and represented in the traditional position of a donor. Aside from specific denotations of the images, however, the work of art projects a mysterious and disquieting air.

Kenneth Noland is among a number of younger painters appropriately referred to by the critic Clement Greenberg as "Post Painterly Abstractionists." He is most closely allied to Helen Frankenthaler and Morris Louis, but all these artists owe a debt to Mark Rothko. Each of them has followed the older artist in applying thin stains of paint to unsized canvases to create softly blurred, matte surfaces on which the texture of the canvas itself plays a role. Further, it should be noted, the old distinction of figure and ground thus disappears for they simply become one and the same.

While Frankenthaler's works still seem to bear resemblances to landscapes or even figures, Noland's work has become steadily more abstract. In 1962 he was still working on a series of targets which he had started to do several years earlier—before Jasper Johns used that particular theme. *Warm Reverie* is one of the most delicately balanced and sensitively painted works of this series. It is as though the rigorous composition and carefully adjusted color relations of Albers were fused with the sensuous and subtly nuanced surface of Rothko. The dominant tone is a warm reddish earth color running from brownish hues through red and orange to a reddish ochre. At the same time the warm greenish outer ring and the blue-violet of the bull's eye provide a cooler, middle-value key to which the warm tones can be related for intensity, value, and hue. It does not seem to "sing" with the crisp vibrancy of an Albers nor to "growl" or "throb" with the muffled, sonority of a Rothko; it seems instead (to continue the analogy) to "hum" in muted but resonant tones.

151 Kenneth Noland, *Warm Reverie*

Alexander Calder has always been obsessed by the idea of movement. At first his experiments were devoted to humorous animated toys and circus figures, but a visit to Mondrian's studio in Paris in 1930 provided the "necessary shock" to begin a line of development using abstract shapes moving in space which eventually culminated in the "mobile," so named by Marcel Duchamp. *Red Sun, Black Clouds* is a recent example of this art form invented by Calder. In it, the genial humor of his toys and wire figures has been translated into an abstract play of shapes and forms.

The Constructivists in the 1920's had tentatively introduced simple mechanical movement—pendulums and the like—into their sculpture and Calder also first re-stricted himself to the rhythmic movement of one or two motor-operated objects on a fixed base or within a frame. In a short while, dissatisfaction with the limited and repetitious pattern of these movements and a growing friendship with Joan Miró led to an interest in chance rhythms and forms. From a purely geometric shape endowed with restricted movement in a two-dimensional field, Calder moved to the free-hanging mobile, which gives its constituent elements a chance to combine and recombine in endless variations. The transparency of its structure permits a three-dimensional visual gesture describing an unlimited variety of figures in space. This interest in the effects of chance does not, however, minimize the role of the artist; as Calder has stated, "It is

152 Alexander Calder,
Red Sun, Black Clouds

the apparent accident to regularity which the artist actually controls by which he makes or mars a work."* Thus the artist provides and sets in motion a system of possibilities, limited only by its own structure and the imagination of the artist. R. W.

*Quoted in James J. Sweeney, *Alexander Calder* (New York: Museum of Modern Art, 1951), p. 70.

Following the creation of the *Royal Bird* in 1948 came years of intense work and production for David Smith. During this period he gradually turned from a style based on that of Gonzalez and Picasso to one more frankly geometric and constructivist in feeling. Two works that indicate the wide latitude of imagery that this new direction allowed him are *Cubi XIV* and *Zig VII,* both from 1963. The first is quite clearly assembled from hollow cubes and rectangular shapes fabricated from stainless steel. Yet the informality with which these components are arranged owes much to Smith's Surrealistic experiments. Large in scale, and direct in conception, the individual parts retain their independence. It is by means of the system of relationships established between the forms that a unity is produced. The great massive blocks of steel are welded into positions that appear to have been lightly tossed there by some giant force and "frozen" into position. The "Cubi" sculptures, as exemplified by this one, bring together two contradictory aspects of Smith's work—delicate balance and rough power.

153 David Smith, *Cubi XIV*

Zig (for Ziggurat) *VII* is more complex in its variety of forms and their arrangement. The motive of the circle is echoed throughout the work, appearing in various guises as wheels, perforated discs, and rims. Unlike *Cubi XIV,* which is basically flat and linear, *Zig VII* alternately blocks off space by means of the large slanting plane and reaches out into space through the forms attached at various angles all around the sculpture. Again, the circles with holes make the sculpture transparent, while the large flat sheet hides part of it, forcing the viewer to take nothing for granted and to walk around it. Color is also an important element in this work. Smith hesitated neither to exploit the appearance of the bare steel nor to cover it over with paint when it served his purpose.

Like their creator, these sculptures are straightforward, withholding nothing and playing no coy technical tricks. They are big, often in physical fact and always in spirit. They range from graceful to awkward, but always they are the result of honest attempts to make the best sculptures of which the artist was capable. R. W.

154 David Smith, *Zig VII*

The Belgian painter René Magritte has evolved his own particular brand of Veristic Surrealism, undoubtedly influenced by the "Metaphysical" paintings of Giorgio de Chirico. Like the Italian, he is an inventor of strikingly haunting images. Magritte denies that his paintings involve symbolism, conscious or unconscious. Works such as *La Lunette d'Approche* deal precisely with the visible world—which the artist says ". . . is rich enough to form poetic language, evocative of the invisible and the visible." Yet, the dark disquieting void glimpsed in the slit in the surface of a lovely world shockingly reveals—nothing. Rather than call it explicitly symbolic, however, perhaps it is more accurate to consider it as metaphorical. If the ordinary world of sensory perceptions leads to the concept of a relativistic world of science and ordinary experience, and the world of abstract thought to the traditional ideal world of absolute reality, then Magritte's art exists in the area between, providing a bridge of visual analogues between the two. The images that he creates of objects in the world are clear and precise. It is indeed their high degree of realism that makes the shock of recognizing the unreality of illogical relationships so great.

155 Rene Magritte, *La Lunette d' Approche*

In the 1930's Mark Tobey began doing small abstract temperas composed of weaving webs of line, and line was always to remain the most important element in his art. He discovered Cubism and its concern for the continuous surface of the painting, as well as for the integration of forms and space. During his extensive travels he also discovered Oriental calligraphy and certain mystical religious and philosophical ideas. All these ideas and methods have contributed in a major way to his art.

Pollock and Kline were artists whose magnificently vigorous gestures were—like athletes—of the total body. That of De Kooning—like a billiard player or a musician—is of the arm: sure, clean, and controlled. Tobey's calligraphic gesture is of the wrist and hand. Partly for this reason, his paintings have seldom been large, and they always express a more intimate and elegant mood than those of artists like Pollock, Kline, or De Kooning.

Only a very small number of Tobey's paintings have been done in oil on large canvases. *Untitled* demonstrates how these few large works still remain intimate in spirit. As usual, the artist's major means of expression is line—a line that reveals the delicate movement of the hand and wrist translated through the tip or edge of the brush. Wiry, crisp, and fluid lines combine to build a network so deep that it suggests both palpable texture and space. At the same time, the lines do not define forms; they connote energy and actions of particular kinds.

156 Mark Tobey, *Untitled*

One of the dominant art movements in recent years is that called "Optical." A great variety of types and levels of art is included under this broad heading. Some artists seem to be primarily concerned with the illustration of specific optical effects. The works they create derive primarily from the laboratory rather than from the tradition of painting. Other artists, while using science as a source for ideas, still derive from the tradition of painting. Optical phenomena, mathematics, and psychological effects only serve as useful material in the creation of paintings. Such an artist is Victor Vasarély.

Influenced by Bauhaus theories, particularly of Albers and Moholy-Nagy, Vasarély's work organizes sharply defined geometrical shapes in complex but precise relations. Establishing two or more different but related systems of shapes and colors, the artist achieves extremely complex visual systems.

Orion Blanc combines a series of white circles and ellipses of various sizes with a series of colored squares to create several integrated systems. In the upper left-hand corner, for example, three concentric squares made up of series of circles of graduated sizes are organized around a single light square. On the lower left center this arrangement—with variations—is repeated on a larger scale. Further, the color systems overlap the organization of geometrical figures. As these separate arrangements are interrelated, they form even more complex systems. Particularly the relations of white figures to various colored grounds create illusions of space as they appear to advance or recede.

For Vasarély it appears that the world is infinitely complex, involving a multitude of interrelated and integrated systems, yet perfectly ordered.

157 Victor Vasarely, *Orion Blanc*

158 Mark Rothko, *1964, No. 2*

Contrary to some opinions, Mark Rothko is neither a religious painter nor a mystic. It is not the "unknowable" or supernatural that his paintings refer to; it is the felt experience of emotions and moods that are simply inexpressible in ordinary language.

Yet the experiences which find expression in the works of art do not necessarily precede the creation of that work. In a real sense, the artist is engaged in a "dialogue" with the paint and canvas; he *finds* what he is going to express—and thus what he holds true and valuable, and so who he is—during the course of this "dialogue." Picasso put it succinctly when he said "I do not seek, I find." Thus the artist invents his "language" as he seeks ever more poignant expression of experience—experience which in turn is inextricably involved with the development of that "language" of visual forms. This is an open, constantly changing, and evolving process.

The painting *1964, No. 2* includes just one black rectangle on a plum ground. The deep red tone is applied thinly so that the texture of the canvas is apparent. The black shape, however, is different in character from those in the two earlier paintings: the edges are firmer; the surface is flatter (quite different from the surrounding area); the color is denser, more opaque; yet there is also a peculiar, elusive, almost silvery quality about the black tone. The rectangle is almost square, it dominates the picture plane, and its insistent weight and density seem oppressive. One is no longer distracted by subtle variations of tone, nuances of color and value; there are no other shapes or hues to create relationships that would tend to mitigate the overwhelming effect of the great black image. Maybe this is the most direct and powerful statement of a profound sense of despair that one can imagine. On the other hand, perhaps the despair is only in the heart of this beholder. But the artist has produced a form that enters through the eye and, by means of its commonly associated meanings, unlocks that experience.

In contrast with the abstract "field" paintings by Rothko, artists like Jasper Johns and Robert Rauschenberg—inspired by the ideas and personality of Marcel Duchamp and the poetry of Joseph Cornell's boxes and collages—founded an art based on relationships of images and materials taken from the mundane world. More than any others, these two artists stimulated the development of so-called Pop art —that is, painting and sculpture which takes its subject matter and techniques from advertising art, comic strips, billboards, and the like.

Although most of these artists insist that their attitude is pure, loving, and ingenuous and that their aim is to embrace the world without excluding any of its aspects, one must recognize a strong strain of irony in their art—most particularly that of Rauschenberg.

The collage painting by this artist entitled *Tracer*, for example, includes such disparate images as a photograph of a city street scene; an open limousine with some shadowy silhouettes of figures, apparently with guns; a bald eagle; two caged birds; a reproduction of a Rubens *Venus*; two army helicopters; and two perspective drawings of boxes. These elements are all joined by areas as painterly as anything by De Kooning.

There is no question that such art is literary. It has moved from the "visual metaphors" of Abstract Expressionism to "visual similes" or even symbols. Thus iconography once more becomes important to the study of art. Here, one recognizes with a shock that what at first seem to be rather amusing images of ordinary figures and scenes includes what is possibly a reference to one of the tragic events of modern history.

159 Robert Rauschenberg, *Tracer*

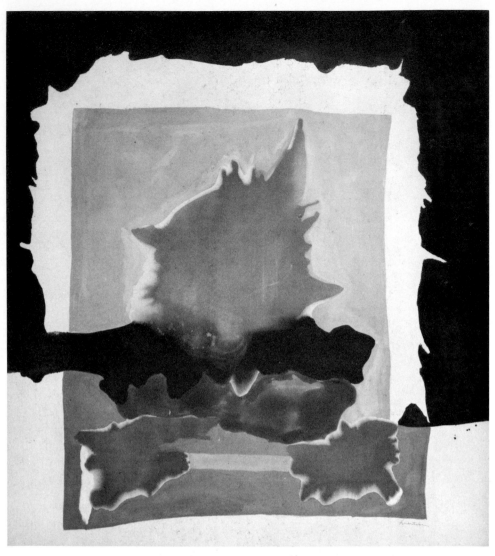

160 Helen Frankenthaler, *Interior Landscape*

Of the artists of the post-Abstract-Expressionist group called "post-painterly" by Clement Greenberg, Helen Frankenthaler stands alone, yet related to both groups. She works (and perhaps was the first after Rothko to do so) in thin washes of color on unsized canvas. This method gives the appearance of a stain rather than a palpable paint surface. She does not rely on a single image such as Louis' stripes or Noland's targets and chevrons. More like Abstract Expressionists such as Hofmann (with whom she studied) or Pollock, she creates a new image each time she works.

Most often her compositions (like Kandinsky's) seem related to landscapes. *Interior Landscape,* however, seems to have less to do with the outer world than with the inner. Yet any "landscape" of the inner mind must derive its elements from the outside world. (The source for its order or "form" is a complex philosophical question better avoided here.) Further, it is only by means of clues provided by analogous forms and common associations that the observer can "read" the work of art for its content as well as its form.

The pure blue rectangle, light green leafy shapes, and surrounding yellow area in this painting are enclosed within a ragged, starkly contrasting edge of black. The black shape starts abruptly on the edges but is overlapped on the left side by a trailing, dark, smoky green shape which enters the lighter, more lyrical center of the picture and is finally dissipated there.

This is one of the first of a series of paintings which have occupied the artist since late in 1964. It is also one of the most provocative and ominous.

Seymour Lipton is a self-taught sculptor whose work parallels—insofar as it is possible—the aims and methods of the Abstract Expressionist painters. Like David Smith, Roszak, Gonzalez, Picasso, and many others, he has adapted welded metal and certain industrial techniques to his aims. The character of his work depends largely on his method (developed in 1950) of cutting out pieces of sheet steel with shears and then bending and welding them edge to edge. He makes a rough texture and various tones by melting nickel, silver, or bronze rods, over the surfaces in small "puddles." Thus, as in *The Loom,* the forms are typically broad and "heavy" and surfaces are irregular.

Like some of the Abstract Expressionist painters, he is concerned with images having both biological and emotional associations, and he aims deliberately for the expression of inner feelings. In 1947 he wrote, "The bud, the core, the spring, the darkness of earth, the deep animal fountainhead of man's forces are what interest me most as the main genesis of artistic substance. . . ."*

*Quoted by Sam Hunter, *Modern American Painting and Sculpture* (New York: Dell Publishing Co., Inc., 1959), p. 178.

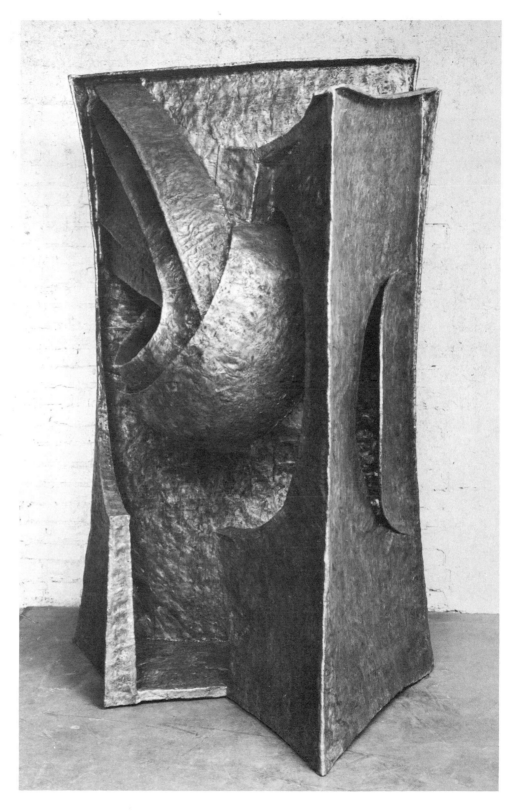

161 Seymour Lipton, *The Loom*

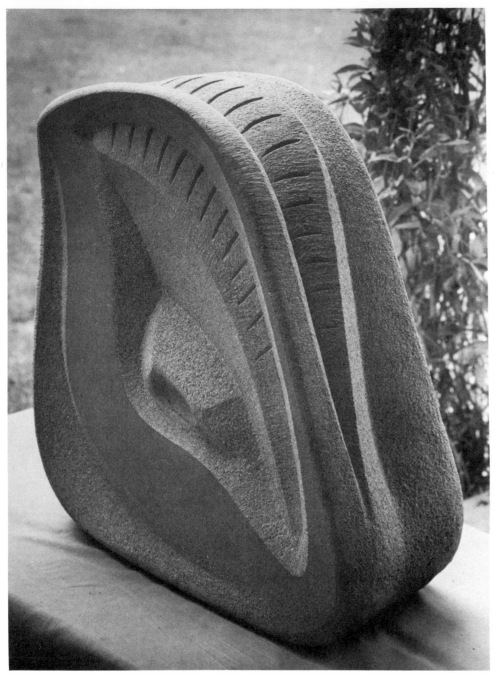

The Russian-born artist Naum Gabo was principally responsible for the invention of Constructivist sculpture and theory. His early studies in mathematics and physics, combined with his interest in the theories of Heinrich Wölfflin and the art of the Blue Rider group, resulted in his Constructivist sculptures as well as the *Realist Manifesto,* which he drew up in 1920. This document contained the basic Constructivist principles, including the ideas that line should indicate forces and rhythms; volume should be replaced by transparency and depth; and kinetic rhythms, which are expressive of the modern age, should replace static or suggested rhythms.

Gabo is not doctrinaire, however, and—as in *Granite Carving*—he has returned on occasion to solid forms. He insists that these works are also Constructivist. By this he probably means to suggest that they still refer to space and that they imply action in time rather than seeming static.

Gabo's work is thus related to many of the avant-garde sculptures of today in its concern with space, time, structure and movement. Artists as diverse as Calder and David Smith, Butler, and Chillida all owe something to Gabo.

162 Naum Gabo, *Granite Carving*

Leon Polk Smith stands—like Burgoyne Diller and Ellsworth Kelly among others—in a tradition steming from Mondrian. In works such as the screen entitled *Four Involvements in One,* Smith's concern with space and with color can be clearly seen. Each panel functions independently and also as part of a larger unit. In each instance the relationship of the figure to the ground is an important concern. Does the left center panel, for example, exhibit a yellow figure on a blue ground? Or a blue figure on a yellow ground? Which area seems to come forward and which recedes? The yellow is lighter and warmer but the blue is intense and occupies a larger area.

What about the panel on the right center: does a blunt white figure invade a black ground? Or does a curved black figure intrude on a white ground? Is its character thus aggressive or recessive? What is the relationship between this panel and that on the extreme left? The similarity of colors is obvious but is there a parallel of figure-ground relations? If black is the ground, we are looking through an aperture; but if white forms the ground, then we are looking at a peculiar, multi-bulged column.

Smith, like Diller and Kelly, must be regarded as standing on the side of intellectually controlled, precisely defined order. Yet, in contrast with Neo-classical masters such as Jacques Louis David, ambiguity is deliberately cultivated. Perhaps visual tensions caused by relationships of color and shape are a modified

163 Leon Polk Smith,
Four Involvements in One

avatar of psychological tensions of Mannerism. It may even be that this is an inevitable development in a world that has given up the notion of the Absolute, yet one in which at least some people still seek an order which might culminate the relativity of experience.

JOSEF ALBERS
American, born 1888
Born in Germany, Albers studied at the Berlin Academy, in Essen, and at the Bauhaus in Weimar. He was a Master at the Bauhaus in Dessau and in 1933 came to the United States. In this country he taught at Black Mountain College in North Carolina and was chairman of the art department at Yale University. Albers' teaching and his carefully controlled paintings have influenced many artists—particularly those of the so-called Optical movement.

131a *Homage to the Square: Star Blue*
Oil on board, 29-7/8 x 29-7/8 in., 1957. Signed and dated (on back). Contemporary Collection of The Cleveland Museum of Art.

JEAN (HANS) ARP
French (Alsatian), born 1887
Born in Strasboug, he was attracted to painting after his first contacts with modern art in Paris in 1904. He studied at the Weimar Academy from 1905 to 1907. In Paris the following year he attended the Académie Julian. He met Klee in Switzerland in 1909 and Kandinsky in Munich in 1912. In 1914 he was back in Paris where he met Modigliani, Apollinaire, Max Jacob, and Delaunay. During World War I he played an important role in the formation of the Dada movement in Zurich. In Cologne in 1920 he joined with Ernst and Baargeld to form a Dadaist group. He met Schwitters in Hanover in 1923. Later he was a Surrealist, and elements of Dadaism, Surrealism, and abstraction can be found in his sculptures both in the round and relief. His marble and bronze works seem to be in the tradition of Brancusi.

108 *Silence*
Marble, H. 20 in., 1949. Mr. and Mrs. Otto Preminger.

114 *Configurations*
Oil on wood, 29-1/2 x 23-1/2 in. Signed and dated (on back): Meudon 1952. Mr. and Mrs. Sigmund W. Kunstadter.

139 *Fruit d'une Pierre (Fruit of a Stone)*
Marble, 26 x 49 in., ca.1959. Galerie Chalette.

FRANCIS BACON
British, born 1909
Born in Dublin of English parents, Bacon lived in Berlin and Paris before settling in London in the late 1920's. Originally an interior decorator, he is self-taught as a painter. He began to paint in 1932, but abandoned it periodically until 1944. Like his compatriot Graham Sutherland, he spends part of each year in southern France.

96 *The Magdalene*
Oil on canvas, 57-1/4 x 50-3/4 in., ca.1945–46. Bagshaw Art Gallery.

116 *Dog*
Oil on canvas, 78-1/4 x 54-1/4 in., 1952. The Museum of Modern Art, New York, William A. M. Burden Fund.

BALTHUS (BALTHASAR KLOSSOWSKI)
French, born 1908
Balthus was born in Paris to parents of Polish background, both of whom were painters. His father knew Bonnard, Ker-Xavier Roussell, Derain, Duret, Vollard, and others of this period intimately. Balthus' childhood was spent in Paris and in Switzerland. In 1924 he met and became a close friend of André Gide. His precise representational style is related to Surrealism in its preoccupation with subjects of a psychoanalytical nature. "Je fais du Surréalisme à la Courbet," is the artist's own summary of his position.

70 *Le Rêve*
Oil on canvas, 59-1/4 x 51-1/4 in., 1938. Signed and dated. Louis McLane.

WILLIAM BAZIOTES
American, 1912–1963
Baziotes was born in Pittsburgh and studied at the National Academy of Design in New York from 1933 to 1936. He painted for the W.P.A. on various projects until 1941. He won first prize at the exhibit of Abstract and Surrealist American Artists in 1947 and in the same year helped found the school "Subjects of the Artist." He taught at the Brooklyn Museum Art School, New York University, and Hunter College in New York.

120 *Congo*
Oil on canvas, 71-1/4 x 59-3/4 in., ca.1954. Signed. Los Angeles County Museum of Art, gift of Mrs. Leonard Sperry, through the Contemporary Art Council.

MAX BECKMANN
German, 1884–1950
Born in Leipzig, he studied painting at the Weimar School of Art. Later he traveled to Italy where he was impressed by the work of Piero della Francesca and to Paris where he was influenced by Cézanne's paintings. His experiences on the battlefield during World War I affected him deeply, and most of his important canvases were done after that time. Political persecution caused him to leave Frankfort for Berlin in 1933, and Berlin for Amsterdam in 1936. Finally in 1947 he came to the United States, where he lived until his death.

20 *The Dream*
Oil on canvas, 71-3/4 x 35-7/8 in., 1921. Signed. Collection of Morton D. May.

66 *The King*
Oil on canvas, 53-1/4 x 39-1/4 in., 1937. Signed. Collection of Morton D. May.

PIERRE BONNARD
French, 1867–1947
He first studied law in Paris. After he was twenty he studied art at the Académie Julian. He became friends with Vuillard, Denis, and Serusier and helped establish the Nabis. With Vuillard he formed an inner group called the "Intimists," devoted to subjects from everyday, middle-class life. Bonnard traveled in Holland, England, Italy, and Spain. He lived much of his life around Deauville and Trouville on the Channel coast and Le Cannet near Cannes in the south of France.

94 *Dark Nude*
Oil on canvas, 31-1/2 x 27-5/8 in., 1942–45. Signed. Private Collection, Paris.

CONSTANTIN BRANCUSI
Rumanian, 1876–1957
Born in Pestisani, near Targu Jiu, Rumania, he left his father's farm when he was eleven years old to explore the world. After wandering for seven years and working as an apprentice cabinetmaker, he attended the Bucharest Art School on a scholarship. At twenty-six he set off again, and after stays in Munich, Zurich, and Basel, he ended up in Paris. In that city, he attended the Ecole des Beaux-Arts and was at first influenced by Rodin. He soon rejected both Rodin's romanticism and academic classicism and developed his own particular brand of abstraction based on natural forms but tending toward an ever increasing purity of form. He worked until his death in proud isolation in his studio in Paris, refusing honors and rewards. "To create like a god," he said, "to command like a king, to work like a slave."

5 *Torso*
Brass, H. 18-3/8 x W. 12 x D. 6-5/8 in., 1917. Signed. The Cleveland Museum of Art, Hinman B. Hurbut Collection.

8 *Chimera*
Oak, H. 36 x W. 9-3/4 x D. 8-1/4. (base: oak, H. 23-3/4 in.), 1918. Signed. Philadelphia Museum of Art, The Louise and Walter Arensberg Collection.

34 *Bird in Space*
Bronze, H. 50-1/4 x W. 7 x D. 5-1/4 in. (base: marble and oak, H. 48-1/8 in.), 1925. Signed. Philadelphia Museum of Art, The Louise and Walter Arensberg Collection.

35 *Fish*
Bronze and stainless steel, L. 19-1/2 x H. 6 in. (base: stone and wood, H. 27 in.), ca.1926. Sidney Janis Gallery.

GEORGES BRAQUE
French, 1882–1963
Born in Argenteuil, he studied at the Ecole des Beaux-Arts in Le Havre and at the Ecole Nationale des Beaux-Arts and Académie Humbert in Paris. In 1904 he joined the Fauve group and a few years later—with Picasso—he created Cubism. Braque was largely responsible for the development of the technique of *papier collés* in 1912. He was severely wounded in World War I, and after his return from the battlefields the close collaboration with Picasso ended. The evolution of Braque's art from that point on was steady and consistent, with its roots always in Cubism.

41 *The Black Rose*
Oil on canvas, 20 x 37 in., 1927. Signed. From the collection of Mr. and Mrs. Burton Tremaine.

42 *The Table*
Oil on canvas, 70-3/4 x 28-3/4 in., 1928. Signed. Mr. and Mrs. Daniel Saidenberg.

69 *Studio With Black Vase*
Oil and sand on canvas, 38-1/4 x 51 in., 1938. Signed and dated. Paul Rosenberg & Co.

REG BUTLER
British, born 1913
Butler's interest in architecture preceded his career as a sculptor. He practiced architecture until 1950. In 1953 he was awarded first prize in an international competition for a monument honoring the Unknown Political Prisoner. His bronzes all have in common the illustration of some idea—often social. He has taught at the University of Leeds, the Slade School, and the University of London.

126 *The Manipulator*
Shell bronze, 65-1/4 x 22 x 16-1/2 in., 1954. Albright-Knox Art Gallery, Charles Clifton Fund.

ALEXANDER CALDER
American, born 1898
Born in Philadelphia, Calder studied engineering at the Stevens Institute in New Jersey and art at the Art Students League in New York. While working as an illustrator for the *National Police Gazette* in the mid-twenties, he was influenced by the circus and created small mobile toys based on this theme. Abstract mobile sculpture was his invention. He divides his time between Paris and Connecticut.

67 *Whale*
Stabile, painted sheet steel, 68 x 69-1/2 x 45-3/8 in., 1937 (second version 1964). The Museum of Modern Art, New York, Gift of the artist.

125 *Snow Flurry, May 14*
Mobile, steel and aluminum, approx. 96 x 168 in., 1954. Signed (stamped) and dated. Yellow Transit Freight Lines, Inc.

152 *Red Sun, Black Clouds*
Metal, 33 x 130 in., 1963. Signed (initials) and dated. Perls Galleries.

MARC CHAGALL
Russian, born 1887
Born in Vitebsk, Russia, into a Jewish family of the Chassidic sect, he first studied at the Society for the Protection of the Arts in St. Petersburg and then in the studio of Leon Bakst, the theatrical designer. In 1910 he went to Paris, where he formed friendships with Roger de la Fresnaye, Delaunay, and Modigliani. At this time Cubist elements appear in his work. After the Revolution, he returned to Russia and was appointed Commissar for the Fine Arts in the District of Vitebsk. After a conflict with the academicians of the new regime, he returned to France in 1922. Shortly thereafter he discovered the south of France, its lush vegetation and rich colors. In 1941 he came to the United States at the invitation of the Museum of Modern Art. He returned to France in 1947 and settled in Vence in 1949.

12 *Green Violinist*
Oil on canvas, 35 x 20 in., ca.1918. Mr. and Mrs. Joseph R. Shapiro.

24 *Lovers Under Lilies*
Oil on canvas, 45-3/4 x 35-3/8 in., 1922–25. Signed and dated. Mrs. Evelyn Sharp.

EDUARDO CHILLIDA
Spanish, born 1924
Born in St. Sebastian, he began his art career with the study of architecture at the Madrid Art School. After 1947 he began to do sculpture, working first in clay, plaster, and then granite. In Paris, where he stayed from 1948 to 1951, he discovered iron as a material for sculpture. After

returning to Spain, his work became completely abstract.

146 *Whispering of the Limits*
Steel, 36 x 45 x 30 in., 1961. Mrs. Katherine W. Merkel.

GIORGIO DE CHIRICO
Italian, born 1888
Born at Volos, Greece, of Italian parents, he studied at a polytechnic school. There he devoted himself to painting, particularly to landscapes and seascapes. In 1906 he went to Munich, where he was influenced by German Romantic painting (particularly that of Arnold Böcklin). He moved to Florence in 1910, and it was there that he painted his first "metaphysical" canvases. In 1911 he went to Paris where Guillaume Apollinaire praised him as "the most astonishing painter of his time." Back in Italy when World War I broke out, he was conscripted, and in 1915, while at a rest center in Ferrara, he met Carlo Carra and they formed the nucleus of what was called the *Scuola Metafisica,* denoting a kind of proto-Surrealist style. By 1920 he had already changed his direction and around 1930 he broke with the Surrealists.

3 *The Amusements of a Young Girl*
Oil on canvas, 18 x 15-1/2 in., ca.1916. James Thrall Soby.

LOVIS CORINTH
German, 1858–1925
East Prussian by birth, Corinth studied at the Königsberg Academy and the Munich Academy before going to Paris in 1884 to study with Bouguereau at the Académie Julien. He later became a leading member of Berlin Secession with Slevogt and Liebermann. In 1911 he suffered a paralytic stroke, but overcame this to continue painting with a marked change in style and increase in expressiveness.

33 *Letztes Selbstporträt*
Oil on canvas, 31-11/16 x 23-13/16 in., 1925. Signed. Kunsthaus Zürich.

JOSEPH CORNELL
American, born 1903
Born in Nyack, New York, he attended Phillips Academy at Andover, Massachusetts. He is self-taught and has always refused to follow any artistic development that was not clearly his own. His boxes and collages bring together formal arrangements reminiscent of Constructivism and images that seem related to Surrealism—or perhaps even more, to French Symbolism. He lives in Flushing, New York.

82 *Medici Slot Machine*
Mixed media, 15-1/2 x 12 x 4-3/8 in., 1942. Mr. and Mrs. Bernard J. Reis.

123 *Night Skies: Auriga*
Mixed media, 19-1/4 x 13-1/2 x 7-1/2 in.,
ca.1954. Mr. and Mrs. E. A. Bergman.

124 *Night Owl*
Mixed media, 11-1/4 x 8-1/4 x 5-1/8 in.,
ca.1954. Mr. and Mrs. E. A. Bergman

128 *Bleriot*
Mixed media, 18-1/2 x 11 x 4-3/4 in.,
ca.1954–55. Collection Eleanor Ward.

SALVADOR DALI
Spanish, born 1904
Born at Figueras near Barcelona in Catalonia, he
studied art in Madrid. In 1928 he went to Paris,
met Picasso, and joined the Surrealist movement.
In 1929 and 1931 he collaborated with Luis
Buñuel on the films *Le Chien Andalou* and
L'Age d'Or. In 1940 he came to the United States
to stay, having visited in 1937. At this time he
broke with André Breton and orthodox Surreal-
ism. In recent years he has painted a number of
large canvases with Christian subjects.

47 *Illumined Pleasures*
Oil on board, 9 x 13-1/4 in., 1929. Collection
Sidney Janis.

STUART DAVIS
American, 1894–1964
Born in Philadelphia, he grew up in an artistic
environment which included members of "The
Eight." He was at first influenced by Robert Henri
with whom he studied in New York. He exhibited
five water colors in the Armory Show at the age
of nineteen. He was in Paris in 1928 and 1929. He
taught at the Art Students League in 1931 and
later at the New School for Social Research.
More than almost any other American artist his
work has demonstrated the influence of Cubism.

92 *For Internal Use Only*
Oil on canvas, 45 x 28 in., 1945. From the
collection of Mr. and Mrs. Burton Tremaine.

110 *Owh! in San Pao*
Oil on canvas, 52-1/4 x 41-3/4 in., 1951.
Signed. Whitney Museum of American Art.

ROBERT DELAUNAY
French, 1885–1941
Delaunay was concerned above all about color.
After undergoing the influences of Seurat and
Fauvism, he became interested in Cézanne's de-
velopment of space just at the time that Picasso
and Braque were creating Cubism. He joined the
Cubists and around 1912 became one of the first
painters to make completely non-objective com-
positions. The poet Guillaume Apollinaire chris-
tened Delaunay's lyrical, coloristic abstractions
"Orphism." He was very close to the German
artists of the Blue Rider movement, particularly
Franz Marc and Auguste Macke.

30 *L'Equipe de Cardiff*
Tempera on canvas, 57-1/2 x 44-1/2 in., 1923.
Galerie Louis Carré.

PAUL DELVAUX
Belgian, born 1897
Born in Antheit-Les-Huy, Belgium, he painted
alternately in Neo-Impressionist and Expression-
ist styles until the mid-thirties. Then the com-
bined influences of Giorgio de Chirico's early
works and Rene Magritte drew him into the
Surrealist movement. From then on he aimed to
explore the intimate and secret domain of his
own inner life. Delvaux was the son of a lawyer
and began by studying architecture. He later
studied painting at the Académie des Beaux Arts
in Brussels. He teaches at the Institut National
Superior d'Architecture et des Arts Décoratifs.

71 *La Ville Endormie (The Sleeping Town)*
Oil on canvas, 53-1/8 x 66-15/16 in., 1938.
Signed and dated. Robert Giron.

EDWIN DICKINSON
American, born 1891
Born in Seneca Falls, New York, the son of a
minister, he studied at Pratt Institute and the
Art Students League and was a student of William
Chase and Charles W. Hawthorne. He traveled
in Italy, Spain, and France. He has taught at
Brooklyn Museum School, Columbia University
School of Painting and Sculpture, Cooper Union,
and Pratt Institute.

85 *Ruin at Daphne*
Oil on canvas, 48 x 60-1/4 in., 1943–53.
Signed and dated. The Metropolitan Mu-
seum of Art, The Edward Joseph Gallagher
III Memorial Collection, 1955.

RICHARD DIEBENKORN
American, born 1922
Born in Portland, Oregon, he studied at the
University of California, Stanford University,
and the California School of Fine Arts. He was
associated with David Parks and Elmer Bischoff
in establishing a West Coast school of figurative
painting. In 1958 he was invited to exhibit at the
Brussels World Fair. He taught at the University
of Illinois and Colorado Springs and now teaches
at the California College of Arts and Crafts.

138 *Interior with Book*
Oil on canvas, 70 x 64 in., 1959. Signed and
dated. Nelson Gallery—Atkins Museum,
Friends of Art Collection.

JEAN DUBUFFET
French, born 1901
Born in Le Havre, he went to Paris in 1918 to
study painting. He remained isolated from all
artistic movements, however, as he has ever

since. He has destroyed most of the work he did
prior to his first major exhibition in 1944. In the
years since, he has produced a tremendous
volume of work in various media, ranging from
conventional means to collages of butterfly
wings and sculpture of sponge. Influenced by
Klee and sharing the Surrealists' distrust of cere-
bration, he has a strong feeling for immediacy
and impact and a love for his materials. He has
also written extensively and illustrated books.

87 *Grand Jazz Band*
Oil and tempera on canvas, 45-1/8 x 57-7/8
in., 1944. Signed and dated. Mr. and Mrs.
Gordon Bunshaft.

131 *Lit de Debris au Pied du Mur*
Oil on canvas (assemblage), 104-5/8 x 46 in.,
1957. Signed and dated. Private Collection.

MARCEL DUCHAMP
French (American), born 1887
Born near Rouen, he was trained as a librarian
and attended the Académie Julian. Along with
his brothers Jacques Villon and Duchamp-Villon,
his sister Suzanne Duchamp, and a number of
other artists including Léger, Gris, and Delaunay,
he formed the *Section d'Or* group of Cubists. His
painting *Nude Descending a Staircase* caused a
sensation at the Armory Show in 1913. In 1915
he visited the United States and became a
leader of a proto-Dada group also including
Picabia and Man Ray. Duchamp is the originator
of the "ready-made"—manufactured articles of
little value which with slight additions or altera-
tions and the proper presentation acquire poetic
significance.

83 *Boite-en-Valise (Box in a Suitcase)*
Cardboard box containing 68 reproductions
of works, 15-1/2 x 13-3/4 in., 1941–42.
Signed. Cordier & Ekstrom, Inc.

RAOUL DUFY
French, 1877–1953
Born in Le Havre, he began to study painting
there, later attending the Ecole des Beaux-Arts in
Paris. In the early years of the century he was
impressed by the paintings of Van Gogh and
then by those of Matisse. He took part in the
Fauve movement and was later influenced by
Cubism. In 1908 he worked with Braque at
L'Estaque. Later he traveled in Sicily and Morocco.
In 1937 he did an enormous mural to decorate
the Palais de l'Electricité at the World's Fair. In
1950 and 1951 he was in Boston.

51 *The Gate*
Oil on canvas, 50-1/4 x 63-3/4 in., ca.1930.
Signed. Mrs. Evelyn Sharp.

MAX ERNST
German, born 1891

Born in Brühl, near Cologne, he studied philosophy at the University of Bonn. He was first influenced by German Expressionism, and by the paintings of Picasso and De Chirico. After World War I, he was one of the founders of a Dadaist group in Cologne. In 1922 he went to Paris, where he played a leading role in the development of Surrealism. He traveled in the Far East and many European countries. In 1941 he escaped occupied Europe and came to the United States. He returned to Europe in 1949 and has lived there—with visits to the United States—ever since.

16 *Fruit of a Long Experience*
Wood and metal painted, 18 x 15 in., 1919. Collection Roland Penrose.

43 *Flower and Animal Head*
Oil on canvas, 39-1/4 x 31-3/4 in., 1928. Signed. Mr. and Mrs. Arne H. Ekstrom.

60 *Blind Swimmer*
Oil on canvas, 36 x 28-1/2 in., 1934. Signed and dated. Collection Mr. and Mrs. Julien Levy.

LYONEL FEININGER
American, 1871–1956

His parents, German immigrants, were both musicians. He returned to Germany to study music, but soon decided to devote himself to painting. Around 1912 the experience of Cubism enabled him to find his own way. He was one of the first artists to be invited by Walter Gropius in 1919 to teach at the Bauhaus. In 1937 he left Germany for political reasons and returned to the United States, settling in New York City.

45 *Gables III*
Oil on canvas, 42 x 34 in., 1929. Signed and dated. Mrs. John Sargent Pillsbury.

HELEN FRANKENTHALER
American, born 1928

Born in New York, she is a graduate of Bennington College and studied with Hans Hofmann. She has traveled widely in Europe, and is married to the painter Robert Motherwell.

160 *Interior Landscape*
Acrylic on canvas, 104-3/4 x 92-3/4 in., 1964. Signed and dated (back). André Emmerich Gallery.

NAUM GABO
American, born 1890

With his brother, Antoine Pevsner, he was a leader of the Russian Constructivist group which influenced the Bauhaus. After leaving Russia in 1922, he lived and worked in Berlin, Paris, and England before coming to America in 1946.

139a*Linear Construction No. 4*
Aluminum, H. 39 in., ca.1959-61. Joseph H. Hirshhorn Collection.

162 *Granite Carving*
Pennsylvania granite, 25 x 24 x 10 in., 1964–65. Mrs. Miriam Gabo.

ALBERTO GIACOMETTI
Swiss, 1901–1966

Born in Italian Switzerland, son of an Impressionist painter, Giacometti studied in Geneva and Rome before going to Paris at age twenty-one to study sculpture with Antoine Bourdelle. His art at first developed into a Cubist style close to that of Lipchitz. Soon, however, he was drawn to Surrealism. The human form has long dominated Giacometti's work—particularly elongated, thin, bronze figures. He is also an important painter, specializing in expressive portraits done in a linear style.

59 *Invisible Object (Hands Holding the Void)*
Bronze, H. 61 in., 1934–35. Mr. and Mrs. Lee A. Ault.

106 *City Square*
Bronze, figures H. ca.7 in., base 24-1/2 x 15 in., 1949. Signed. Wadsworth Atheneum.

140 *Walking Man*
Bronze, H. 72-1/2 in., 1960. Mr. and Mrs. Arnold H. Maremont.

JULIO GONZALEZ
Spanish, 1876–1942

Born in Barcelona, he settled in Paris with his family in 1900. He came from a family of metalworkers (his father and grandfather were goldsmiths), and he learned the art from his father and studied painting at the School of Fine Arts in Barcelona. In 1893 he and his older brother exhibited their metalwork for the first time at the Barcelona International Exhibition and won a gold medal. In Paris he became an intimate friend of Picasso. In 1927 he abandoned painting for sculpture. During 1930 and 1931 he assisted Picasso on his welded sculpture and changed his own style. From this point on he pioneered in the making of abstract sculptures in welded metal and the techniques of constructing the figure around space instead of within it. At this time, space became his main interest, although he later returned to a more compact form.

52 *Woman with a Basket (La Femme à la Corbeille)*
Iron, H. 71 in., ca.1931. Mme. Roberta Gonzalez.

53 *Daphné*
Bronze, H. 55 in., ca.1932. Signed. Galerie Chalette.

ARSHILE GORKY
American, 1904–1948

Born in Armenia, he studied at the Polytechnical Institute in Tiflis, Georgia, before coming to the United States in 1920. He studied engineering at Brown University and painted in his spare time. He was influenced in turn by Picasso, Léger, Miró, and Arp before arriving at his own highly personal abstract style based on Surrealism. Almost entirely self-taught, he was a leader—along with Pollock, Hofmann, Motherwell, Rothko, De Kooning, and a few others—of a group of New York artists later identified as Abstract Expressionists.

98 *The Betrothal, II*
Oil on canvas, 50-3/4 x 38 in., 1947. Signed and dated. Whitney Museum of American Art.

99 *Agony*
Oil on canvas, 40 x 50-1/2 in., 1947. Signed and dated. The Museum of Modern Art, New York, A. Conger Goodyear Fund.

ADOLPH GOTTLIEB
American, born 1903

A native of New York, he studied with John Sloan and Robert Henri at the Art Students League. He went to Paris, Berlin, and Munich in 1921 and 1922. In 1934 he founded a painters' group called "The Ten" with Mark Rothko. Later he worked for the Federal Art Project and lived for a time in the Southwest. He is one of the original members of the group of New York artists that have come to be known as Abstract Expressionists.

134 *Exclamation*
Oil on canvas, 90 x 72 in., 1958. Signed and dated. Mrs. Adolph Gottlieb.

JUAN GRIS
Spanish, 1887–1927

He studied engineering in Madrid, where he was born. At the age of twenty he moved to Paris and soon became friendly with Picasso, Braque, Apollinaire, Kahnweiler, and the Steins. In 1910 he joined the Cubist movement and played an important role in the development of the "Synthetic" phase of that style. He died near Paris at the age of forty.

2 *Still Life with Playing Cards*
Oil on canvas, 27-3/4 x 22-3/4 in., 1916. Signed and dated. Collection of Washington University.

22 *Le Canigou*
Oil on canvas, 25-1/2 x 39-1/2 in., 1921. Signed and dated. Albright-Knox Art Gallery.

GEORGE GROSZ
German (American), 1893–1959
Born in Berlin in 1893, he studied at the Academies of Dresden and Berlin. Although he had begun to paint before 1914, it was as a caricaturist that he did his first important work. In 1918, Grosz was a member of the Dada group of Berlin, which had a pronounced political character. In 1925 he briefly turned to the brutal realism of the *Neue Sachlichkeit*. In 1932 he was invited to teach at the Art Students League in New York. He settled in America in 1933, and a romantic and idyllic note appeared in his art. In 1959 he returned to Germany, where he died.

7 *The City*
Oil on canvas, 39-1/2 x 40-1/4 in., 1916–1917. Signed. Richard L. Feigen.

PHILIP GUSTON
American, born 1913
Born in Montreal, Canada, he moved to the United States at an early age. He studied at the Art Institute, Los Angeles, in 1930. After gaining national recognition as a painter in a poetic realist style, he began to do abstractions around 1948. His abstractions were at first labeled "Abstract Impressionist" to differentiate between them and canvases with more athletic brushwork by Pollock, Kline, and De Kooning. Obviously, however, his work belongs to the Abstract Expressionist development.

127 *The Room*
Oil on canvas, 71-7/8 x 60 in., ca.1954–55. Signed. Los Angeles County Museum of Art, Contemporary Art Council Fund.

132 *Sleeper I*
Oil on canvas, 66-1/4 x 76 in., 1958. Signed. Contemporary Collection of The Cleveland Museum of Art.

AUGUSTE HERBIN
French, 1882–1960
Born at Quievy near Cambrai, he studied at the Ecole des Beaux-Arts, Lille, before going to Paris in 1903. In 1909 he was affiliated with the Cubist group, *Section d'Or*. He was a co-founder of Salon des Sur-indépendants in 1929. With Gabo, Pevsner, and Mondrian he was a member of the Abstraction-Création group founded in 1932. He also designed tapestries.

133 *Lier*
Oil on canvas, 39 x 26 in., 1958. Signed and dated. Galerie Chalette.

HANS HOFMANN
American, 1880-1966
Born in Weissenburg, Germany, he studied in Munich and Paris, and took part in the Secessionist movement in Germany. He has always

been noted as a teacher as well as an artist. He founded a School of Modern Art in Munich and taught in the Bavarian mountains, Italy, and France. In 1930 he came to the United States to teach at the University of California and in 1934 opened his own school in New York, the same year that he became an American citizen.

118 *Composition No. 10*
Oil on canvas, 31-1/2 x 39-1/2 in., 1953. Signed. Abbott Laboratories.

137 *Smaragd Red and Germinating Yellow*
Oil on canvas, 55 x 40 in., 1959. Contemporary Collection of The Cleveland Museum of Art.

EDWARD HOPPER
American, born 1882
Born in Nyack, New York, Hopper studied with Robert Henri and Kenneth Hayes Miller at the New York School of Art (Chase School). He began doing etchings in 1919 and water colors in 1923. He exhibited in the Armory Show in 1913. His work has passed through a number of phases but in style has remained clear and explicit. His subjects are peculiarly American in character; architectural motifs are a major means of establishing a context (usually urban) and of indicating the circumstances of life and the character of the people.

81 *Nighthawks*
Oil on canvas, 33-3/16 x 60-1/8 in., 1942. Signed. The Art Institute of Chicago, Friends of American Art Collection.

JASPER JOHNS
American, born 1930
Born in Allendale, South Carolina, he studied at the University of South Carolina. Since 1952 he has been living and working in New York. Johns stands between Abstract Expressionism (in his painterly, expressive technique) and "Pop Art" (in his use of everyday, banal images as subject matter). Among his favorite subjects have been numbers, letters, targets, flags, and maps.

130 *Grey Alphabets*
Encaustic on paper on canvas, 66 x 49 in., ca.1956. Mr. and Mrs. Ben Heller.

WASSILY KANDINSKY
Russian, 1866–1944
Born in Moscow, he studied law and only took up painting at thirty years of age. In 1896 he moved to Munich, where he studied at Azbe's school of painting and under Stuck at the Academy. He was a leader of the Phalanx association and a member of the Berlin Secession movement. From 1903 to 1908 he traveled in France, Italy, and Tunisia. Beginning in 1908 he lived in Munich and Murnau, painting deeply

colored landscapes of Expressionist character which gradually he transformed into abstract painting. By 1910 he was the first modern painter to do purely non-objective compositions. He organized and led The Blue Rider movement in Munich and later The Blue Four group at the Bauhaus. He published a major treatise, *Concerning the Spiritual in Art*, in 1912. In 1933 he moved to Paris, where he died at Neuilly-sur-Seine in 1944.

13 *En Gris*
Oil on canvas, 50-3/4 x 76-5/16 in., 1919. Madame Nina Kandinsky.

26 *Composition 8*
Oil on canvas, 55-1/2 x 79-1/8 in., 1923. Signed (initialed) and dated. The Solomon R. Guggenheim Museum.

56 *Soft-White and Hard*
Oil on canvas, 31-1/2 x 39-3/8 in., 1932. Signed (initialed) and dated. Richard Feigen Gallery.

ERNST LUDWIG KIRCHNER
German, 1880–1938
Born at Aschaffenburg, he first studied architecture in Dresden. In 1905, along with Heckel and Schmidt-Rottluff, he founded the Expressionist movement known as *Die Brücke* (The Bridge). Until 1913 he was active in that group as a painter, printmaker, and spokesman. From 1914 to 1917 he was in the army. Following a collapse, he left Germany to settle permanently in Switzerland. He continued with painting and graphic work there and experimented with textile design and sculpture. He committed suicide in 1938 at Davos.

11 *Self Portrait with Cat*
Oil on canvas, 47-1/4 x 31-1/2 in., 1918. Signed and dated. Busch-Reisinger Museum, Harvard University.

PAUL KLEE
Swiss, 1879–1940
Born at München-Buchsee near Berne, son of an orchestra conductor, he first studied the violin. He went to Munich when he was nineteen years old and studied art there with Franz von Stuck. After traveling in Italy, he moved to Munich, where he became friendly with the *Blau Reiter* artists. In 1914 he made a trip to Tunis which had a profound influence on his art. From 1916 to 1918 he was in the German army. In 1922 he joined the staff at the Bauhaus. In 1925 he was represented in the first Surrealist exhibition in Paris. At the Bauhaus he joined with Kandinsky, Feininger, and Jawlensky to form The Blue Four, a group continuing the tradition of The Blue Rider. In 1930 he was appointed to the Düsseldorf Academy. He remained there until the Nazis drove him out in 1933; he then returned to

Switzerland, where he died at Muralto near Locarno.

25 *The Twittering Machine*
Water color, pen and ink, 16-1/4 x 12 in., 1922. Signed and dated. The Museum of Modern Art, New York, Purchase.

27 *Lomolarm*
Gouache on cardboard, 13 x 8-3/4 in., 1923. Signed and dated. F. C. Schang.

55 *Rock Flower*
Water color on paper, 17 x 12-3/4 in., 1932. Signed and dated. F. C. Schang.

62 *Child Consecrated to Suffering*
Gouache on paper, 6 x 9-1/4 in., 1935. Signed and dated. Albright-Knox Art Gallery.

FRANZ KLINE

American, 1910–1962
Born in Wilkes Barre, Pennsylvania, he studied at Boston University and at Heatherly's Art School in London. In 1938 he returned to New York. He taught at Black Mountain College and at Pratt Institute in Brooklyn. Kline was of the second generation of Abstract Expressionist artists. His large black and white compositions are broadly painted and the energetic gestures of the artist are their primary expressive means.

109 *Cardinal*
Oil on canvas, 78 x 57 in., ca.1950. Signed. Poindexter Gallery.

142 *Turin*
Oil on canvas, 80 x 95 in. Signed and dated. Nelson Gallery—Atkins Museum, Gift of Mrs. Alfred B. Clark to the Friends of Art Collection.

GEORG KOLBE

German, 1877–1947
Born at Waldheim, Germany, Kolbe began as a painter, studying painting and drawing at the Dresden Academy and in Munich. He went to Paris in 1898 and was in Rome until 1900, where he turned to sculpture. A slight indebtedness to Rodin is apparent in his treatment of surfaces and choice of subjects. A virtuoso in bronze, he turned from one unusual sculptural pose to another with movements or attitudes that are alive and full of energy. Around 1920 his designs became more conventional, figures were more solidly conceived and their inner life more strongly emphasized.

21 *Assunta*
Bronze, H. 76 in., 1921. Signed with monogram. The Detroit Institute of Arts.

WILLEM DE KOONING

American, born 1904
He attended night classes at the Fine Arts Academy in Rotterdam, where he was born. One of his professors there introduced him to *De Stijl* principles. He later spent a year in Brussels, where Flemish paintings made a lasting impression on him. In 1926 he came to the United States, where he first worked as a house painter. He was a close friend of Gorky's and was an early member of the group called Abstract Expressionist.

90 *Pink Lady*
Oil on canvas, 48-1/4 x 35-1/4 in., ca.1944. Signed. Mr. and Mrs. Stanley K. Sheinbaum.

115 *Woman II*
Oil on canvas, 59 x 43 in., 1952. Signed. The Museum of Modern Art, New York, Gift of Mrs. John D. Rockefeller, 3rd.

129 *Saturday Night*
Oil on canvas, 69 x 79-1/2 in., ca.1956. Signed. Washington University.

WALT KUHN

American, 1880–1949
Born in Brooklyn, he traveled to Europe for study and was awarded a silver medal in Munich in 1905. Returning to the United States, he began a career as a journalist-cartoonist which he soon abandoned to devote his full time to painting. He was one of the organizers and prime movers of the Armory Show of 1913. He taught at the New York School of Art in 1908 and the Art Students League in 1927 and 1928.

73 *Lancer*
Oil on canvas, 45 x 26 in., 1939. Signed and dated. The Currier Gallery of Art.

YASUO KUNIYOSHI

American, 1893–1953
Born in Okayama, Japan, he came to the United States in 1906. He studied first in Los Angeles and then in New York at the National Academy and the Henri School. He taught for many years in the Art Students League and at the New School for Social Research. He was a sensitive draftsman, and drawing is the basis for all his works. His colors were normally applied thinly and were usually earth tones until, toward the end of his life, he adopted high-keyed, intense hues. His work is a curious mixture of Oriental and contemporary European-American elements, but is entirely personal.

63 *Girl Thinking*
Oil on canvas, 50 x 40 in., 1935. Signed and dated. Mr. and Mrs. James S. Schramm.

GASTON LACHAISE

American, 1882–1935
Born in Paris, he studied at the Ecole Bernard-Palissy and at the Ecole des Beaux-Arts. He came to the United States in 1906, staying first in Boston and then in New York. Known for his heroic female nude sculptures, he also did occasional portraits and reliefs. He was a meticulous workman—carving directly in stone or, if he used bronze, polishing the cast form himself until it assumed the desired lustre. He loved the great rounded masses of exaggerated feminine shapes and he endowed them with great vigor.

40 *Standing Woman*
Bronze, H. 70 in., 1912–1927. Signed and dated. Albright-Knox Art Gallery.

FERNAND LEGER

French, 1881–1955
Léger came to Paris in 1900 and studied at the Ecole Nationale des Beaux Arts. He adopted the Cubist vocabulary around 1910. The years from 1917 to 1920 were a period of dynamic compositions; after that they are usually static. He first visited New York in 1930. Later he spent the years of World War II there, returning to Paris in 1945. He painted a few basic themes in a broad, tightly composed, "classical" style.

23 *Le Petit Déjeuner*
Oil on canvas, 40 x 53 in., ca.1921. From the collection of Mr. and Mrs. Burton Tremaine.

91 *Big Julie*
Oil on canvas, 44 x 50-1/8 in., 1945. Signed and dated. The Museum of Modern Art, New York. Acquired through the Lillie P. Bliss Bequest.

JACK LEVINE

American, born 1915
Born in Boston, he grew up during the depression years in the tenement district of that city. He studied in the children's classes at the Boston Museum, and Harold Zimmerman and Denman Ross of the Fogg Museum were his mentors. From the beginning he painted wry, satirical images of the environment he knew best—the slums of a big city. An Expressionist, his work is related stylistically and technically to that of such artists as Soutine, Daumier, El Greco, and Tintoretto, as well as to Byzantine icons.

95 *Welcome Home*
Oil, 40 x 60 in., 1946. Signed. The Brooklyn Museum.

RICHARD LINDNER

American, born 1901
A native of Germany, he studied at Nuremberg in 1923 and Berlin in 1928. He was in Paris from 1933 to 1940, working as a book and magazine

illustrator. In the United States since 1941, he has been active as a painter and an illustrator and as a teacher at the Pratt Institute.

150 *Louis II*
Oil on canvas, 50 x 40 in., 1962. Signed and dated. Contemporary Collection of The Cleveland Museum of Art.

JACQUES LIPCHITZ
American, born 1891
Born in Druskieniki, Lithuania, he studied architecture at Vilna and in 1909 went to Paris to study sculpture. In 1941 he escaped from Europe and came to the United States where he has since been living. He is a master in exploiting the possibilities of cast metal, and most of his works are in bronze. After a period during which he applied Cubist principles to sculpture, he did small-scale wire works. Later, large baroque sculptures are devoted to epic themes of man's spiritual struggle in a materialistic world.

4 *Man with Mandolin*
Limestone, 29-3/4 x 10-3/4 in., 1917. Yale University Art Gallery, Collection Société Anonyme.

50 *Figure*
Plaster, H. 96 in., 1926–30. Signed. Jacques Lipchitz.

SEYMOUR LIPTON
American, born 1903
Born in New York and a graduate of Columbia University, he is self-taught as a sculptor. He taught at the Cooper Union Art School in 1945–1946 and later at the New School of Social Research. He was invited to the Venice Biennale in 1958, and was a guest critic at Yale University from 1957–1959.

161 *The Loom*
Nickel silver on monel metal, H. 70 x W. 47 in., ca.1965. Marlborough-Gerson Gallery.

EL (ELIEZER) LISSITZKY
Russian, 1890–1941
Born in Smolensk in Russia, he studied engineering and architecture at the Darmstadt Technical School in Germany in 1909–1914. He returned to Russia at the outbreak of World War I, and in 1919 was associated with Malevich and the Suprematist movement. He later published an influential journal, *Der Gegenstand,* in Berlin and established close relations with the Bauhaus and *De Stijl.* Again in Russia, he became involved with the application of Suprematist and Constructivist principles to the design of displays, pavilions, and particularly posters. He died in Moscow in 1941.

28 *Proun G 7*
Gesso, tempera and lacquer on canvas, 30-1/4 x 24-1/2 in., ca.1923. Galerie Chalette.

MORRIS LOUIS (BERSTEIN)
American, 1912–1962
Born in Baltimore, he studied and later taught at the Maryland Institute. He worked on a Federal Art Project in New York in the early 1930's. He died in Washington, D.C. His works were exhibited posthumously at the 1964 Venice Biennale.

141 *Beth*
Acrylic resin paint on canvas, 105 x 106-1/4 in., ca.1960. André Emmerich Gallery.

RENE MAGRITTE
Belgian, born 1898
After a brief period of influence by Cubism, Magritte joined the Surrealist movement in 1925. He became close friends with the poet Paul Eluard while living in Paris, but he never followed the Surrealist tendency toward automatism urged by André Breton. Instead, following the lead of De Chirico, he preferred to create striking images by incongruous combinations and juxtapositions of figures and their metamorphoses to suggest similarities and create a visible poetry.

155 *La Lunette d'Approche*
Oil on canvas, 69 x 45-1/2 in., 1963. Signed (dated on back). Collection University of St. Thomas.

ARISTIDE MAILLOL
French, 1861–1944
Born in the south of France, he first studied painting in Paris with Cabanel from 1882 to 1886. He was a member of the Nabis and began wood carving under the influence of Gauguin. From 1899 until his death, however, he worked as a sculptor in a truly classical style. He occasionally did book illustrations.

58 *Venus with a Necklace*
Bronze, H. 69-9/32 in., ca.1918–1933. Collection City Art Museum of Saint Louis.

ALFRED MANESSIER
French, born 1911
Born at Saint-Ouen, he went to the School of Fine Arts at Amiens. He studied architecture at the Ecole des Beaux-Arts in Paris during the early thirties. At this time he also attended classes at the Louvre and various academies. The titles and motifs of his abstract canvases often refer to religious subjects. He has done designs for stained-glass windows and other church decorations. He has been closely associated with Bazaine, Bis-

sière, and other French abstract painters in the post-World War II period.

121 *Crown of Thorns*
Oil on canvas, 44-1/2 x 63-1/2 in., 1954. Signed and dated. Museum of Art, Carnegie Institute.

HENRI MATISSE
French, 1869–1954
Born at Le Cateau in the north of France, he died near Nice in the south. Matisse came rather late to painting. He studied at the Ecole Nationale des Beaux Arts, where he was a pupil of Gustave Moreau. In association with Rouault, Vlaminck, Derain, Marquet, and others he created the Fauve movement beginning around 1904. He was the unquestioned leader of this movement and, indeed, for some time of the entire French school. After a modest involvement with Cubism he developed his own richly colored, decorative, and linear style. He settled in Nice on the Riviera and toward the end of his life, while designing the Chapel at Vence, he invented a method of working with cut-out colored paper called *découpage.* Matisse was unquestionably one of the greatest and most influential masters of the twentieth century.

14 *White Plumes*
Oil on canvas, 28-3/4 x 23-3/4 in., 1919. Signed. The Minneapolis Institute of Arts.

39 *Decorative Figure on Ornamental Background*
Oil on canvas, 51-1/8 x 38-1/2 in., 1927. Signed. Musée National d'Art Moderne.

75 *Interior with Etruscan Vase*
Oil on canvas, 29 x 42-1/2 in., 1940. Signed and dated. The Cleveland Museum of Art. Gift of Hanna Fund.

101 *Bunch of Yellow Flowers*
Papier de coupe, 43-5/8 x 24-3/4 in., 1947. Signed and dated. Col. Samuel A. Berger.

113 *Poissons Chinois*
Gouache and crayon on cut-out and pasted paper, 75-1/4 x 35-3/4 in., 1951. Signed and dated. Private Collection.

ROBERTO MATTA (ECHAURREN)
Chilean, born 1912
A native of Santiago, Chile, he is of French and Spanish extraction and spent much of his childhood in France and Spain. Matta worked as an architect in Le Corbusier's studio until 1937. In that year he joined the Surrealist movement and turned his attention to painting. He illustrated Breton's *Prologema to a Third Surrealist Manifesto* in 1942. He was in the United States in 1939, remaining until 1948, and during that time was close to a number of the Americans who later became known as Abstract Expressionists.

84 *The Earth Is a Man*
 Oil on canvas, 72 x 96 in., ca.1942. Mr. and
 Mrs. Joseph R. Shapiro.

89 *To Escape the Absolute*
 Oil on canvas, 38 x 50 in., ca.1944. Mr. and
 Mrs. Joseph Slifka.

JOAN MIRO

Spanish, born 1893

Born at Montroig near Barcelona in Spain, he at-
tended the School of Fine Arts of Barcelona and
later took courses at the Gali Academy. In 1919
he went to Paris, where he met Picasso and ex-
perimented briefly with Cubism. In 1924 he
signed the First Manifesto of Surrealism and in
1925 participated in the first Surrealist exhibi-
tion. He has since continued in the Surrealist
tradition, if not in the movement, collaborating
at times with Max Ernst and acknowledging the
influence of Klee. In 1948 he returned to Bar-
celona to live.

31 *Carnival of Harlequin*
 Oil on canvas, 26 x 36-5/8 in., 1924–25.
 Signed and dated. Albright-Knox Art Gallery.

37 *Dog Barking at the Moon*
 Oil on canvas, 29 x 36-1/4 in., 1926. Signed
 and dated. Philadelphia Museum of Art,
 A. E. Gallatin Collection.

68 *Head of a Woman*
 Oil on canvas, 18-1/8 x 21-5/8 in., 1938.
 Signed and dated. Mr. and Mrs. Donald Win-
 ston and The Minneapolis Institute of Arts.

76 *Constellation: Wounded Personage*
 Gouache and oil wash on paper, 15 x 18-1/8
 in., 1940. Mrs. Claire Zeisler.

77 *Constellation: Woman with Blond Armpit
 Combing Her Hair by the Light of the Stars*
 Gouache and oil on paper, 15 x 18-1/8 in.,
 1940. Signed. Contemporary Collection of
 The Cleveland Museum of Art.

78 *Constellation: Awakening at Dawn (Le
 Reveil au Petit Jour)*
 Gouache on paper, 18 x 15 in., 1941. Signed
 and dated. Collection of Mr. and Mrs.
 Ralph F. Colin.

AMEDEO MODIGLIANI

Italian, 1884–1920

Born in Leghorn, Italy, he studied painting in
Florence and Venice. In 1906 he arrived in Paris.
Like so many other painters he discovered
Cézanne and became a close friend of the sculp-
tor Brancusi, who introduced him to African
sculpture, which, thereafter, exercised a pro-
found influence on his art. Modigliani was aware
of the experiments of Picasso and Braque, but he
was not temperamentally suited for Cubism. He
died in Paris.

6 *L'Algérienne Almaissa*
 Oil on canvas, 32-1/2 x 46-1/2 in., 1917.
 Signed. Mr. and Mrs. Paul Wurzburger-
 Valabrègue.

PIET MONDRIAN

Dutch, 1872–1944

Born in Amersfoort, Holland, he was at first in-
fluenced by traditional Dutch art. In 1910–11 he
was in Paris, where he came under the influence
of Cubism, leading finally to his completely ab-
stract mature style. He was a leader of *De Stijl*
group and founded Neo-Plasticism in 1920. In
1938 he went to England, where he influenced
the painting of several artists. In 1940 he came
to New York, where he spent his remaining years.

19 *Composition in Grey, Red, Yellow, and Blue*
 Oil on canvas, 39-5/8 x 39-3/4 in., 1920.
 Signed (monogram) and dated. Marlborough-
 Gerson Gallery.

44 *Foxtrot B*
 Oil on canvas, 17-3/4 x 17-3/4 in., 1929.
 Signed (initialed) and dated. Yale University
 Art Gallery, Collection Société Anonyme.

CLAUDE MONET

French, 1840–1926

Born in Paris, he grew up in Brittany on the coast
of the English Channel, where he studied paint-
ing with Boudin. He is largely responsible for
creating the Impressionist method and finally
defining the style. As a student in the Académie
Suisse and the Académie Gleyre he met and be-
came friends with Pissarro, Renoir, Bazille, and
Sisley—the artists who formed the nucleus of the
Impressionist movement. Influenced or en-
couraged by Courbet, Constable, Turner, Dela-
croix, the Barbizon painters, Boudin, and Jong-
kind, the Impressionists, led by Monet, devel-
oped the method of painting directly in "patches"
of pure color juxtaposed to suggest the flicker
of light reflected from the changing surface of
the landscape. After a stay in England in 1870,
Monet arrived at the full development of his art.
A slow and consistent evolution of his style led
him finally to stress painterly qualities over ob-
jective representation of nature. His last years
were spent at his home in Giverny, outside Paris,
where he spent most of his time painting in his
garden. It was at this point that his paintings of
his lily pond lost all sense of solid forms and de-
veloped an expressive vocabulary based on the
artist's brush stroke. And it is these works that re-
veal an affinity with Abstract Expressionist paint-
ings of the 1940's and 1950's.

18 *Water Lilies*
 Oil on canvas, 79 x 167-1/2 in., ca.1919–1926.
 Signed with estate stamp. The Cleveland
 Museum of Art, John L. Severance
 Collection.

HENRY SPENCER MOORE

British, born 1898

Born in Castleford, Yorkshire, the son of a miner,
Moore joined the army in 1917, was demobilized
in 1919. He attended the Leeds School of Art in
London until 1925. From about 1931 to 1939 his
essentially humanistic interests were increasingly
diverted into abstract forms. From 1930 onwards,
he returned to the theme that he has made par-
ticularly his own—the reclining figure with varia-
tions from near-realism to almost complete ab-
straction. The mother and child, the family
group, the stricken warrior, and the form within
a form are other favorite themes.

97 *Reclining Figure*
 Elmwood, 34 x 75 x 20 in., ca.1945–46. Gal-
 leries—Cranbrook Academy of Art, Bloom-
 field Hills, Michigan.

145 *Three Piece Reclining Figure*
 Bronze, 64 x 114 x 53-1/4 in., ca.1961–62.
 Signed. M. Knoedler & Company, Inc.

GIORGIO MORANDI

Italian, 1890–1964

Born in Bologna, he studied at the Academy of
Fine Arts in that city. He taught for many years in
elementary schools and after 1930 at the Bologna
Academy. Although he never went to Paris, he
was influenced by Cézanne above all other ar-
tists. Cubism also had an effect and he was briefly
associated with Futurism, the *Scuola Metafisica*
and the group known as *Valori Plastici*. Etching
was as important a medium for Morandi as paint-
ing. He never painted the human figure, concen-
trating instead on still lifes of bottles, glasses,
and pots. He died in Bologna.

72 *Still Life*
 Oil on canvas, 17-3/8 x 20-7/8 in., 1939.
 Signed and dated. Private Collection, New
 York.

ROBERT MOTHERWELL

American, born 1915

Born in Aberdeen, Washington, Motherwell
studied philosophy at Harvard, attended the Uni-
versity of Grenoble, and the School of Art and
Archaeology at Columbia University where he
studied with the art historian, Meyer Schapiro.
He also studied engraving with Kurt Seligmann
and Stanley W. Hayter. Later, he taught at Hunter
College, New York, and directed the *Documents
of Modern Art* project for Wittenborn and Com-
pany. Along with Gorky, Pollock, Hofmann,
Tomlin, Rothko, and a few others, he was one
of the leaders in the development called The
New York School or Abstract Expressionism.
During the early forties he was in close touch
with Matta and through this artist introduced
Surrealist ideas to American art.

122 *Elegy to the Spanish Republic XXXIV*
 Oil on canvas, 80 x 100 in., 1953–54. Signed (initialed). Albright-Knox Art Gallery, Gift of Seymour H. Knox.

144 *Elegy to the Spanish Republic, 54*
 Oil on canvas, 70 x 90-1/4 in., ca.1957–61. Signed (on reverse). The Museum of Modern Art, New York.

ROBERT MULLER
Swiss, born 1920
A native of Zürich, he studied sculpture in the studio of Germaine Richier during 1939–1944. After working in Genoa and then Rome, he settled in Paris in 1950. He was awarded the Regina Feijel prize in the 1957 Sao Paulo Biennale.

136 *Aaronstab*
 Welded metal, H. 66 in., ca.1958. Albert Loeb Gallery.

ISAMU NOGUCHI
American, born 1904
Born in Los Angeles, he spent his childhood in Japan. In 1918, he returned to the United States and was apprenticed to a cabinetmaker. His first attempts at sculpture were made under Gutzon Borglum. In Paris, during 1927 and 1928, he was an assistant to Brancusi. He also came to know the work of Calder, Giacometti, Picasso, and Miró. In 1929 he returned to the United States and now divides his time between this country and Japan.

135 *Woman with Child*
 White marble, 44 in., 1958. Contemporary Collection of The Cleveland Museum of Art.

KENNETH NOLAND
American, born 1924
Born in North Carolina, Noland studied at Black Mountain College and in Paris with Zadkine. He lived and worked for a while in Washington, D.C. Along with Morris Louis and Helen Frankenthaler, he is one of the leaders of what the critic Clement Greenberg has termed "Post Painterly Abstraction." Reacting against the vigorous, painterly look of works by artists such as De Kooning, these younger artists are more closely related to such Abstract Expressionists as Rothko and Gottlieb.

151 *Warm Reverie*
 Acrylic polymer on canvas, 45 x 45 in., 1962. Frank H. Porter.

JOSE CLEMENTE OROZCO
Mexican, 1883–1949
Born at Ciudad Cuzmán, Mexico, he was closer to the Aztec tradition and less influenced by European art than most modern Mexican artists. He studied architectural drawing at the National Academy of Fine Arts in Mexico City and worked as a draftsman for some years before beginning his serious art work in 1913. Along with Diego Rivera and David Siqueiros he formed the nucleus of an important group of Mexican mural painters and established the Syndicate of Painters and Sculptors.

49 *Wounded Soldier*
 Oil on canvas, 44-1/2 x 36-1/2 in., 1930. Signed. The Cleveland Museum of Art, Gift of Mr. and Mrs. Michael Straight.

JULES PASCIN (PINCUS)
American, 1885–1930
He left his native Bulgaria in 1902 to study and pursue a career as a cartoonist in Vienna and Munich. In 1905 he went to Paris, where he began to paint. He came to the United States at the outbreak of World War I and became a citizen in 1920. He was active as a draftsman and book illustrator as well as a painter. He committed suicide in 1930.

36 *Seated Girl (Cinderella) (Cendrillon)*
 Oil on canvas, 36-1/2 x 29 in., 1925–26. Signed. The Toledo Museum of Art, Gift of Edward Drummond Libbey.

ANTOINE PEVSNER
Russian, 1884–1962
Born in Orel, Russia, he came from a family of engineers and attended art schools in Kiev and St. Petersburg. The most important part of his training was in Russian medieval art. In a monastery of Novgorod, he saw an icon with inverted perspective which modified his conception of space. At the same time he discovered the Impressionists and the Cubists. In 1911–13 he was in Paris, where he met Archipenko and Modigliani. The sculpture of Pevsner's brother, Naum Gabo, influenced him to turn from painting to sculpture. In 1919 Pevsner and Gabo worked out a philosophy of sculpture, "depending entirely on reason and strict logic." Both signed the *Realist Manifesto* which contained the guiding principles of their art. Pevsner belonged to the Abstract-Creation group before the war, and in 1946 founded with Herbin, Gleizes, and some others the Réalités Nouvelles group in Paris, which held its first Salon in 1947.

88 *Construction*
 Metal relief, 16 x 26 in., 1944. Mr. and Mrs. Arnold H. Maremont.

104 *Construction in the Egg*
 Bronze (unique cast), 28 x 19-3/4 x 17-1/4 in., 1948. Dated. Albright-Knox Art Gallery.

PABLO PICASSO
Spanish, born 1881
Although he was born in Malaga, Spain, studied in Barcelona, and is thoroughly Spanish in temperament, Picasso has lived most of his life in France. His first visits to Paris came in 1901 and 1902. It is impossible to do more than hint at his enormous accomplishments in the fields of painting, sculpture, ceramics, and graphic arts. He has, in a sense, thrown away powerful ideas which other artists have fed on for most of their careers. Along with Braque, he invented Cubism and Expressionism, and his work contains elements of Dadaism, Surrealism, Classicism, and poetic-realism. Yet, such categories are primarily for the convenience of the art historian; they cannot begin to contain the vigorous works of this artist.

9 *Harlequin with Violin (Si Tu Veux)*
 Oil on canvas, 56 x 39-1/2 in., 1918. Signed and dated. Private Collection, New York.

23a *Dog and Cock*
 Oil on canvas, 60-7/8 x 30-1/8 in., 1921. Signed and dated. Yale University Art Gallery, Gift of Stephen C. Clark.

29 *Woman in White*
 Oil on canvas, 39 x 31-1/2 in., ca.1923. Signed. The Metropolitan Museum, Rogers Fund, 1951, acquired from The Museum of Modern Art, Lizzie P. Bliss Collection.

54 *The Dream*
 Oil on canvas, 51 x 38 in., ca. 1932. Mr. and Mrs. Victor W. Ganz.

61 *Interior with Girl Drawing*
 Oil on canvas, 51-1/8 x 76-5/8 in., 1935. Dated. Private Collection, New York.

64 *Minotauromachy*
 Etching, 19-1/2 x 27-1/4, 1936. Signed and dated. National Gallery of Art, Rosenwald Collection.

74 *Woman Dressing Her Hair*
 Oil on canvas, 51-1/4 x 38-1/8 in., 1940. Signed and dated. Mrs. Bertram Smith.

79 *Portrait of Madame Eluard*
 Oil on canvas, 28-3/8 x 23-5/8 in., 1941. Dated. Musée National d'Art Moderne.

93 *Ile de la Cité, Paris*
 Oil on canvas, 31-1/2 x 47-1/2 in., 1945. Sidney Janis Gallery.

112 *Monkey and Her Baby*
 Bronze, 22-1/2 x 13-1/8 x 24 in., 1951. Dated. The Minneapolis Institute of Arts.

JACKSON POLLOCK
American, 1912–1956
Born in Cody, Wyoming, he died in Southampton, New York. He studied at the Art Students League in New York with Thomas Hart Benton. From 1943 to 1947 he worked on W.P.A. Federal Arts Projects. Around 1940 he began ab-

stractions closely allied in method and spirit with Surrealism. Along with Gorky, Hofmann, Rothko, Motherwell, and others, he was a leading figure of the New York School of Abstract Expressionism. It was probably the Surrealist notion of automatism that led to Pollock's development of his unique method of dripping paint on large canvases tacked to the floor.

86 *Pasiphaë*
Oil on canvas, 56-1/8 x 96 in., ca.1943. Signed. Marlborough-Gerson Gallery.

100 *Cathedral*
Duco and aluminum paint on canvas. 71-1/2 x 35-1/16 in., 1947. Signed and dated. Dallas Museum of Fine Arts, Gift of Mr. and Mrs. Bernard J. Reis.

119 *Ocean Greyness*
Oil on canvas, 57-3/4 x 90-1/8 in., 1953. Signed and dated. The Solomon R. Guggenheim Museum.

ROBERT RAUSCHENBERG
American, born 1925
Born in Texas, Rauschenberg studied at the Kansas City Institute, the Académie Julian in Paris, Black Mountain College and the Art Students League in New York. He has traveled in Europe and North Africa. In 1964 he was awarded the Grand Prize at the Venice Biennale.

159 *Tracer*
Oil on canvas, 84 x 60 in., 1964. Mr. and Mrs. Frank M. Titelman.

ODILON REDON
French, 1840–1916
Born in Bordeaux, he died in Paris. Redon belonged to the Impressionist generation, but he never accepted the objective attitude of the painters of this group. He loved nature and studied it closely, but he always insisted on the central role of imagination in art. His precise drawings from nature led to the development of a personal style appropriate to the world of his dreams. Symbolist poets, such as Mallarmé, were quick to recognize affinities between his painting and their own writing. Gauguin, the Nabis, and Matisse were all inspired by his work; and Surrealism later recognized him as a precursor.

1 *Orpheus*
Pastel, 27-1/2 x 22-1/4 in., painted after 1913 (probably in the last year of his life). Signed. The Cleveland Museum of Art, J. H. Wade Collection.

AD REINHARDT
American, born 1913
Born in Buffalo, New York, he studied at Columbia University in New York City but is self-educated in matters of painting. He is well known for his satirical cartoons as well as his painting. Reinhardt is a strict abstract painter who rejects all Expressionist and Surrealist tendencies. His painting has developed in a severely geometrical way based on the horizontal and vertical. It has gone through an evolution from multi-colored compositions, to blue-green works, then to red and red-orange canvases and on to close values and slightly varied tones of black. He teaches at City College in New York.

105 *Abstract Painting, 1948*
Oil on canvas, 76 x 144 in., 1948. Ad Reinhardt.

JEAN-PAUL RIOPELLE
Canadian, born 1923
Born in Montreal, he first studied mathematics at Montreal Polytechnic and only began to paint in 1945. In 1946 he traveled to France, Germany, and New York. He did his first abstract paintings under the influence of Surrealist theories. Since 1947 he has been living in Paris.

143 *Terre Promise*
Oil on canvas, 84 x 108 in., ca.1960. Frank H. Porter.

THEODORE ROSZAK
American, born 1907
Born in Poznan, Poland, he came to the United States with his family in 1909 and settled in Chicago. He studied at the National Academy of Design and the Art Institute of Chicago and first made his living as a draftsman and lithographer. He began his career in fine art as a painter. He has traveled in Europe and has taught at the Art Institute of Chicago and Sarah Lawrence College among other places. His first mature works in sculpture were severely geometrical, influenced by the Constructivist tradition. After World War II he began working with biomorphic, spikey forms in metal which are related to Surrealist images and to Abstract Expressionist paintings.

103 *Recollection of the Southwest*
Brazed iron, 48 long x 31 in., 1948. Mr. and Mrs. Arnold H. Maremont.

MARK ROTHKO
American, born 1903
Born in Dvinsk, Russia, he came to the United States in 1913 and spent his boyhood in Portland, Oregon. He studied at Yale University from 1921 to 1923. He begain painting in 1926 and studied at the Art Students League with Max Weber.

During the mid-thirties he worked for W.P.A. Projects in New York. He has taught at the California School of Fine Arts in San Francisco and at Brooklyn College. Rothko is one of the original members of the group that created the Abstract Expressionist movement. His art is quite different in character, however, from that of "action" painters such as Pollock, Kline, and De Kooning.

148 *No. 118*
Oil on canvas, 114 x 102 in., 1961. Signed and dated (on back). Mark Rothko.

149 *Red Maroons*
Oil on canvas, 79 x 81 in., 1962. Signed and dated (on back). Contemporary Collection and Friends of The Cleveland Museum of Art.

158 *1964, No. 2*
Oil on canvas, 105 x 80 in., 1964. Signed and dated (on back). Mark Rothko.

GEORGES ROUAULT
French, 1871–1958
Rouault was apprenticed to a stained-glass painter in his youth and always retained a taste for luminous colors within a structure of black lines. He also attended courses at the Paris School of Decorative Arts, and in 1891 he entered the Ecole Nationale des Beaux-Arts and studied with Gustave Moreau. In that master's studio he met Henri Matisse, an association leading to his later participation in Fauvist exhibitions. In 1903 he met Huysmans and Leon Bloy, adopting the latter's gloomy brand of Catholicism. He was a master in the graphic arts, stained-glass designing, and ceramics, as well as painting.

48 *End of Autumn #4*
Oil on canvas, 29-1/4 x 41-1/2 in., ca.1919–1929 (dated 1952 in Pierre Courthion's book with catalogue, *Georges Rouault* [New York: Harry N. Abrams, Inc., 1961], p. 454). Signed. The Cleveland Museum of Art, Gift of Mr. and Mrs. Paul H. Sampliner.

65 *The Old King*
Oil on canvas, 30-1/2 x 21-1/4 in., ca.1916–1938 (dated 1937 in Courthion, pp. 237 and 464, and 1936 in the catalogue of the Rouault exhibition at The Museum of Modern Art [New York, 1947, distributed by Simon and Schuster], frontispiece and p. 129). Signed. Museum of Art, Carnegie Institute.

Note: Rouault's habit of reworking his canvases over many years has led to difficulties in assigning exact dates to his works.

KURT SCHWITTERS
German, 1887–1948
Born in Hanover, he studied at the Royal Gymnasium there and attended the Academy of Dresden. He was mobilized during the first

World War and returned to Hanover after the Armistice. He was first influenced by the work of Kandinsky and Franz Marc. A little later he invented *Merz*, his own variation of Dada, and began publishing the *Merz* magazine which was both Dadaist and Constructivist in character. At the same time he undertook his first *Merzbau*, which is to sculpture what *papier collé* is to painting. In 1937 he emigrated to Norway and in 1940 he fled to England, where he died eight years later at Ambleside.

17 *Ja-Was Ist*
Collage and oil paint on board, 38-1/2 x 27-1/4 in., 1920. Signed and dated. Mr. and Mrs. James W. Alsdorf.

BEN SHAHN
American, born 1898
Born in Kovno, Russia, he came to the United States in 1906. After studying painting at City College of New York and at the National Academy of Design, he worked for the W.P.A. Art Project, doing the murals for the Bronx Post Office, and assisted Diego Rivera with the murals for Rockefeller Center. He has traveled in France, Italy, Spain, and North Africa. His paintings have usually dealt with social or political subjects and his figurative style is flat and poster-like.

57 *Women's Christian Temperance Union Parade*
Gouache, 16 x 31-1/2 in., ca.1933–34. Museum of the City of New York.

CHARLES SHEELER
American, 1883–1965
Born in Philadelphia, he studied at the Pennsylvania Academy under William M. Chase. He made trips to England, Holland, Spain, Italy, and Paris and devoted himself for a period to photography and to filmmaking. He was represented in the Armory Show in 1913. The influence of photography and of Cubism combined to contribute to the development of his precise, pure, and geometrical style sometimes called Cubist-Realism.

46 *Upper Deck*
Oil on canvas, 28-5/8 x 21-5/8 in., 1929. Signed and dated. Fogg Art Museum, Harvard University, Louise E. Bettens Fund.

DAVID SMITH
American, 1906–1965
Born in Decatur, Indiana, he studied briefly at Ohio University, Notre Dame University, and the Art Students League in New York. He worked on an automobile frame assembly line and in a factory making locomotive engines. In 1930 he met Stuart Davis and Jean Xceron, who turned him towards abstract art. In 1931 he produced his first

sculptures in painted wood and in 1933 he used wrought iron for the first time. In 1935–36 he visited London, Paris, Greece, Crete, and Russia. A pioneer of welded metal sculpture, Gonzalez and Picasso were his main influences. He taught at Sarah Lawrence College, the University of Arkansas, the University of Indiana, and the University of Mississippi.

102 *Royal Bird*
Stainless steel, 21-3/4 x 59 x 9 in., 1948. Signed and dated (stamped on base). Collection Walker Art Center, T. B. Walker Foundation Acquisition.

153 *Cubi XIV*
Stainless Steel, H. 121-1/2 in., 1963. Marlborough-Gerson Gallery.

154 *Zig VII*
Painted steel, 94-3/4 x 100-3/8 in., 1963. Signed. Marlborough-Gerson Gallery.

LEON POLK SMITH
American, born 1906
Born in Ada, Oklahoma, he studied at Oklahoma State College and in New York. He traveled in Europe and Mexico and then taught high school in Oklahoma and at various colleges including Mills. His first pure abstractions were exhibited in 1941.

163 *Four Involvements in One*
Oil on canvas, 108 x 160 in., 1964–65. Signed and dated. Galerie Chalette.

CHAIM SOUTINE
Russian, 1894–1943
Born in Smilovich near Minsk, he died in Paris. As a boy he went to Minsk and then to Vilna, where he enrolled in the School of Fine Arts while working as a photographer's assistant. In 1913 he arrived in Paris to enroll at the Ecole Nationale des Beaux-Arts. He became friendly with Modigliani, Chagall, Léger, and other avant-garde artists. In 1919 he went to paint in Céret, in the Pyrénées-Orientales where he stayed almost three years, completing around two hundred canvases. In 1925 he went to Cagnes to work.

32 *Side of Beef*
Oil on canvas, 55-1/4 x 42-3/8 in., ca.1925. Signed. Albright-Knox Art Gallery.

NICOLAS DE STAEL
French, 1914–1955
Born in St. Petersburg into an aristocratic Russian family that emigrated to Belgium in 1919, he was orphaned in 1922. He studied at the Académie des Beaux-Arts in Brussels and became a French citizen in 1946. In 1955 he died by his own hand while in Antibes in the south of France.

107 *Rue Gauguet*
Oil on plywood panel, 78-1/2 x 94-3/4 in., 1949. Signed and dated. Museum of Fine Arts, Boston.

RICHARD STANKIEWICZ
American, born 1922
Stankiewicz was born in Philadelphia, grew up in Detroit, and served in the United States Navy during World War II. He did sculpture off and on and studied painting with Hans Hofmann in New York and with Léger in Paris. In the early 1950's he turned completely to sculpture while studying with Zadkine. In 1951 he helped found the cooperative Hansa Gallery. His sculptures are created of discarded metal parts from mechanical industry.

147 *Untitled Piece No. 1961–18*
Steel and iron, 84 x 82 x 54 in., 1961. Signed (initialed) and dated. Stable Gallery.

JOSEPH STELLA
American, 1877–1946
Born at Muro Lucano, Italy, he first studied medicine. In 1900 he came to the United States, studied at the New York School of Art, and worked as an illustrator. From 1909 to 1911 he was back in Europe where he met many avant-garde artists, including the Italian Futurists, who influenced his art. In 1913 he was represented in the Armory Show. In 1940 he made a trip to the West Indies. He died in New York.

10 *Brooklyn Bridge*
Oil on canvas, 84 x 76 in., 1917–18. Signed. Yale University Art Gallery, Collection Société Anonyme.

GRAHAM SUTHERLAND
British, born 1903
Born in London, educated at Epson College, he studied at Goldsmith's School of Art, concentrating on graphic techniques. He was influenced by the work of William Blake and of the Surrealists. After 1935 he began to paint and was represented in the International Surrealist Exhibition in London in 1936. Since 1947 he has regularly visited southern France and has painted thorny, vegetable subjects.

117 *Head III*
Oil on canvas, 45 x 34-3/4 in., 1953. Signed and dated. The Trustees of the Tate Gallery.

YVES TANGUY
French (American), 1900–1955
Born in Paris, he died in Connecticut, where he was living with his wife, the painter Kay Sage. He began painting suddenly after being impressed by a picture of Giorgio de Chirico's which he saw in a window. In 1925 he joined the Sur-

realists and thereafter participated in all their exhibitions. He came to the United States in 1939 and stayed in California and Canada briefly before settling down in Woodbury, Connecticut, in 1942. In 1948 he became an American citizen.

38 *Mama, Papa Is Wounded!*
Oil on canvas, 36-1/4 x 28-3/4 in., 1927. Signed and dated. The Museum of Modern Art, New York, Purchase.

MARK TOBEY
American, born 1890
A native of Wisconsin, he first studied art in Chicago and later in New York with Kenneth Hayes Miller. After working as a fashion illustrator, he moved to Seattle in 1922. In 1935 he traveled to Paris and the Near East. In 1934 he studied calligraphy in Japan and Shanghai. He was awarded the Grand International Prize at the Venice Biennale in 1958.

156 *Untitled*
Oil and collage on canvas, 84 x 61-3/4 in., 1964. Signed and dated. The Art Institute of Chicago, Grant J. Pick Purchase Fund.

VICTOR VASARELY
French, born 1908
Born in Pecs, Hungary, he studied at the Budapest Bauhaus in 1928. He moved to Paris in 1930, where he worked as a graphic designer. He became a French citizen in 1960. He published a manifesto, *Mouvement,* in 1955. He was awarded first prize at the Sao Paulo Biennale in 1965.

157 *Orion Blanc*
Oil on canvas, 82-1/2 x 78-1/2 in., 1962–64. Signed and dated. Dr. and Mrs. Arthur Lejwa.

JACQUES VILLON
French, 1875–1963
Born Gaston Duchamp, at Damville, he studied at the Atelier Cormon. Along with his brothers Marcel Duchamp and Duchamp-Villon and his sister Suzanne Duchamp, he helped establish the *Section d'Or* movement which was allied with Cubism. From 1914 to 1919 he was in the army. During the 1920's he devoted himself to graphics, chiefly etching. In 1930 he returned to painting. He was represented in the Armory Show in the United States in 1913 and in the first Salon des Réalités Nouvelles in 1939. He joined a lyrical palette to a Cubist-derived compositional structure. He died in 1963 at Puteaux.

80 *Potager à la Brunié*
Oil on canvas, 25-5/8 x 36-1/4 in., 1941. Signed and dated. The Cleveland Museum of Art, Purchase, Leonard C. Hanna Jr. Bequest.

MAX WEBER
American, 1881–1961
Born in Byalystok, Russia, he came to the United States when he was ten years old and settled in Brooklyn. He studied at Pratt Institute in Brooklyn and taught drawing in the public schools for several years. In 1905 he went to France where he studied at the Academie Julian, traveled throughout Western Europe, and came to know Henri Rousseau, Picasso, Matisse, and Delaunay, among other avant-garde artists. He took part in the Cubist movement but never lost his concern for the subject. He returned to the United States in 1908 and until his death continued to develop his art in the direction of Expressionism.

15 *Conversation*
Oil on canvas, 42 x 32 in., 1919. Signed and dated. Marion Koogler McNay Art Institute.

ANDREW NEWELL WYETH
American, born 1917
He was trained in a strict academic tradition by his father, the illustrator N. C. Wyeth. Wyeth belongs to no school of painting, nor is he at all influenced by the major art movements of the twentieth century. He works in a native American tradition of poetic realism. He usually works in water color and tempera.

110 *The Trodden Weed*
Egg tempera, 20 x 18 in., ca.1951. Signed. Mrs. Andrew Wyeth.

ADJA YUNKERS
American, born 1900
Born in Riga, Latvia, he has lived, studied, and worked in Leningrad, Berlin, Paris, London, Sweden, West Africa, the Canary Islands, Cuba, and Mexico. In 1947 he came to the United States, where he quickly established himself as one of the leading printmakers of this country, working primarily in colored woodcuts. He works, however, in almost all media, including charcoal, gouache, collage, oil, and pastel. After arriving in the United States, he became friendly with the American Abstract Expressionist artists.

132a *Sestina II*
Pastel on paper, 66-1/4 x 48 in., 1958. Mr. and Mrs. Jasper Wood.

Abbott Laboratories, North Chicago
Albright-Knox Art Gallery, Buffalo
Mr. and Mrs. James W. Alsdorf, Winnetka, Illinois
The Art Institute of Chicago
Mr. and Mrs. Lee A. Ault, New York
Bagshaw Art Gallery, Batley, England
Col. Samuel A. Berger, New York
Mr. and Mrs. E. A. Bergman, Chicago
The Brooklyn Museum
Mr. and Mrs. Gordon Bunshaft, New York
Busch-Reisinger Museum, Harvard University
Galerie Louis Carré, Paris
Galerie Chalette, New York
City Art Museum of St. Louis
Collection of Mr. and Mrs. Ralph F. Colin, New York
Cordier & Ekstrom, Inc., New York
The Currier Gallery of Art,
 Manchester, New Hampshire
Dallas Museum of Fine Arts
The Detroit Institute of Arts
Mr. and Mrs. Arne H. Ekstrom, New York
André Emmerich Gallery, New York
Richard L. Feigen, Chicago
Richard Feigen Gallery, New York and Chicago
Fogg Art Museum, Harvard University
Mrs. Miriam Gabo, Middlebury, Connecticut
Galleries—Cranbrook Academy of Art,
 Bloomfield Hills, Michigan
Mr. and Mrs. Victor W. Ganz, New York
Collection Robert Giron, Brussels
Mme. Roberta Gonzalez, Paris
Mrs. Adolph Gottlieb, New York
The Solomon R. Guggenheim Museum, New York
Mr. and Mrs. Ben Heller, New York
Joseph H. Hirshhorn Collection,
 Greenwich, Connecticut
Collection Sidney Janis, New York
Sidney Janis Gallery, New York
Madame Nina Kandinsky, Paris

M. Knoedler & Company, Inc., New York
Mr. and Mrs. Sigmund W. Kunstadter,
 Highland Park, Illinois
Kunsthaus Zürich
Dr. and Mrs. Arthur Lejwa, New York
Collection Mr. and Mrs. Julien Levy,
 Bridgewater, Connecticut
Jacques Lipchitz, Hastings-on-Hudson, New York
Albert Loeb Gallery, New York
Los Angeles County Museum of Art
Mr. and Mrs. Arnold H. Maremont, Winnetka, Illinois
Marion Koogler McNay Art Institute, San Antonio
Marlborough-Gerson Gallery, New York
Collection of Morton D. May, St. Louis
Mr. Louis McLane, Los Angeles
Mrs. Katherine W. Merkel, Gates Mills, Ohio
The Metropolitan Museum of Art, New York
The Minneapolis Institute of Arts
Musée National d'Art Moderne, Paris
Museum of Art, Carnegie Institute, Pittsburgh
Museum of the City of New York
Museum of Fine Arts, Boston
The Museum of Modern Art, New York
National Gallery of Art, Washington
Nelson Gallery—Atkins Museum, Kansas City
Collection Roland Penrose, London
Perls Galleries, New York
Philadelphia Museum of Art
Mrs. John Sargent Pillsbury, Crystal Bay, Minnesota
Poindexter Gallery, New York
Frank H. Porter, Chagrin Falls, Ohio
Mr. and Mrs. Otto Preminger, New York
Private Collection, New York
Private Collection, New York
Private Collection, New York
Private Collection, Paris
Ad Reinhardt, New York
Mr. and Mrs. Bernard J. Reis, New York
Paul Rosenberg & Co., New York

FIFTY YEARS OF MODERN ART/1916-1966